IMAGES OF AMERICA

FREEHOLD

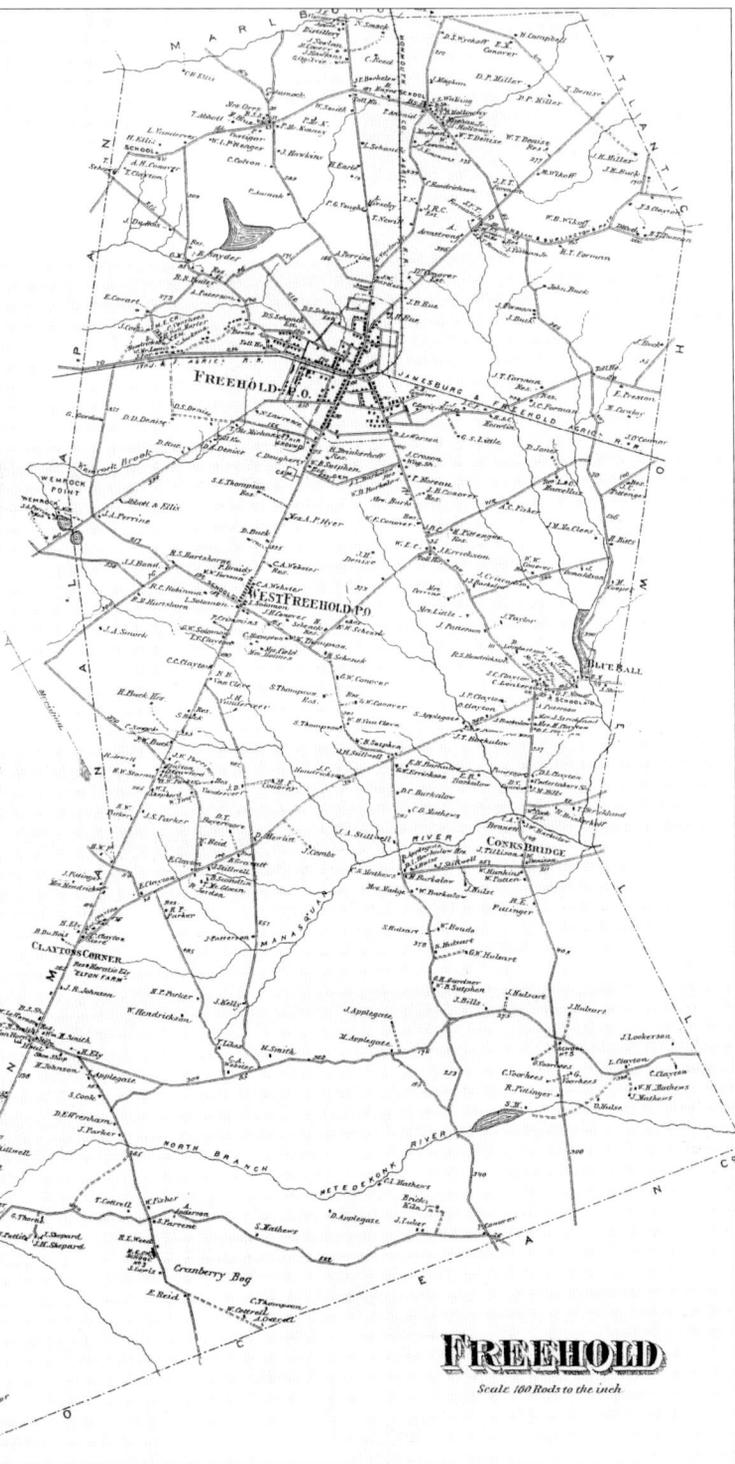

IMAGES OF AMERICA

FREEHOLD

LEE ELLEN GRIFFITH

ARCADIA

Frontispiece: Map of Freehold, *Beers' Atlas*, 1873.

Copyright © 1996 by Lee Ellen Griffith, Ph.D.
ISBN 0-7385-1281-8

First published 1996
Re-issued 2003

Published by Arcadia Publishing
an imprint of Tempus Publishing Inc.
Charleston SC, Chicago, Portsmouth NH,
San Francisco

Printed in Great Britain

Library of Congress Catalog Card Number: 2003106991

For all general information contact Arcadia Publishing at:
Telephone 843-853-2070
Fax 843-853-0044
E-mail sales@arcadiapublishing.com
For customer service and orders:
Toll-Free 1-888-313-2665

Visit us on the internet at http://www.arcadiapublishing.com

Contents

Acknowledgments

I wish to thank all those who have kindly given me assistance in compiling this book by lending photographs, sharing information, or providing general moral support, including: the staff and trustees of Monmouth County Historical Association, especially the library staff (Barbara Carver Smith, Eileen Thompson, and Carla Z. Tobias); Jane Allen; Florence Moreau Backlund; Margaret Buck Bergen; Diane Bethel of Sotheby's Inc. New York; Jeannette Blair; Richard Daesner; Margaret Errickson; Mrs. William Freeman; Carolyn Smith Flock; George Fox; Randall Gabrielan; Barbara Greenberg; Freehold Public Library; Rebecca L. Griffith; Joseph W. Hammond; Lydon Hendrickson; Mr. and Mrs. James Higgins; Nolan Higgins; Bernard Holderer of the Freehold Raceway; Gail Hunton; Fran Hurley of St. Peter's Episcopal Church; George H. Moss Jr.; Alfreda White Perrine; Zack S. Roberts; Marion Russell; Carl N. Steinberg; Mr. and Mrs. Howard VanDerveer; Cheryl Wolf and Wayne Mason; and Nancy DuBois Woods.

Introduction

Freehold, the County Town of Monmouth County, is pleasantly situated within two miles of the Battle Ground, at the Terminus of the Freehold and Jamesburgh Agricultural Railroad, and upon the line of Travel from the Cities of New York and Philadelphia, to Long Branch and the other prominent water-places in the County. It is noted for great Business activity, the excellence of its seminaries of learning, beauty of appearance, its social qualities, and revolutionary history. It has an extensive trade in marl from the famous Squancum Pits, with different parts of the State; the surrounding country is rich in agricultural resources, and both as a place of Business and Residence, Freehold is unsurpassed."— from the 1855 map of Freehold, published by Ezra A. Osborn and Thomas A. Hurley.

Freehold's history in Monmouth County as one of its first three towns to receive a charter (in 1693), as the seat of county government, and as a business and industrial center has contributed to the area's unique character in terms of architecture, events, business, and social activities. The eighteenth century saw Freehold's growth as artisans established their businesses in town and people living in outlying areas settled in small villages and on farms. By the early nineteenth century, Freehold's development as a Main Street town was well underway. With the construction of the railroad line through the business center of Freehold in 1852, the town's role as the commercial hub for the area was established. The railroad enabled farmers to send their crops, principally potatoes, to the Newark and Trenton markets and promoted the development of industrial complexes situated along the rail.

Over the years, two distinct cultural environments evolved in Freehold, both of which are documented in this book, one a bustling commercial town and the other centered on village life and an agricultural economy. In 1919, the Borough of Freehold separated from the township formally and adopted its own government and tax collection system, underscoring that division; yet Freehold Borough remained a center

of activity for much of the surrounding area known as Western Monmouth.

This book's purpose is to present a celebration not only of the rich history of Freehold but also of the art of photography. Freehold was home to a small group of early photographers, the first of whom was John Roth, followed by Ferris C. Lockwood, Arthur L. Hall, John C. Scott, and later, in the twentieth century, Charles F. Ladd. Their skills at portraiture were not limited to studio likenesses, but also captured proud business owners by their storefronts, or families in front of their homes. The work of amateur photographers is also included, notably that of Helen Simpson Truex, who captured touching and playful images of her family and friends at the turn of the century.

In 1872, Ferris C. Lockwood published a pamphlet entitled, "For Parlor or Pocket, The Photograph Album," which outlined the history of photography and advised sitters on what to expect form a portrait session. He also explained, "Photography that is merely mechanical is undeserving of patronage. This calling has its bunglers. Without art and skill the picture will have no merit. Not only taste, but a delicate sense of optical and chemical effect, such as cannot be taught, are required."

The photographic images in this book are principally from two institutions—the Monmouth County Historical Association and the Freehold Public Library—and also from several private collections. It is important to note that this collection of photographs by no means presents a complete picture of Freehold. In particular, Freehold's many important and architecturally significant Victorian houses are under-represented, and perhaps may serve as the basis for another book. It is the author's hope that this volume might encourage another book or two of images of Freehold to augment this one as an historical resource.

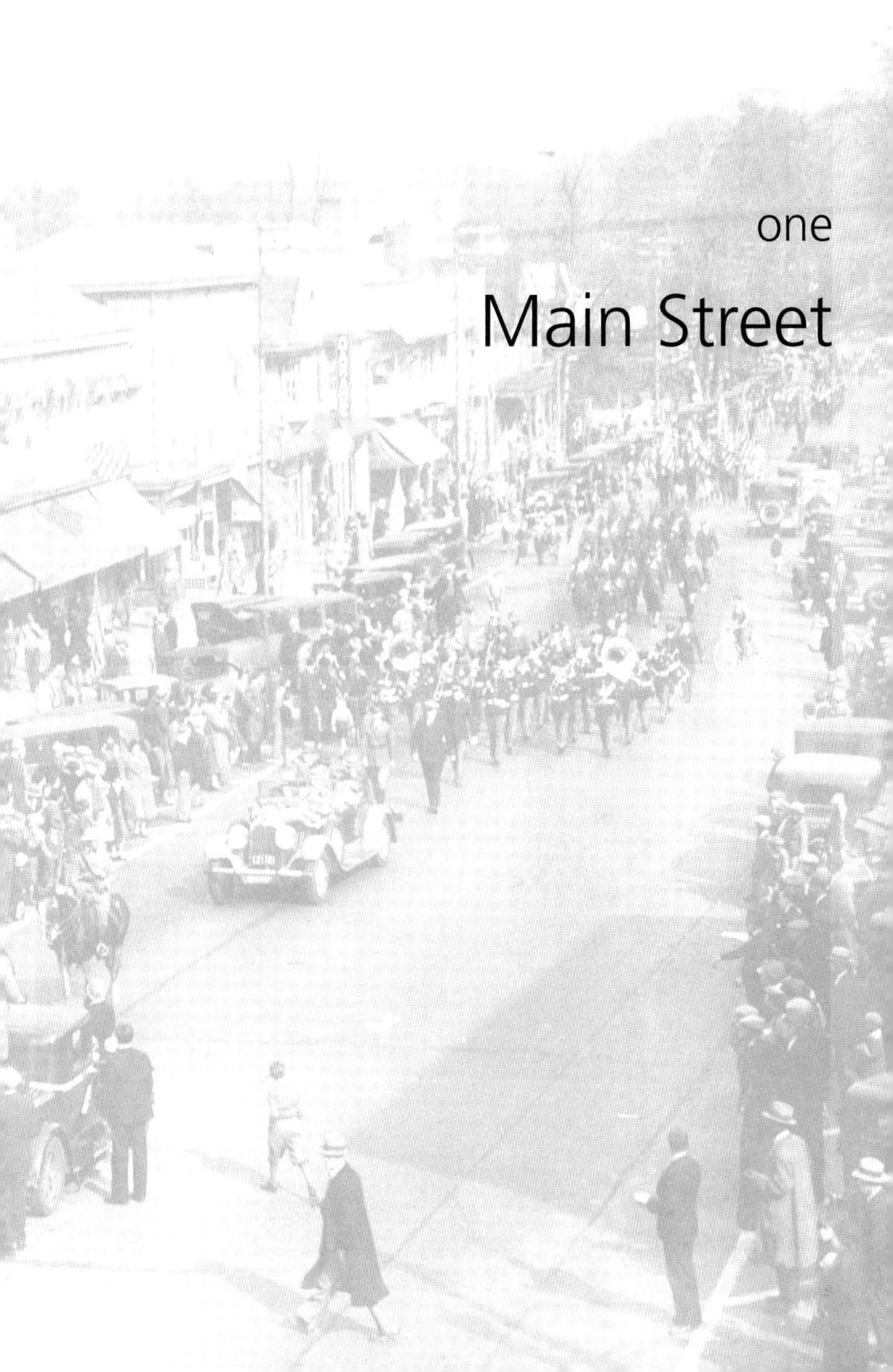

Main Street

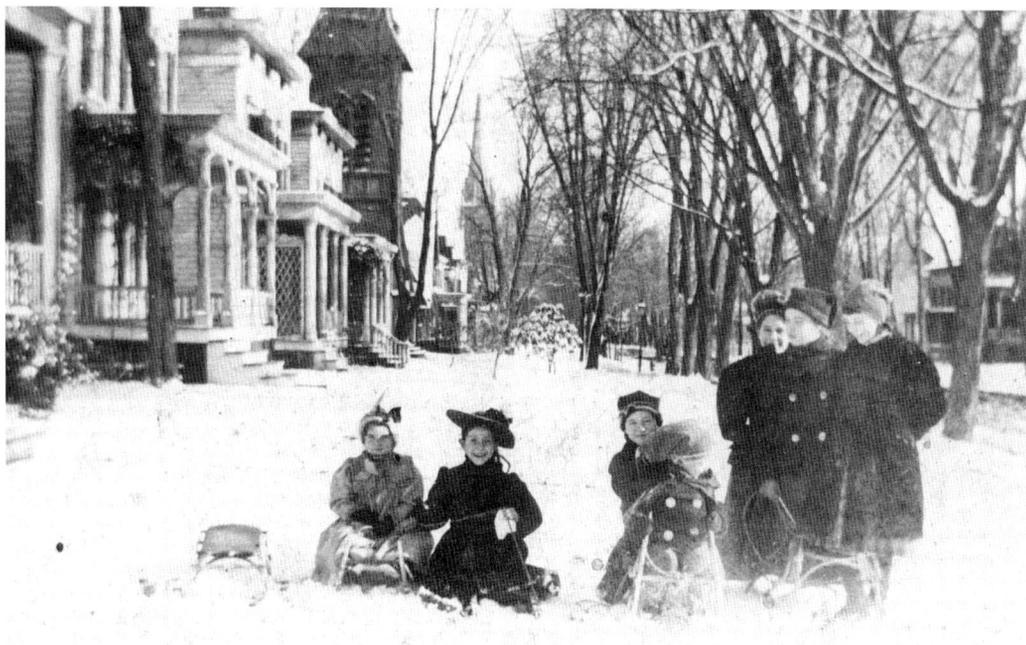

Sledding on Main Street, *c.* 1900.

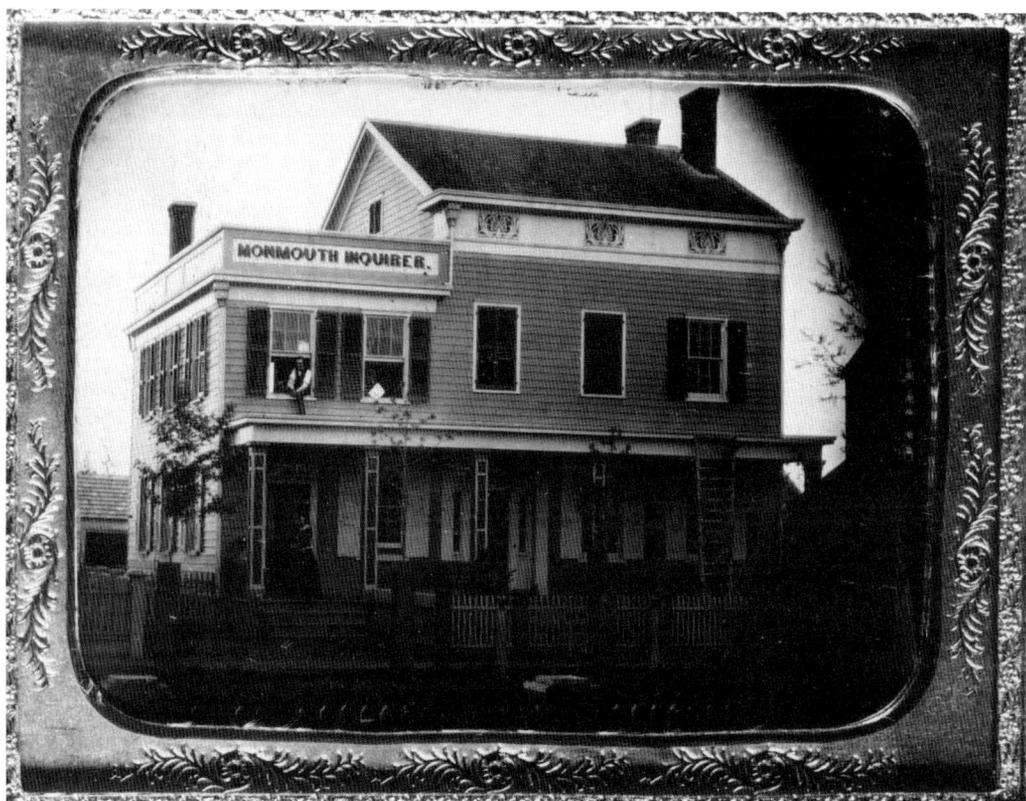

Opposite, below: Offices of the *Monmouth Inquirer, c.* 1855. This rare quarter-plate daguerreotype was one of twelve taken of Freehold buildings which appear as engraved vignettes on the 1855 Osborn and Hurley map of Freehold. Established in 1828 by John and Enos Bartleson, the *Monmouth Inquirer* went through a series of mergers and different owners, including two generations of the Applegate family, until it was purchased in 1933 by *The Freehold Transcript.* At the time this daguerreotype was taken the owner was Orrin Pharo and the location was at the corner of East Main and Sheriff Streets. This daguerreotype was made by Meade Bros., New York. (Courtesy of Sotheby's Inc., New York.)

Right: Detail, map of Freehold, showing the business center of town as delineated in *Beers' Atlas* of 1873. (MCHA Archives.)

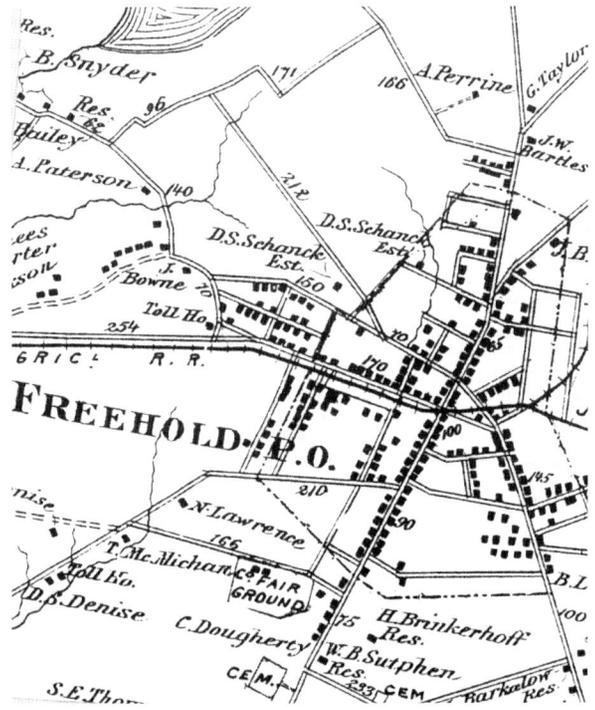

Below: Freehold's Great Fire, October 30, 1873. The devastation is viewed by Elihu B. Bedle, James S. Yard, and David Conover the morning after the fire destroyed Freehold's courthouse as well as a block of wooden storefronts south of Court Street. The photographer was Ferris C. Lockwood of Freehold. (MCHA Archives.)

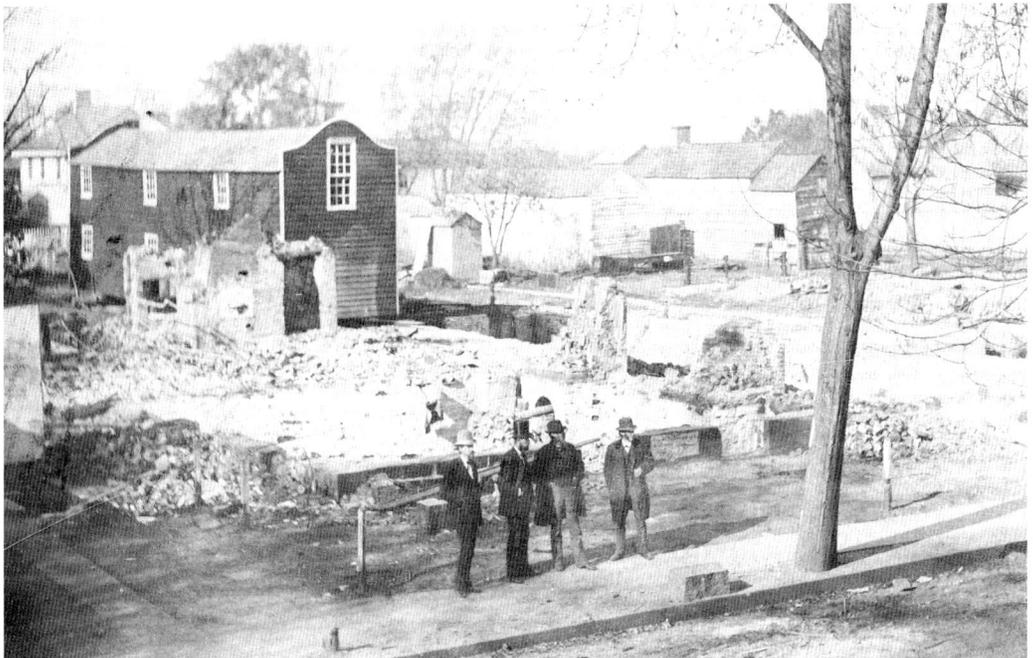

11

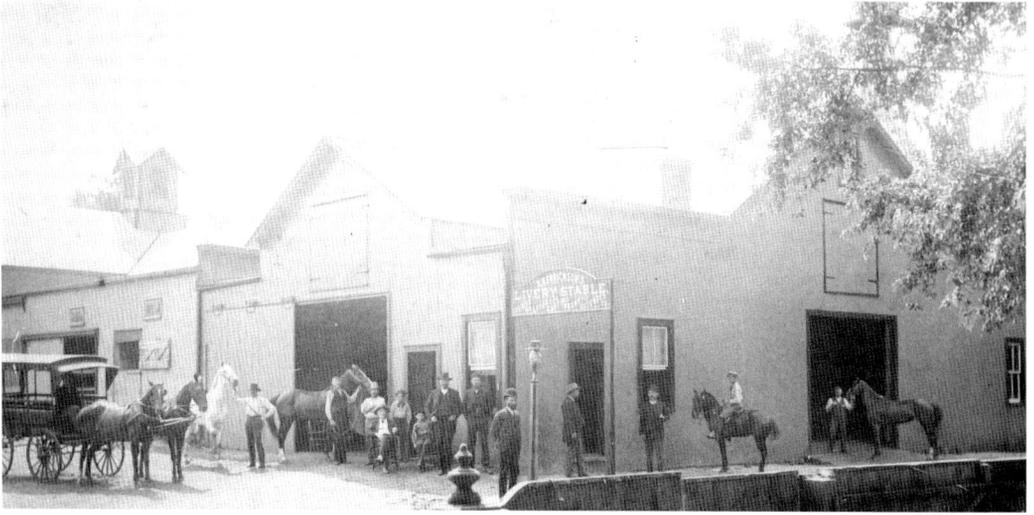

R.H. Errickson's Livery Stable, *c.* 1882. Conveniently located on Court Street near Main Street's large hotels where patrons might need his services, Mr. Errickson's business advertised "orders for livery and carting promptly attended to." He can be seen standing just to the right of the sign. Other subjects are also identified, including Sheriff Conover (seated). (MCHA Archives.)

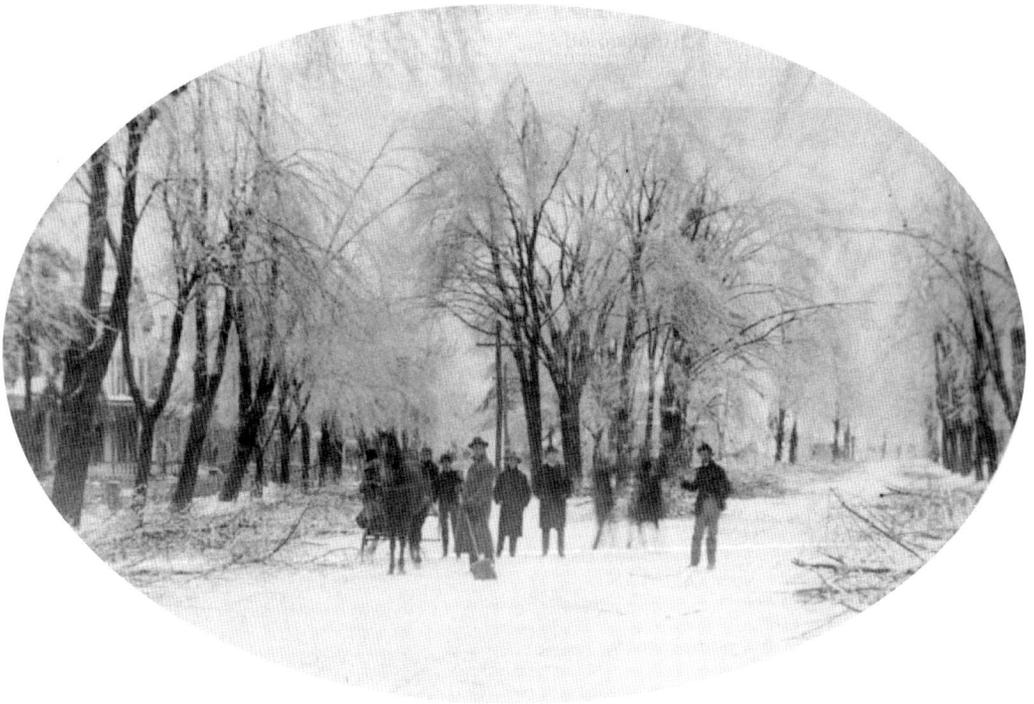

After the Great Ice Storm, February 28, 1902. A number of photographs survive to document this dramatic winter ice storm that littered the town with fallen branches and took down many of the recently installed telegraph lines. This group is assembled in front of the intersection of Broadway and Main, where the Elks' club stands today. (MCHA Archives.)

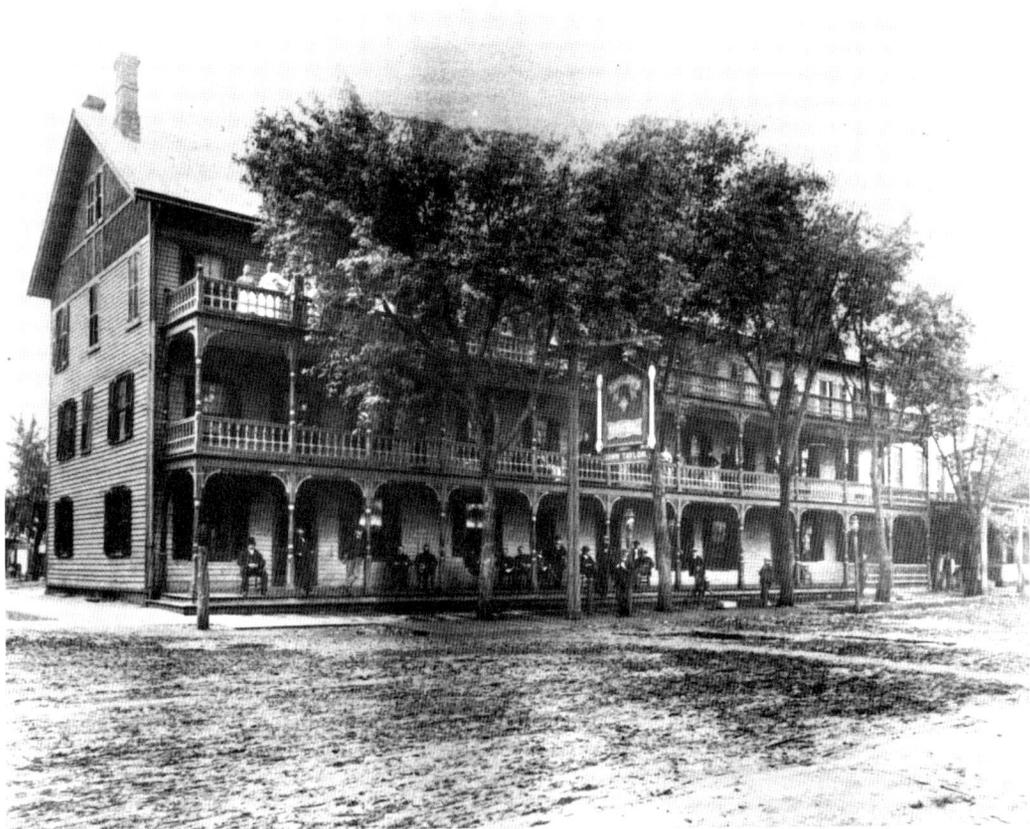

The Taylor Hotel, *c.* 1875. Destroyed by fire on September 11, 1886, the Taylor Hotel was one of the popular major hotels and saloons in the center of Freehold. After its destruction by fire it was immediately rebuilt as Taylor's, but was later renamed the Belmont Hotel (see p. 20). (MCHA Archives.)

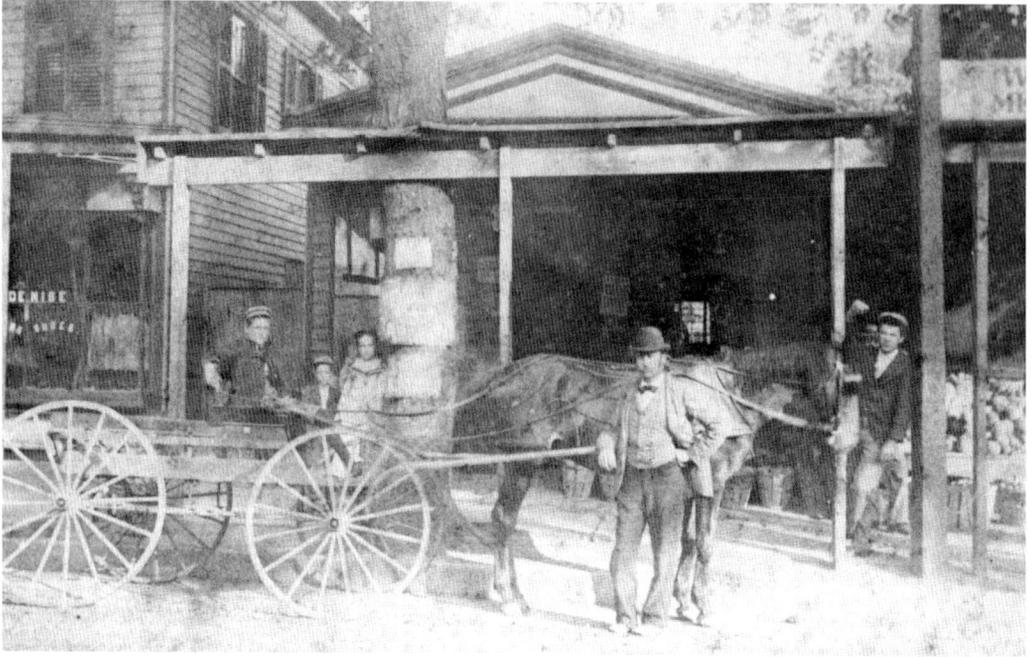

Gardner Woodward's Grocery in the 1870s. At 28 West Main Street, Woodward's Grocery supplied produce from a small storefront, and could make deliveries on the wagon in front of the store. Note the netting on the horse used to help keep flies off. (Courtesy of Freehold Public Library.)

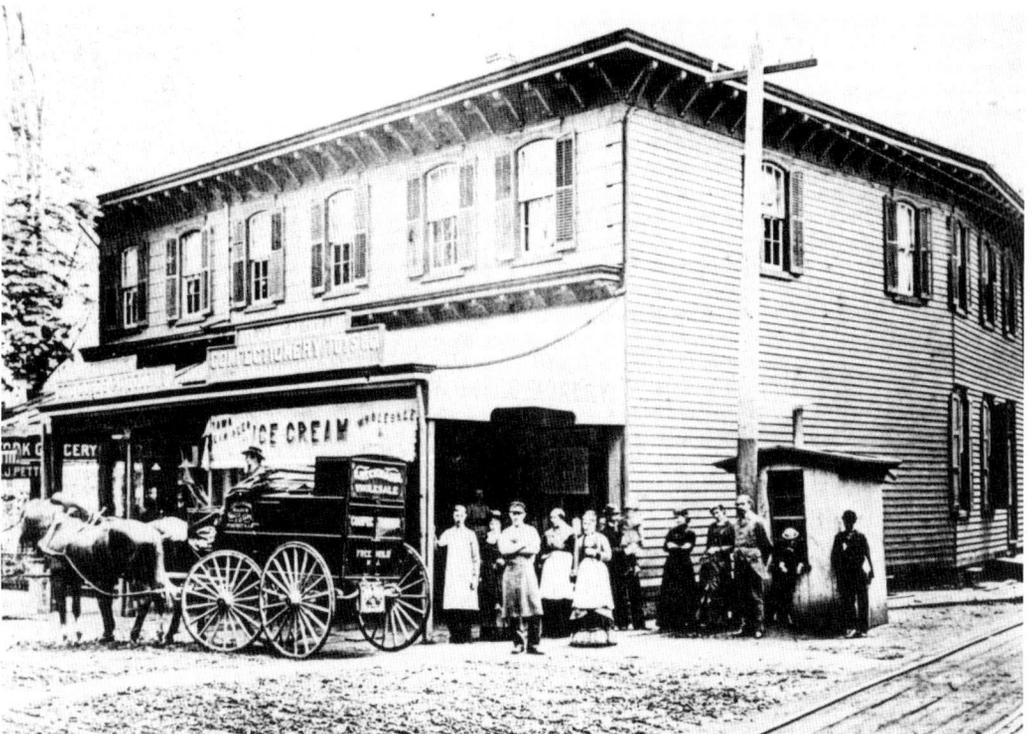

Opposite, below: Heckman's Confectionery Store, *c.* 1875. Located at the corner of Main and Throckmorton Streets, Heckman's specialized in ice cream and also carried children's toys. Members of the Heckman family appear in the photograph as well as James Pettit, who owned the New York Grocery seen next door. At the left of the photograph, the West Main Street railroad watchman's shanty appears. (Courtesy of Freehold Public Library.)

Right: L. Deedmeyer Cigar Manufacturer in the 1870s. In 1861, the post office was located in this building with the cigar store that has subsequently been known as Deedmeyer & Johnson's, Patten's, and Barkalow & Litchfield's cigar store, and is currently the Esquire News & Smoke Shop. (Courtesy of Freehold Public Library.)

Below: Levy Brothers Store, *c.* 1905. Costumed revelers pose in front of the Levy Brothers Store, which was advertised as "Freehold's busiest store" in the 1890s. (Courtesy of Freehold Public Library.)

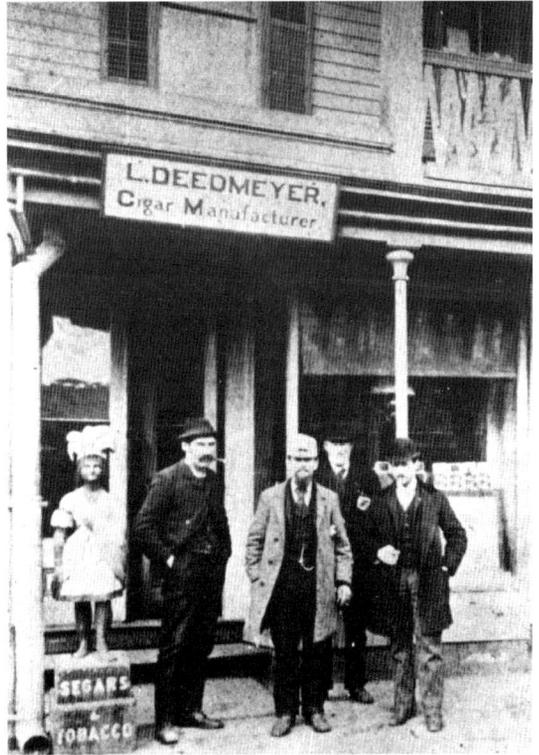

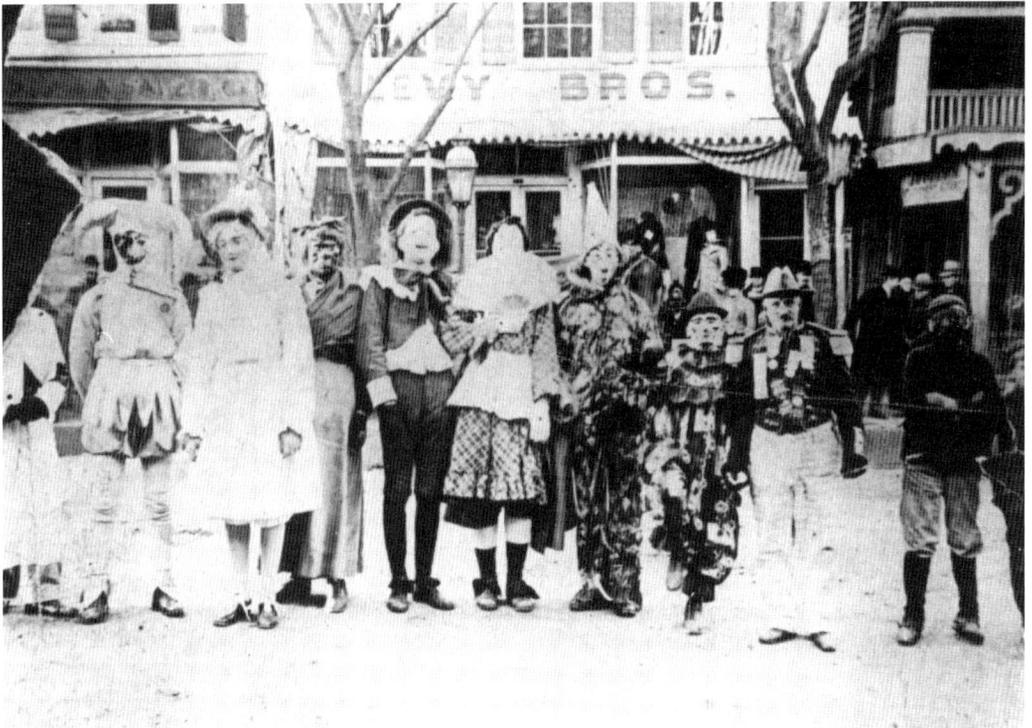

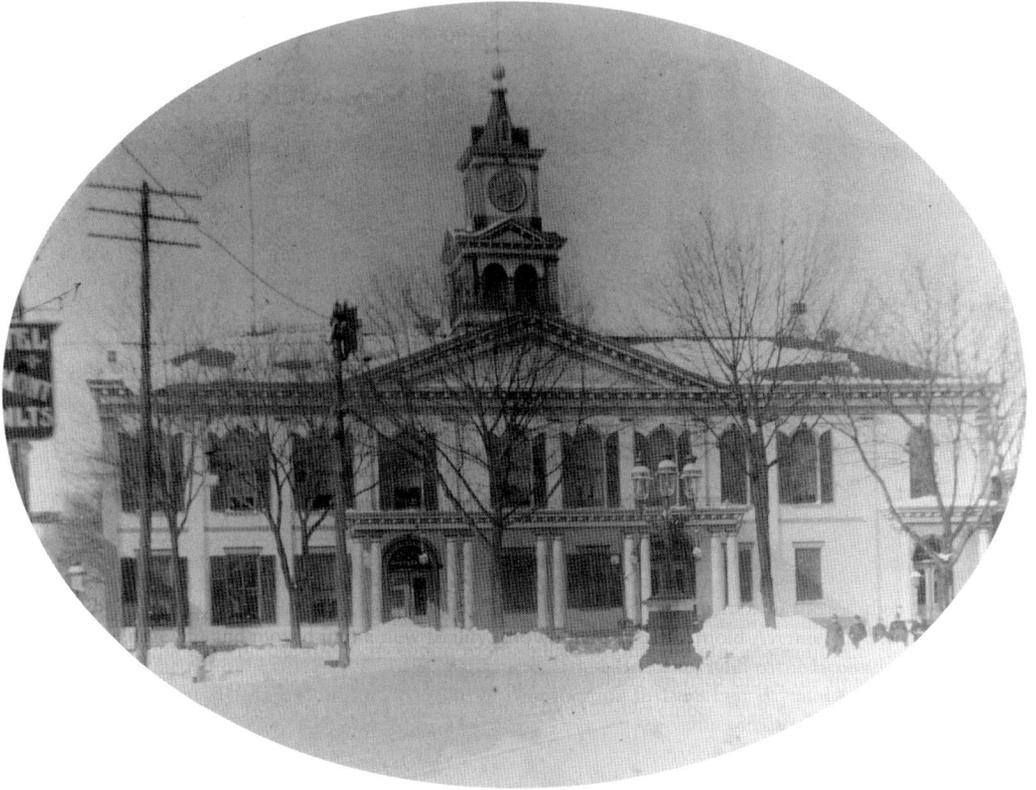

Monmouth County Courthouse, February 14, 1899. A noteworthy snowstorm brought out many of the town's photographers to document the center of town engulfed in snow. The new public water source is visible, surmounted by a triple gas light that replaced the fountain on the following page. (MCHA Archives.)

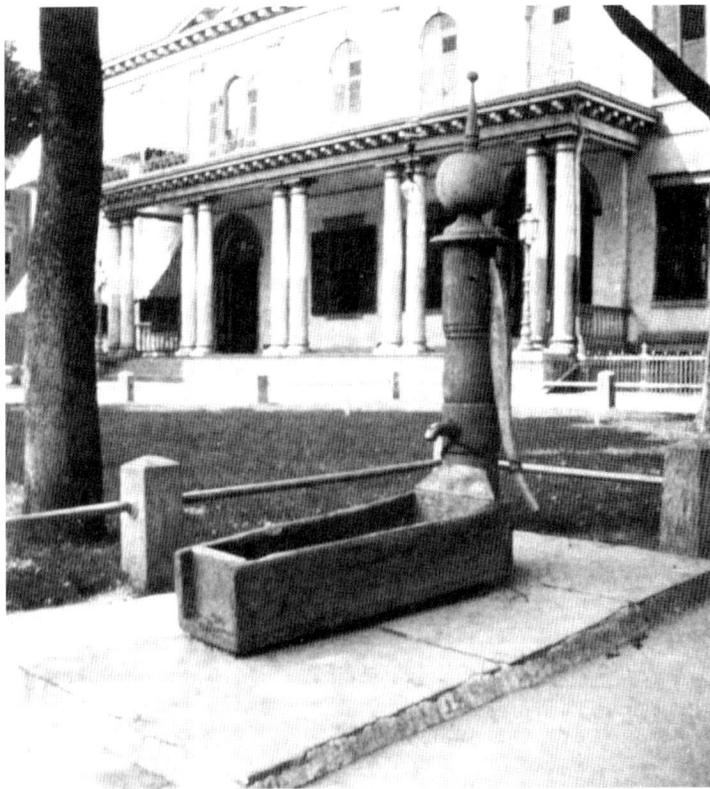

Above: "The Fountain of Other Days," 1898. The wooden pump and horse trough in front of the courthouse was memorialized in July 1898 before it was replaced with a more modern fixture. The sentimental inscription on the reverse of the photograph reads, "Good Bye old pump, Good Bye then." The photographer was Mrs. L.H.S. Conover. (MCHA Archives.)

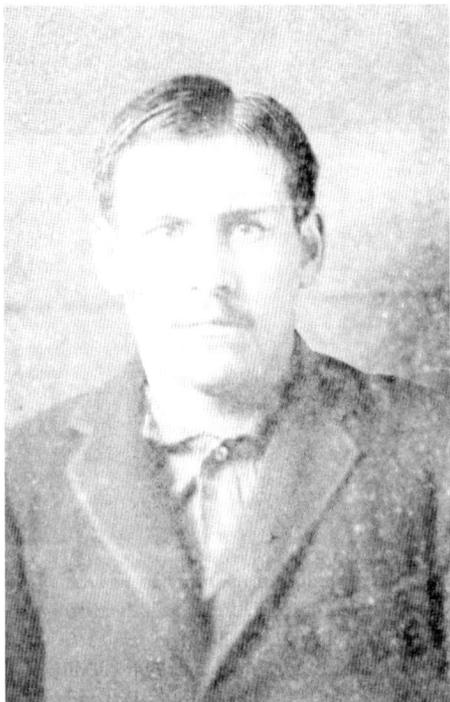

Left: Louis Harriott, murderer, 1892. The Monmouth County Courthouse was the scene of a number of scandalous murder trials in the late nineteenth century, including that of Louis Harriott, who was convicted of the murder of Annie Grover Leonard and executed on April 15, 1892, at the Freehold Jail. This photograph was by Scott Studio of Freehold. (MCHA Archives.)

Monmouth Democrat Office, 1884. The first issue of the *Monmouth Democrat* appeared in April of 1834, published by Bernard Connolly. In 1854, the paper was purchased by James S. Yard (see p. 65), who had some experience in the changing field of journalism, having published the *Village Record* at Hightstown. He built this office in 1860 on land that belonged to St. Peter's Church, to which he paid a "ground rent." The photographer was G.A. Powelson of Matawan. (MCHA Archives.)

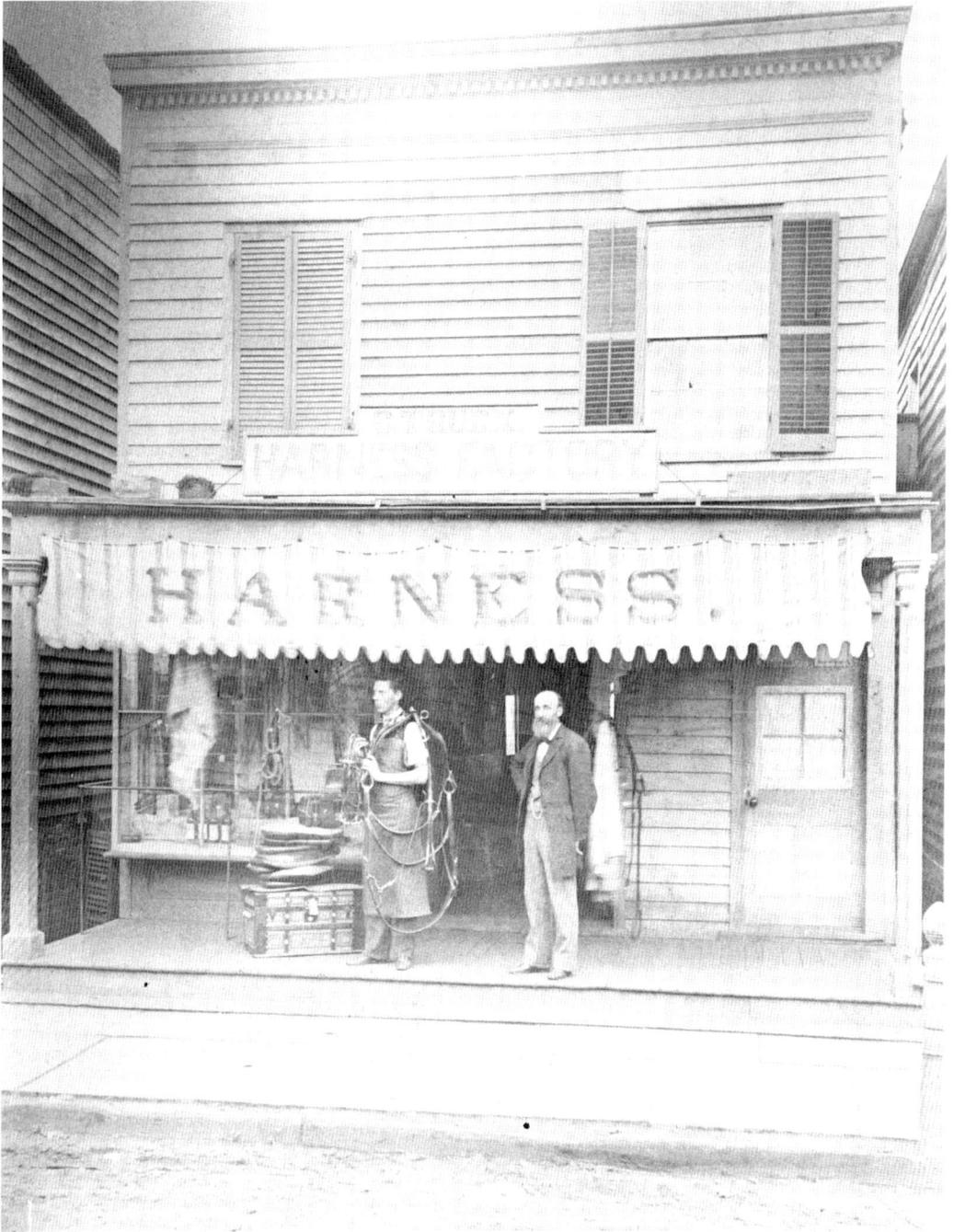

C. Truex Harness Factory, *c.* 1885. Charles Truex's harness shop was located at 13 South Street, where he proudly posed for this photograph with an employee who is holding some of their merchandise. Charles lived close by at 90 South Street where he raised four lovely and talented daughters who appear on pp. 77 through 88 of this volume. This photograph was by G.A. Powelson of Matawan. (MCHA Archives.)

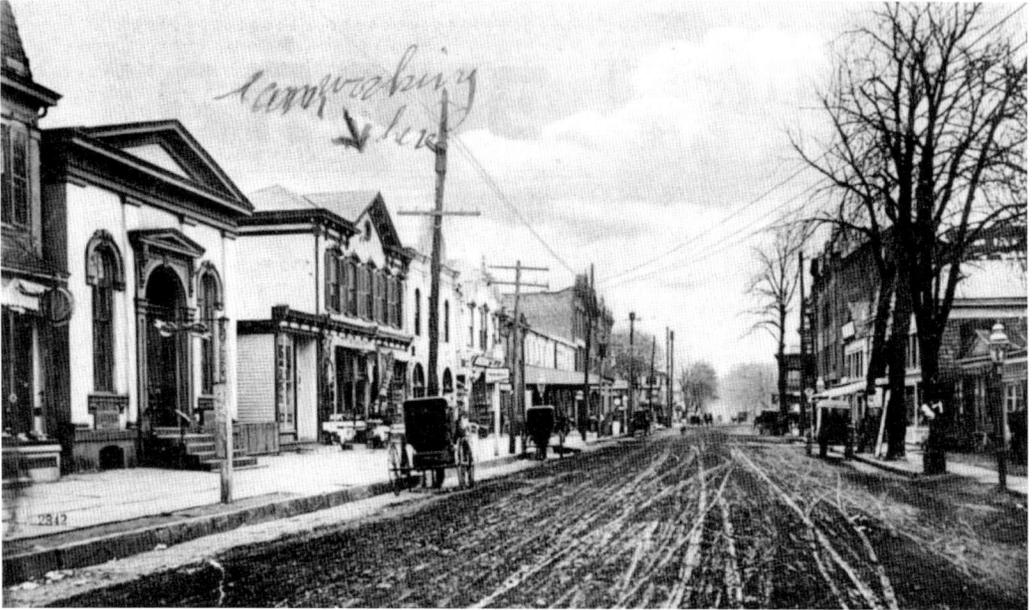

Main Street in 1914. This postcard was sent to Lyman Black from "D.B.," who wrote, "I am working at J.S.M. now. I got your job." (MCHA Archives.)

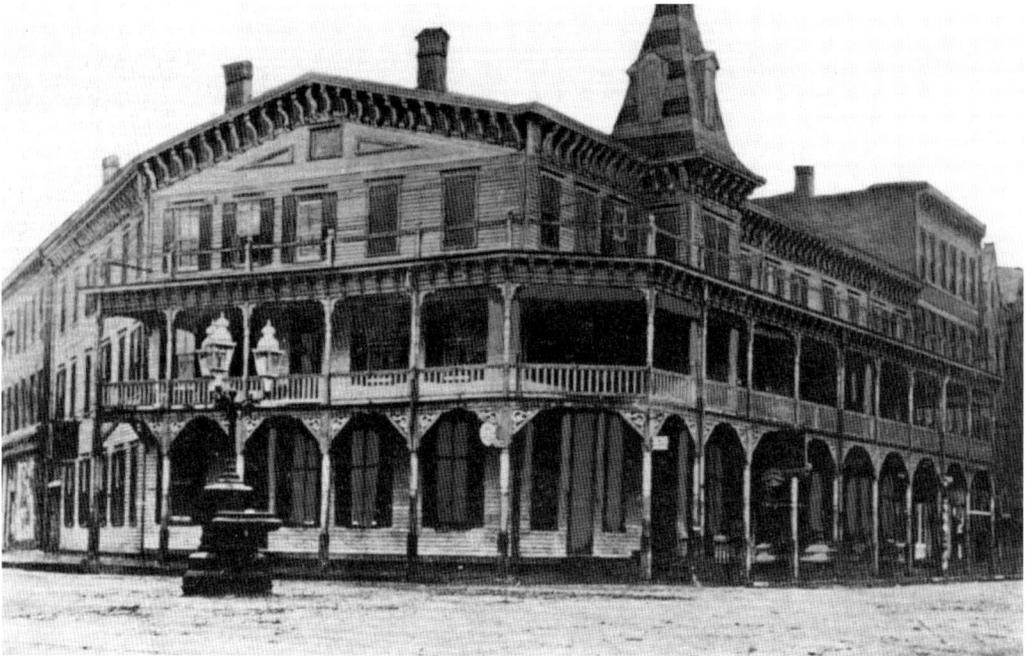

Hotel Belmont. The Hotel Belmont was built in 1887 to conform to the center square at the intersection of South and Main Streets. It was perhaps the most prominent feature on the streetscape of Freehold. Its balconies afforded visitors an opportunity to view special events that occurred in front of the courthouse or parades along Main Street. (MCHA Archives.)

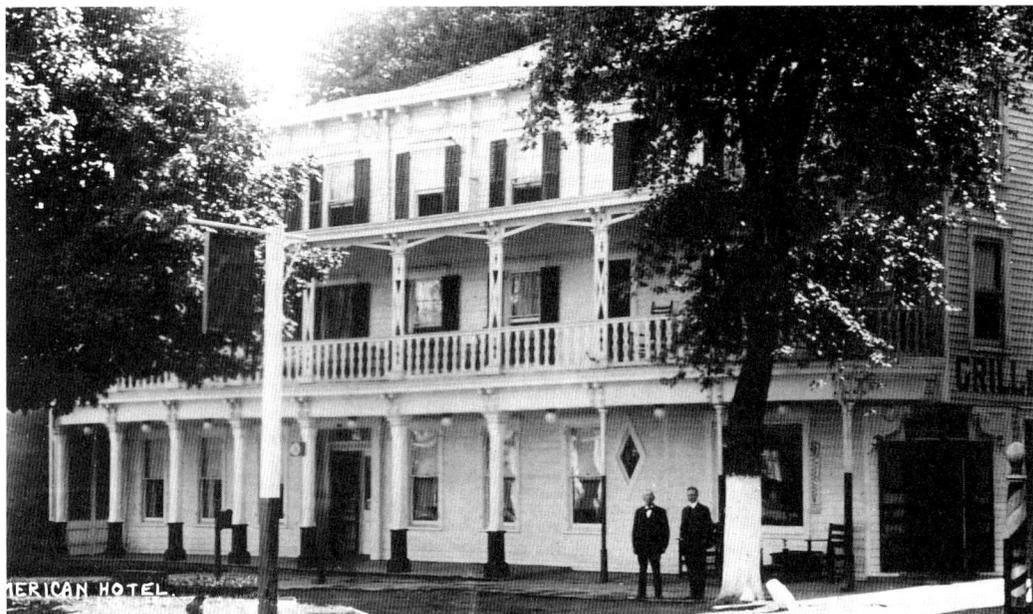

The American Hotel, c. 1910. Located on the south side of East Main Street, the American Hotel featured an arcade and balcony like the nearby Union and Belmont Hotels. (MCHA Archives.)

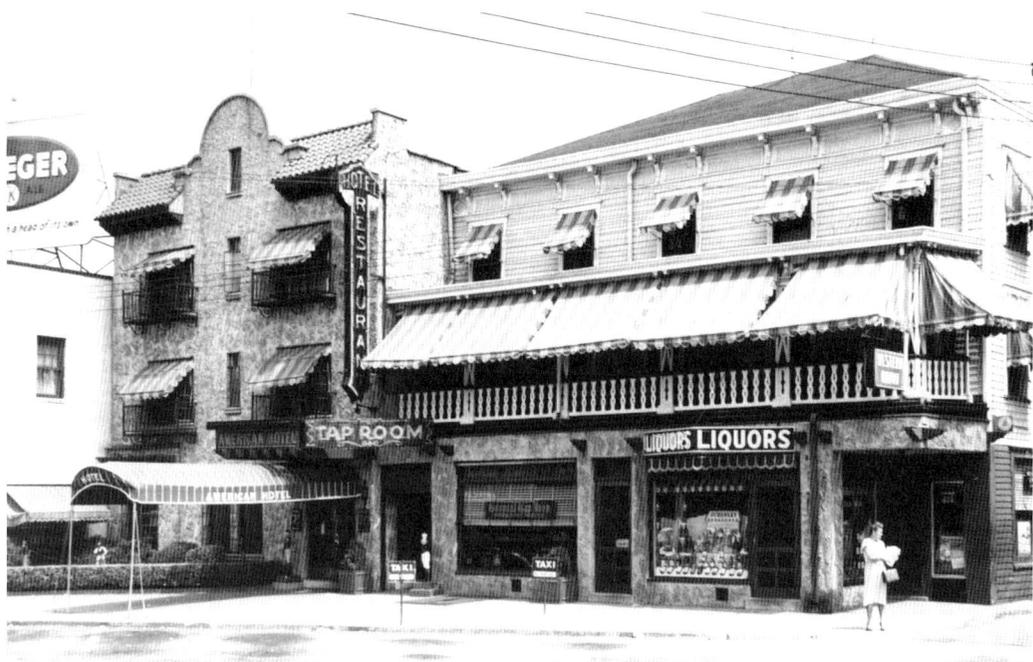

The American Hotel, c. 1945. The last survivor of Freehold's Main Street hotels, the American Hotel continues today to offer refreshment and catering services to local clients. This photograph shows the Spanish Revival facade which replaced the Civil War-era west wing of the building in 1928. (Courtesy of The American Hotel.)

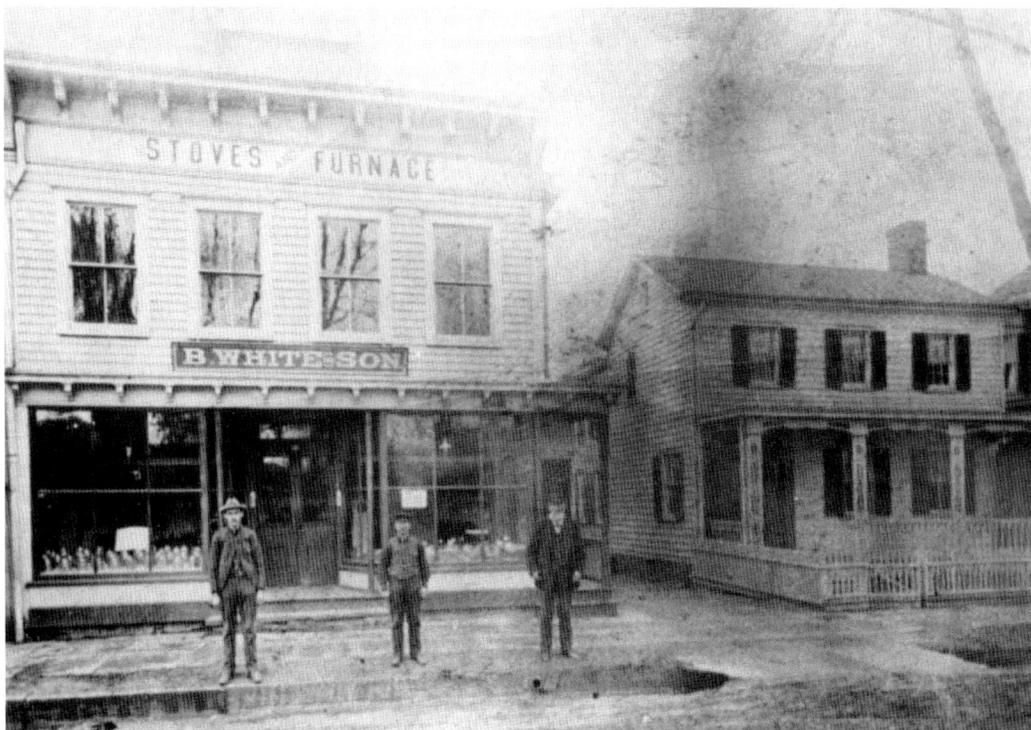

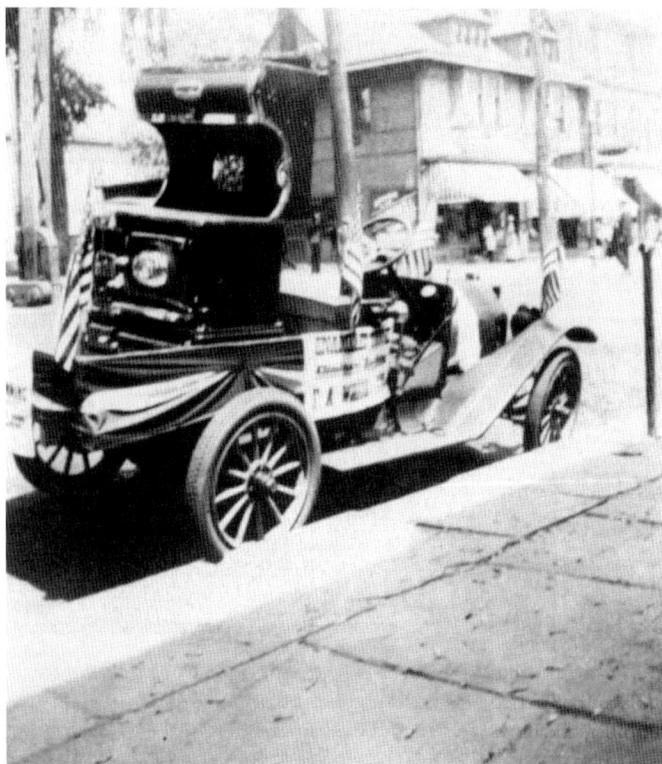

Above: B. White & Son, *c.* 1890. Barzilla White, tinsmith, and his son Frederick operated this establishment one door down from the corner of Main and Throckmorton Streets. The store, one of the oldest remaining in downtown Freehold, still stands and retains much of its original detail and character. The White family lived in the house pictured to the right. (Courtesy of Alfreda White Perrine.)

Left: Frederick White's delivery truck, *c.* 1916. Frederick White assumed the responsibility for the business at his father's death. He continued to supply the town with enameled stoves, one of which is seen on the back of the truck pictured, ready for delivery. (MCHA Archives.)

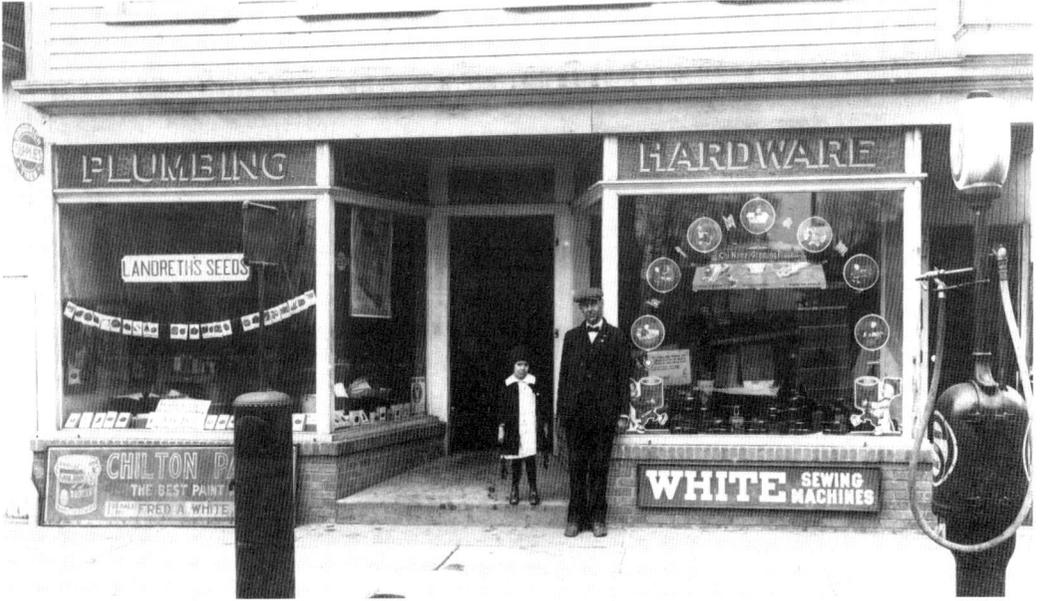

Frederick A. White Hardware Store, *c.* 1920. Frederick and his daughter, Alfreda, who would later inherit and operate the hardware store, pose in front of the building. An air pump and gas pump to service automobiles are in front of the establishment. This photograph was by Hall Studio of Freehold. (MCHA Archives.)

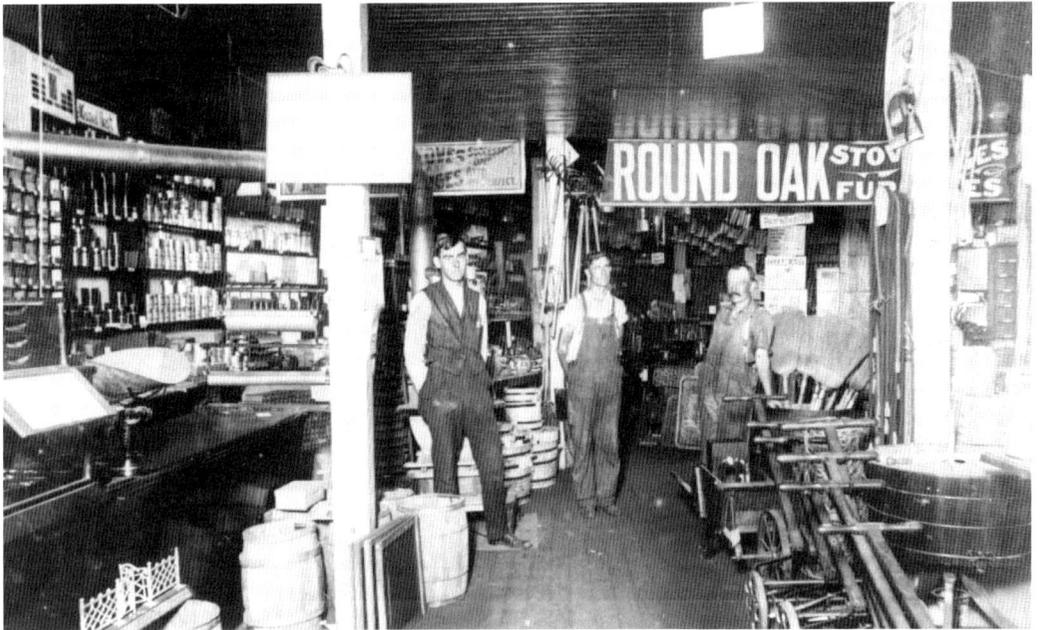

The interior of the Frederick A. White Hardware Store, *c.* 1920. The employees of White's hardware store, one of whom is Frank Gibson, are ready to serve customers who may choose from the parade of lawn mowers on the right of the picture, or may need nails from the barrels on the left. This photograph was by Hall Studio of Freehold. (MCHA Archives.)

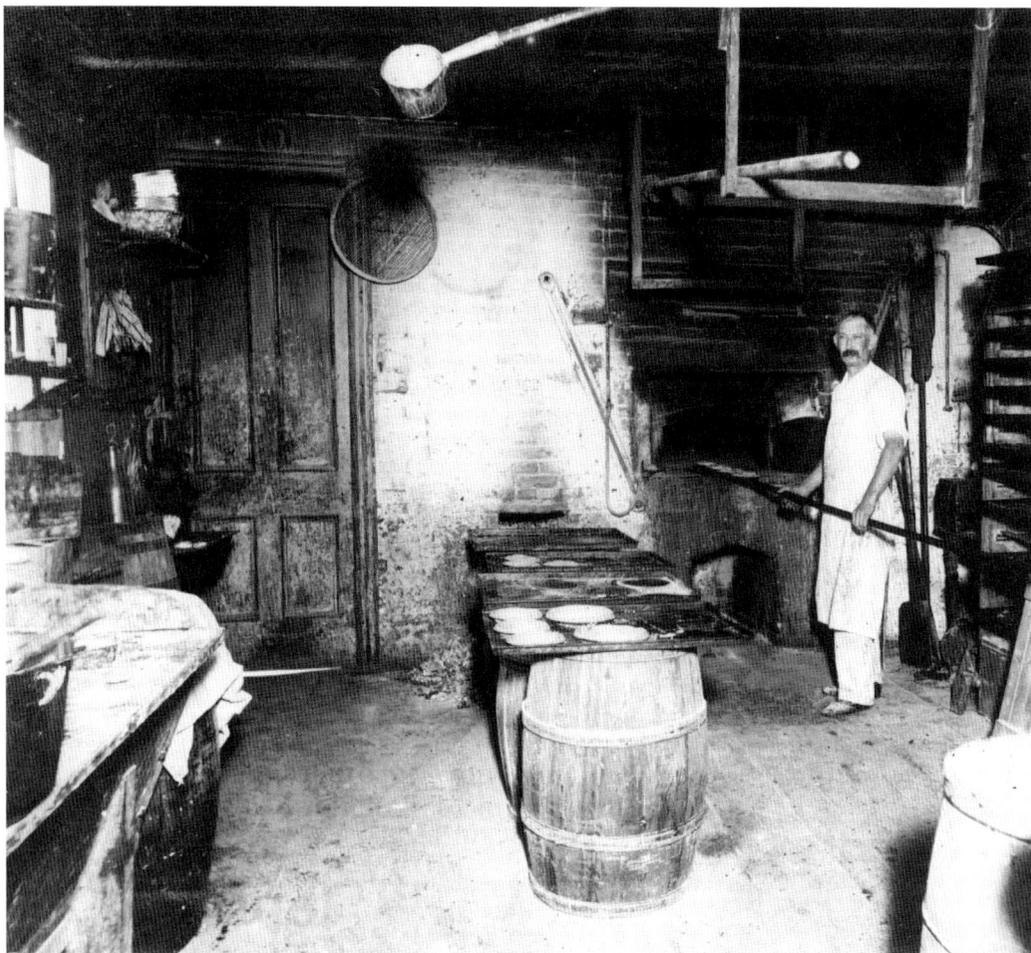

Above: Bakery of Charles Rogers, *c.* 1900. Located opposite the American Hotel on Main Street was a bakery run by Charles Rogers, whose business succeeded another bakery run by W.H. Butcher as early as 1873. Charles was the brother-in-law of Barzilla White, whose hardware store is seen on the previous pages. Charles Rogers appears to be removing pies from the oven. This photograph was by Hall Studio of Freehold. (MCHA Archives.)

Opposite, below: Belmont Hotel Fire, February 11, 1933. At the time of the fire, the Belmont's tower and porches had been removed and the exterior refaced. Prohibition had severely impacted the hotel industry, which relied on serving alcoholic beverages for a large portion of its income. Freehold firemen fought the fire throughout Saturday night and into Sunday morning, sadly, in vain. (Courtesy of Freehold Public Library.)

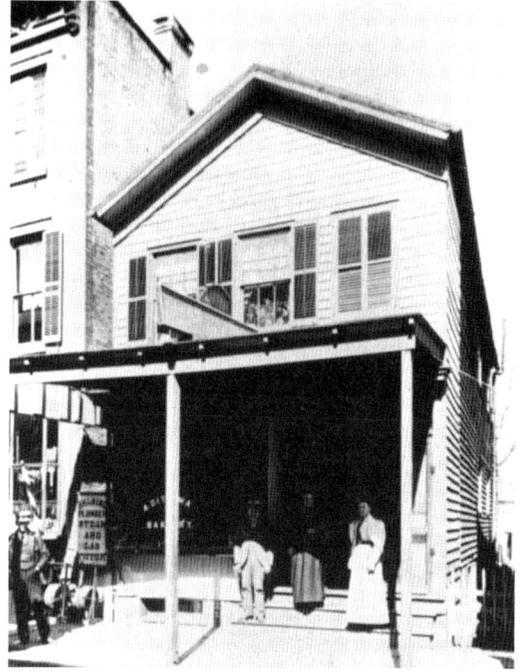

Right: Bakery of Adolph Dittmar, *c.* 1900. Located at 11 South Street, the Dittmar Bakery was one of several in town that supplied bread and baked goods. Dittmar was an immigrant from Germany who had left to escape Bismarck's rule. He came through Ellis Island and eventually settled in Freehold, later to be joined by the German woman who would become his wife. Five of their sons are shown on p. 29 as members of St. Peter's choir. (Courtesy of Freehold Public Library.)

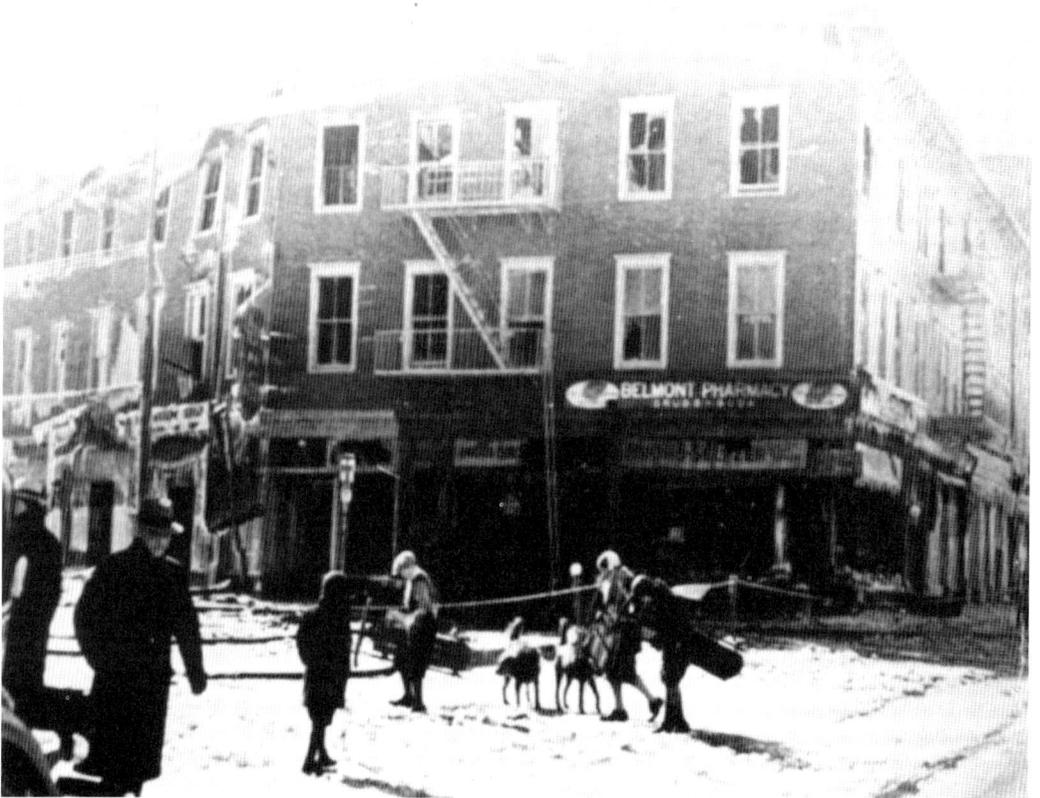

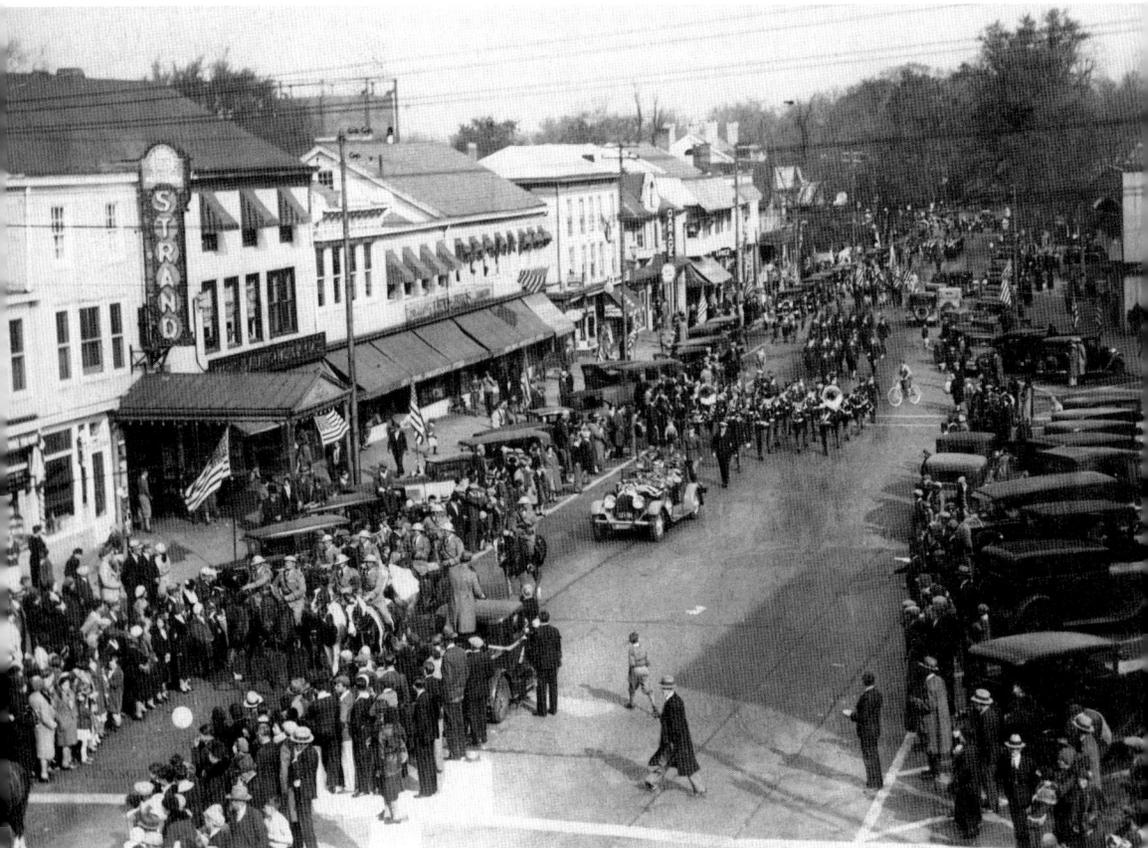

Above: East Main Street, *c.* 1930. Looking east from the courthouse as a parade passes by, one sees the group of stores, including the Strand Theatre, that burned on April 7, 1962, in a fire that destroyed nine stores plus the theatre. (Courtesy of Nancy DuBois Woods.)

Opposite, above: Christopher House, built between 1830 and 1840. A classical temple on Main Street, this Greek Revival structure mirrors the Greek Revival house that stands directly across the street. Daniel Christopher, a nineteenth-century politician, resided here during the mid-nineteenth century; the house also served as a tea room and later was an antique shop. The photograph dates from the 1940s. (MCHA Archives.)

Opposite, below: Freehold Grill, *c.* 1946. One of a few unaltered streamlined Moderne diners in Monmouth County, the Freehold Grill was built by a well-known diner manufacturer, Jerry O'Mahony of Elizabeth, NJ. Its unique attachment to a mid-nineteenth-century house is a wonderful juxtaposition, and the original neon signs add to its character. The diner is located on Main Street, near the intersection of Spring and Center Streets.

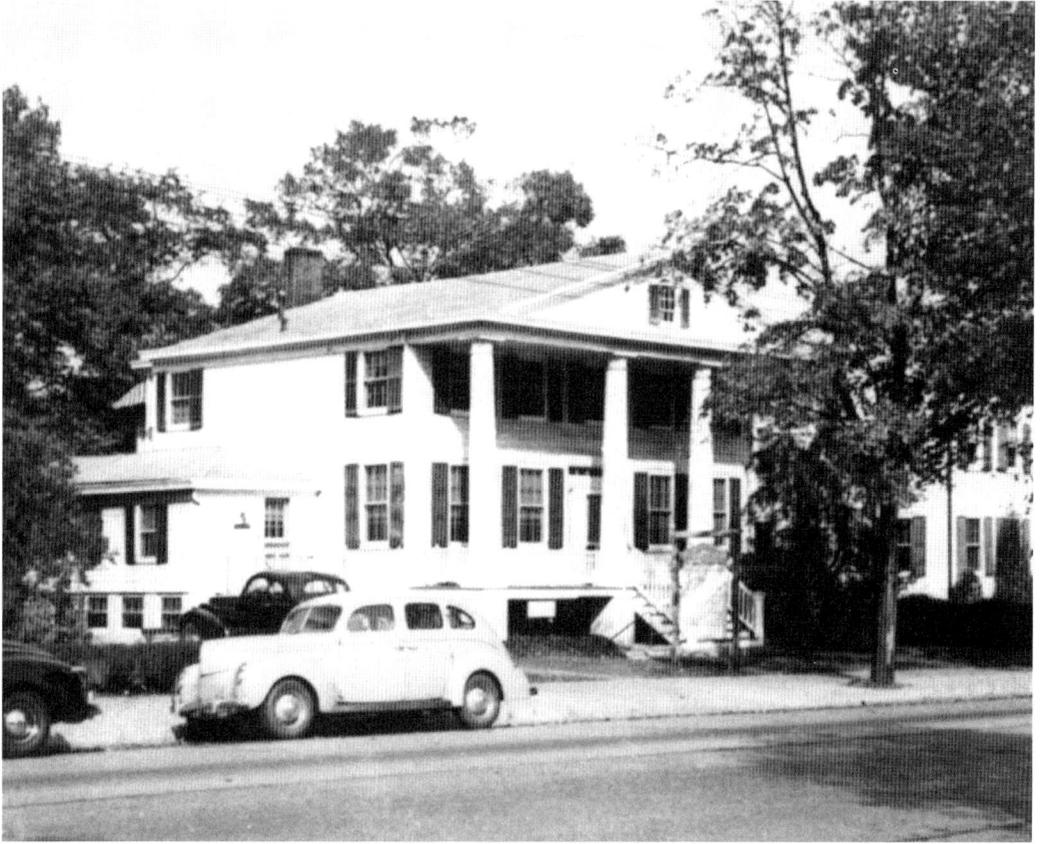

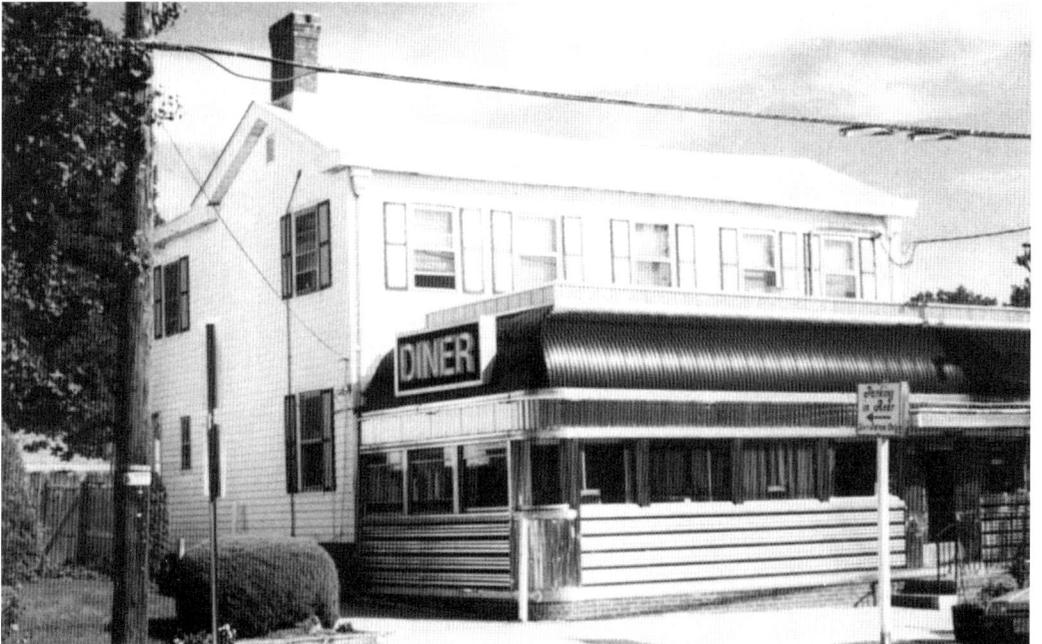

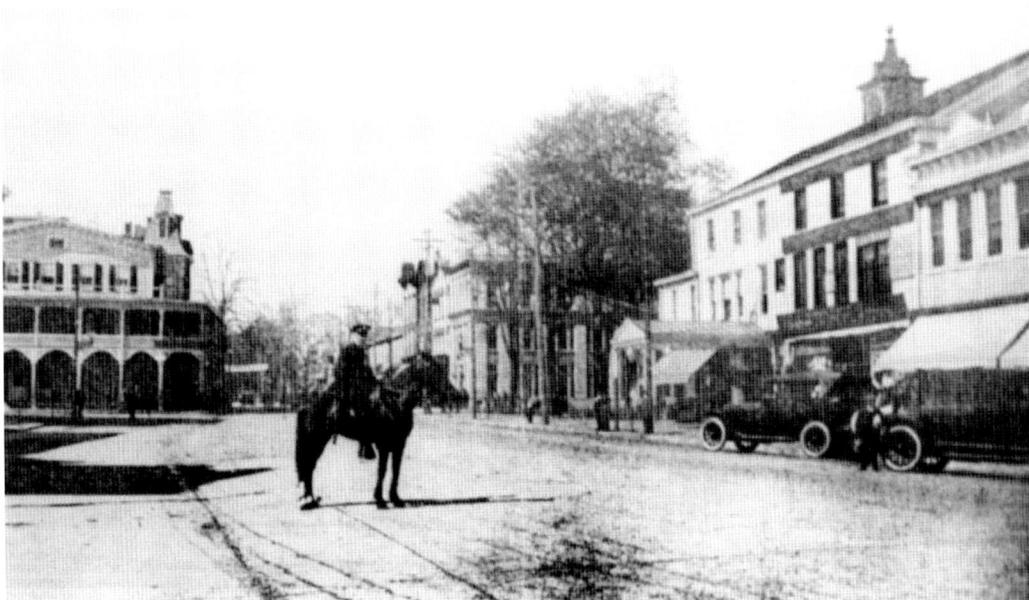

East Main Street, c. 1925. The center of town and the Belmont Hotel (with its tower and porches still intact) compose the background for this shot of a mounted constable. (Courtesy of Carl N. Steinberg.)

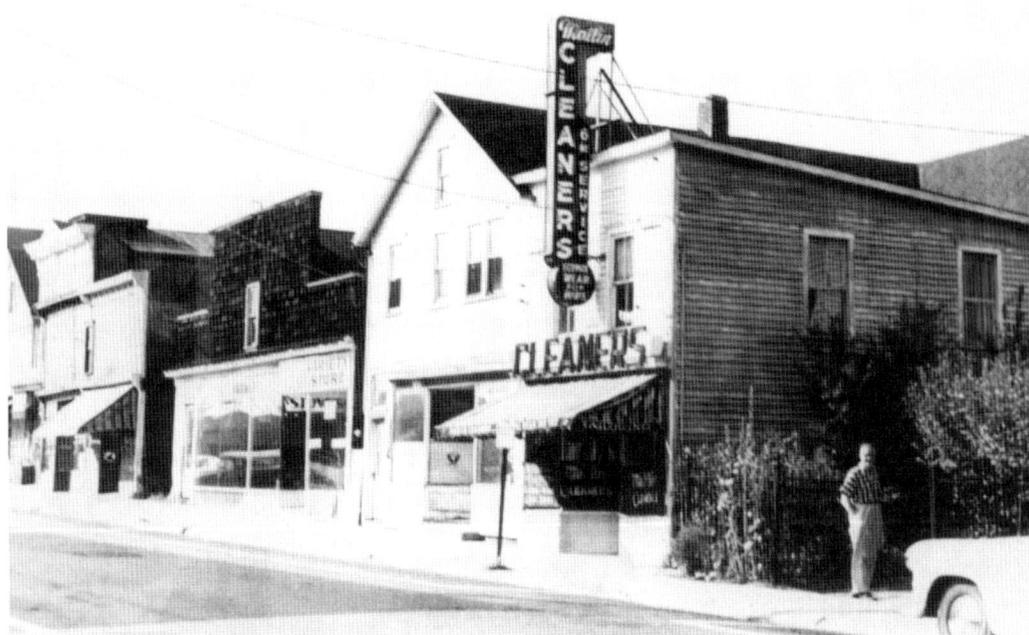

View of Throckmorton Street, c. 1955. In this view of Throckmorton Street, the early Freehold Fire House can be seen at the far left, and in the foreground, at the gate to the grounds of St. Peter's Church, stands the Reverend Bernard Garlick. St. Peter's owned the property up to the fire house, and in 1958 took down the building that appears in the photograph to construct the Keith Building Complex. (Courtesy of Carl N. Steinberg

Houses of Worship

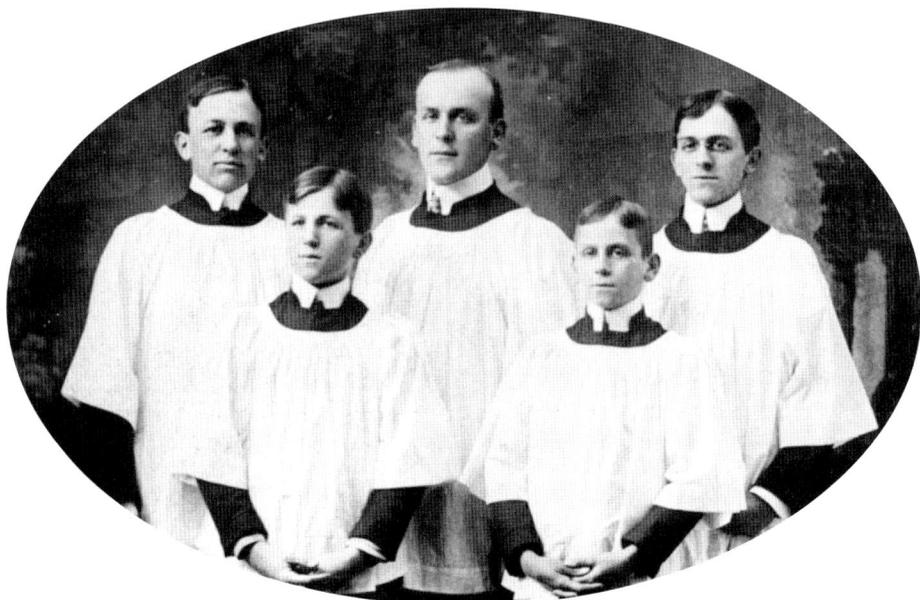

The Dittmar brothers, *c.* 1898. As members of St. Peter's choir, the Dittmar brothers (Julius, Charles, William, August, and George) were photographed in their choir robes. Two of them became lawyers, one a dentist, one was in the lumber business in New York, and one worked at the post office — all a credit to their father Adolph's hard work (see p. 25). (Courtesy of Freehold Public Library.)

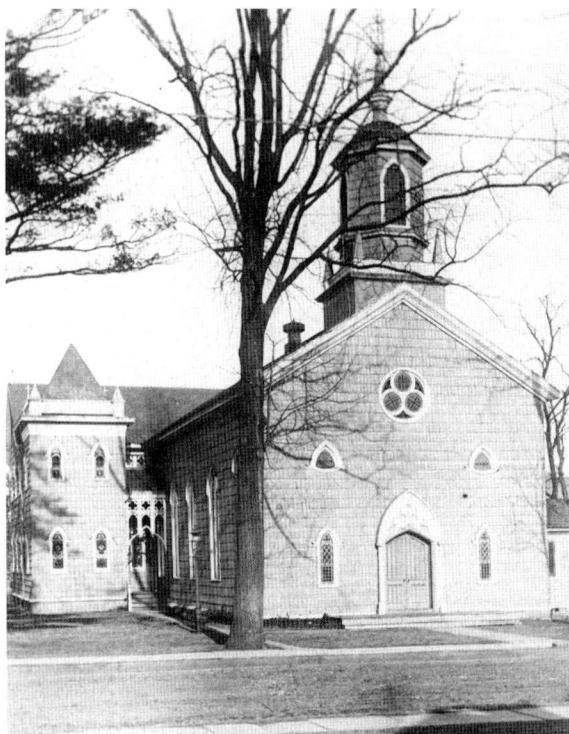

St. Peter's Church, built *c.* 1770. At the time this photograph was taken (c. 1900), the Reverend Howard Thompson was rector of this Episcopal congregation. St. Peter's Church, the oldest church structure standing in Freehold, served as a hospital for the wounded during the Battle of Monmouth in 1778. This photograph was by Hall Studio of Freehold. (MCHA Archives.)

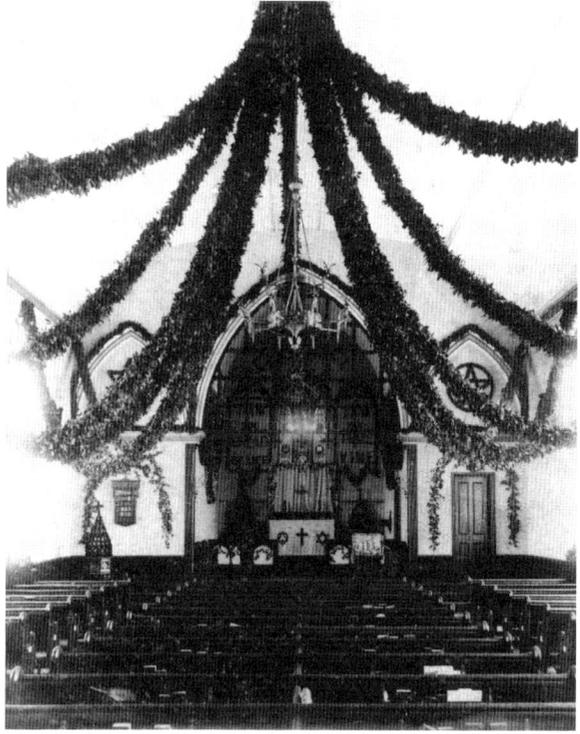

Right: Interior of St. Peter's Church, January 10, 1888. Festooned with boxwood garlands for the holiday season, the interior of the church shows the gothic alterations made by architect Henry Dudley of New York in 1878/9. This photograph was by Stauffer of Asbury Park. (Courtesy of St. Peter's Church.)

Below: Interior of St. Peter's Church, 1900. The funeral service for Reverend William E. Wright at St. Peter's shows further alterations of the interior made to accommodate the new organ. (Courtesy of St. Peter's Church.)

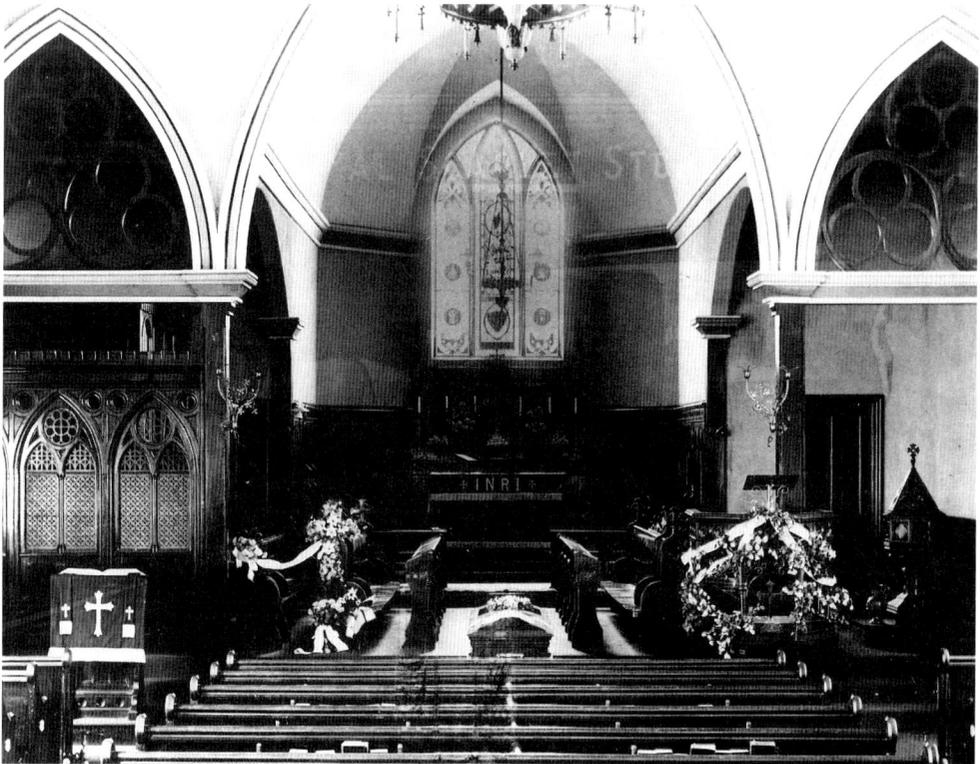

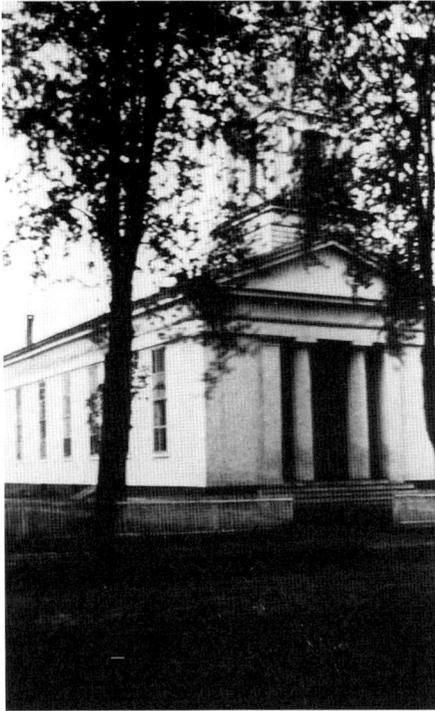

Freehold Baptist Church, built 1846. Organized in 1834 from the Upper Freehold Baptist Meeting, this Greek Revival church was constructed by Freehold builder John B. Gordon in 1840 and served the local congregation until 1889/1890, when it was replaced by the structure that appears below. This photograph was by the Slater Brothers of Matawan. (MCHA Archives.)

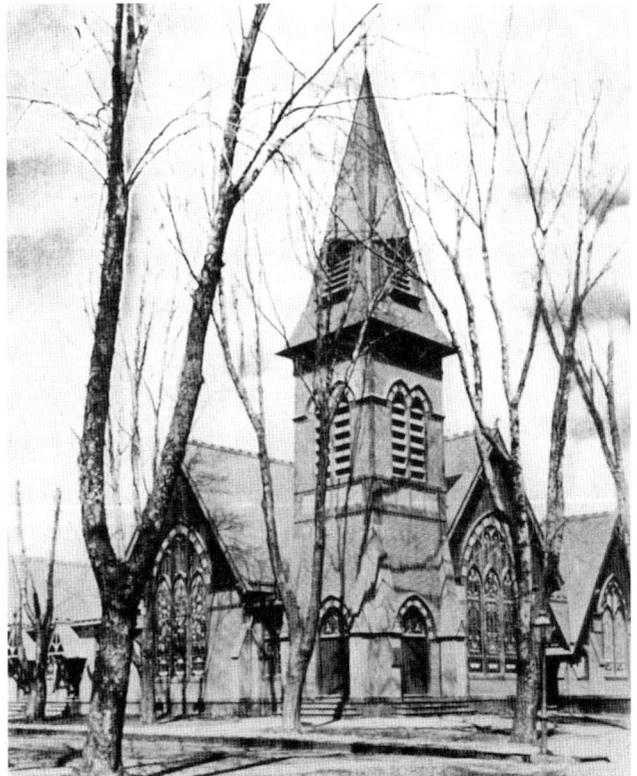

Freehold Baptist Church, built 1889/1890. Architect Isaac Pursell of Philadelphia designed this Victorian Gothic church for the Baptist congregation of Freehold, which later changed its name to the First Baptist Church. This postcard was printed c. 1910. (MCHA Archives.)

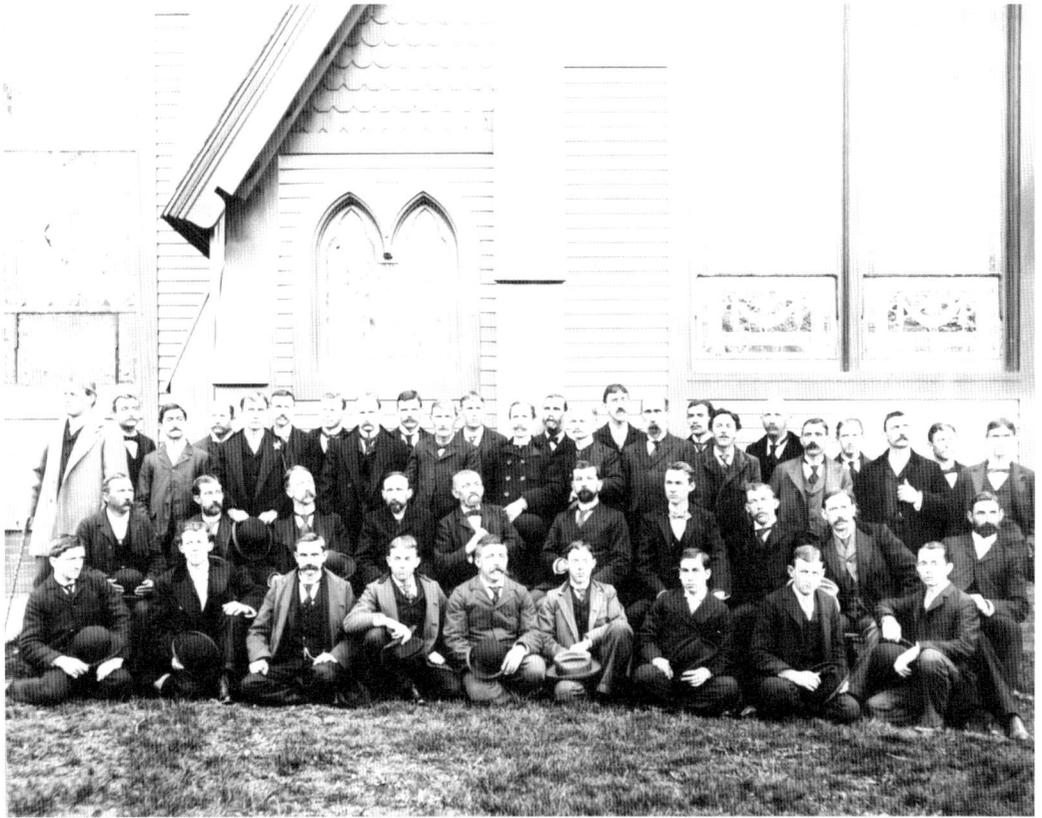

Young Men's Bible Class of the Baptist church, 1897. This class picture includes representatives from many of Freehold's well-known families, including the Claytons, VanDerveers, DuBois, Wykoffs, and Cheesemans. Details of the new church building's stained glass windows and Victorian detailing can be seen in the background. This photograph was by L.R. Cheeseman of Freehold. (MCHA Archives.)

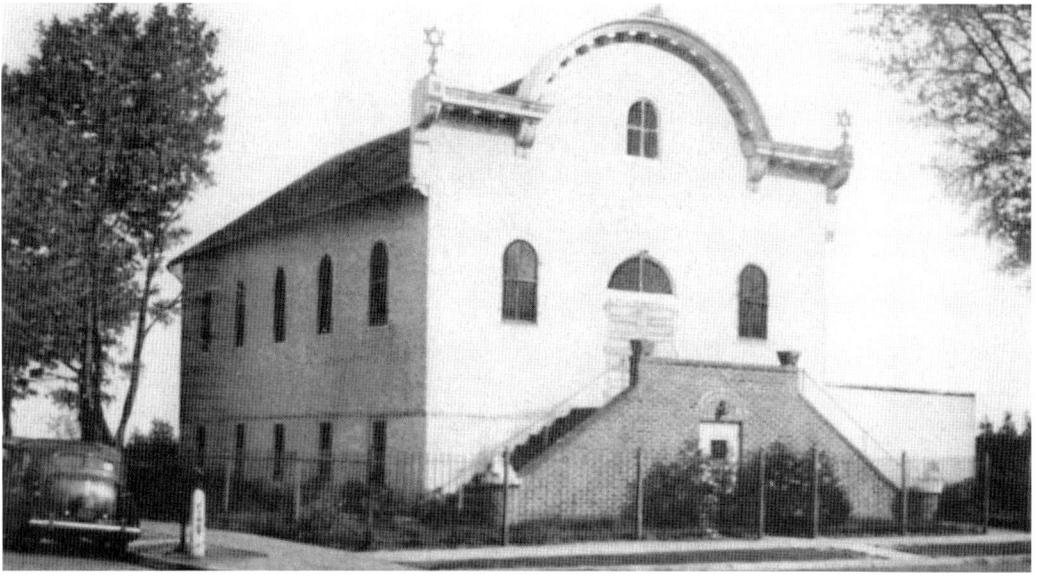

First synagogue of Congregation Agudath Achim, built 1911-16. The first Jewish community organization in Freehold, called the Freehold Hebrew Association, was formed in 1894, and in the fall of 1911, a small wooden building was erected at the corner of First and Center Streets for use as a synagogue. By the 1940s, the congregation had grown considerably, and a new location at Broad and Stokes was purchased for the construction of a larger synagogue and community center which was completed in 1957. (Courtesy of Carl N. Steinberg.)

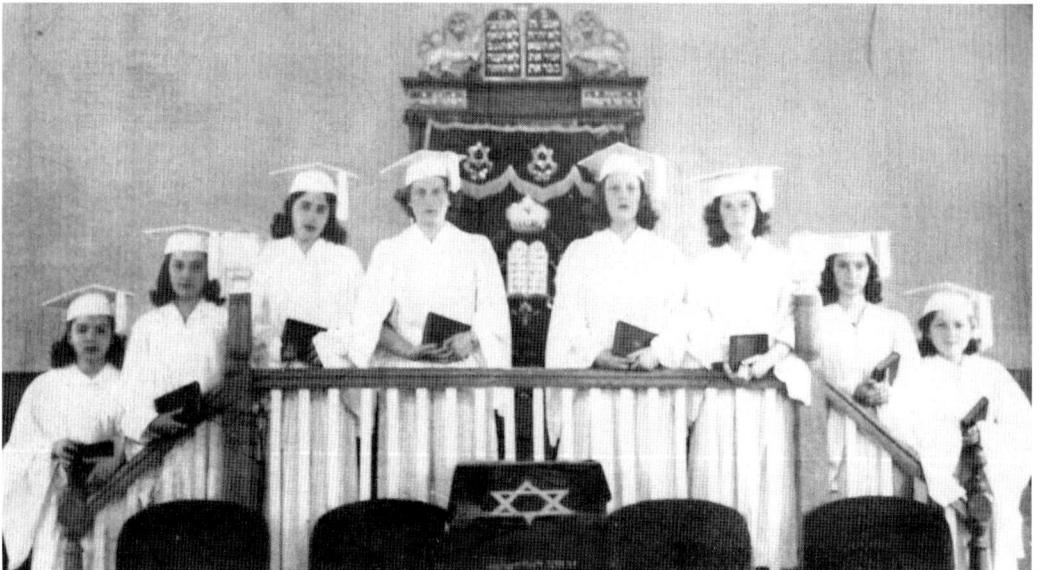

Confirmation Class of 1942. The first class of girls confirmed by the religious school of the Congregation Agudath Achim of Freehold on Sunday, May 24, 1942, included: Betty Hantman, Adele Shapiro, Florence Krane, Dorothy Hantman, Pearl Feldman, Elaine Zlotkin, Barbara Birnbaum, and Harriett Blatt. (Courtesy of Carl N. Steinberg.)

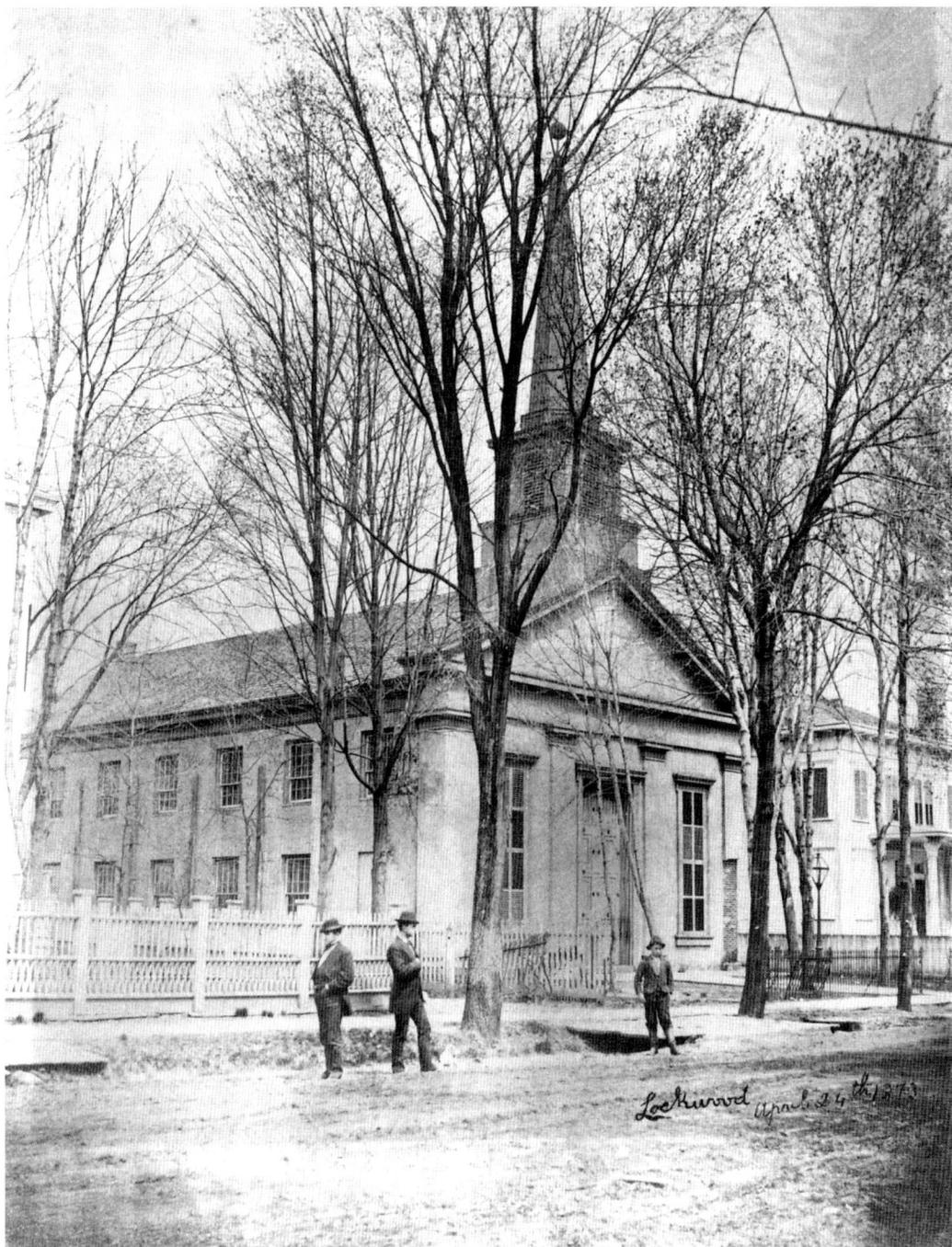

Village Presbyterian Church, built 1835/1836. An off-shoot of the Tennent Church in Marlboro, the Presbyterian congregation is one of Freehold's oldest, organized in 1838. This red brick Greek Revival structure on Main Street was discovered in 1869 to be failing structurally. Supports were installed along the sides (visible in this photograph) to keep the walls from spreading further, and plans for a new church were immediately begun. This photograph was by Lockwood of Freehold. (MCHA Archives.)

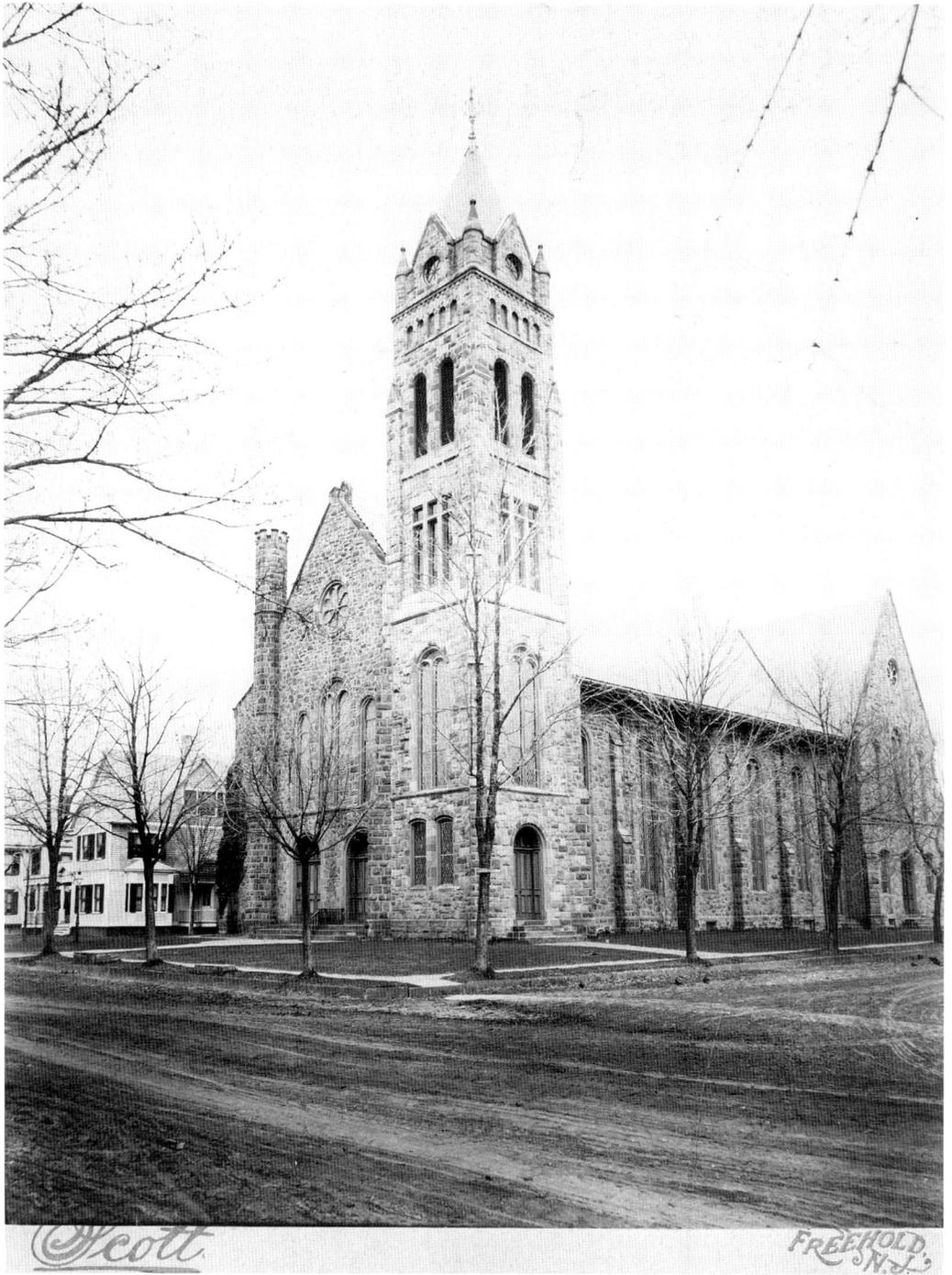

First Presbyterian Church, built 1871-73. Architect M.J. Morrill of Brooklyn designed this elegant Romanesque Revival brownstone church to replace the building shown on the previous page. Structural problems with its original spire necessitated a new tower, constructed in 1887, which appears in this 1890s image. This photograph was by Scott Studio of Freehold. (MCHA Archives.)

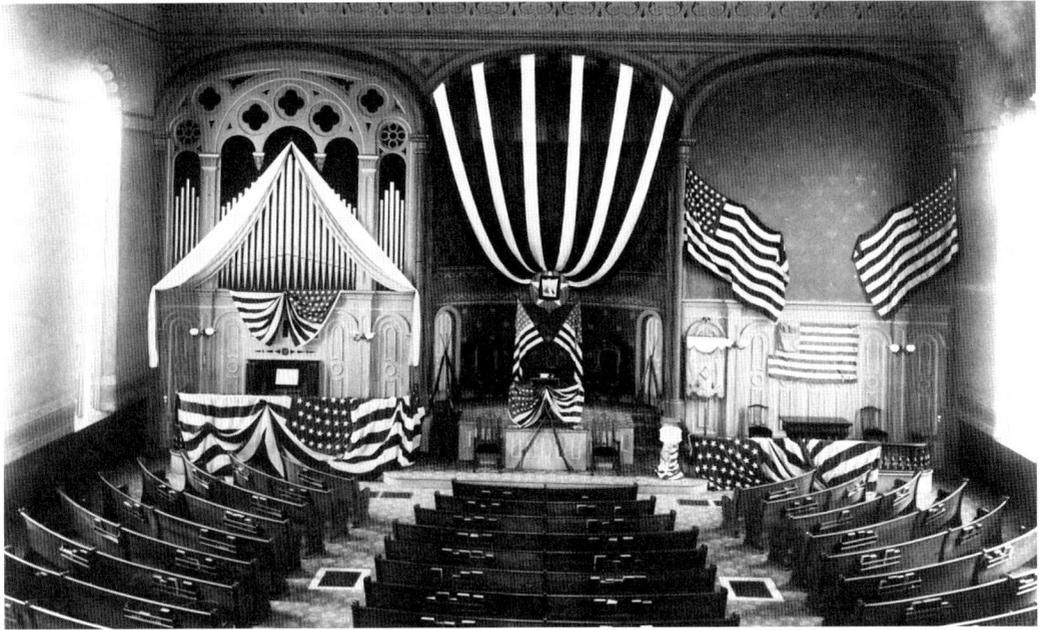

Interior of First Presbyterian Church, February 22, 1897. A patriotic service for George Washington's birthday was planned by the congregation with the help of the Vredenburgh Rifles. Approximately one thousand persons attended the event which featured a sermon preached by the Reverend Hugh B. MacCauley. This photograph was by Scott Studio of Freehold. (MCHA Archives.)

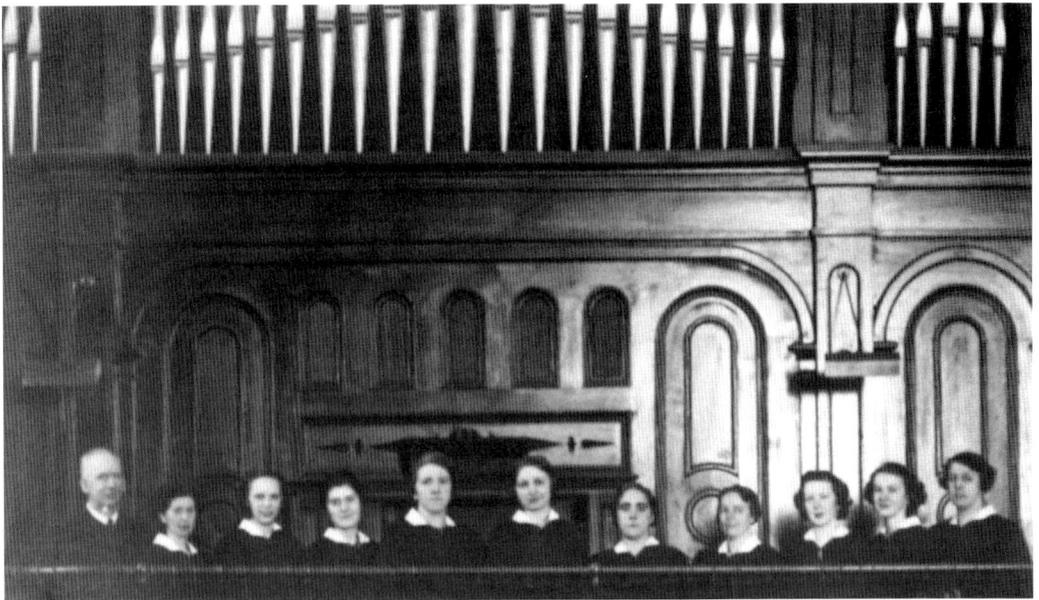

Choir of the First Presbyterian Church, 1937. Pictured are: Archibald Watt, Nellie Abbott, Phyllis Larson, Marcella Ladd, Ruth Barclay, Margerette H. Jackson (organist), Helen McD. B. Kruzen, Isabella Beith, Jean McDermott, Evelyn Moreau, and Georgena L. Musgrave. (Courtesy of Lydon Hendrickson.)

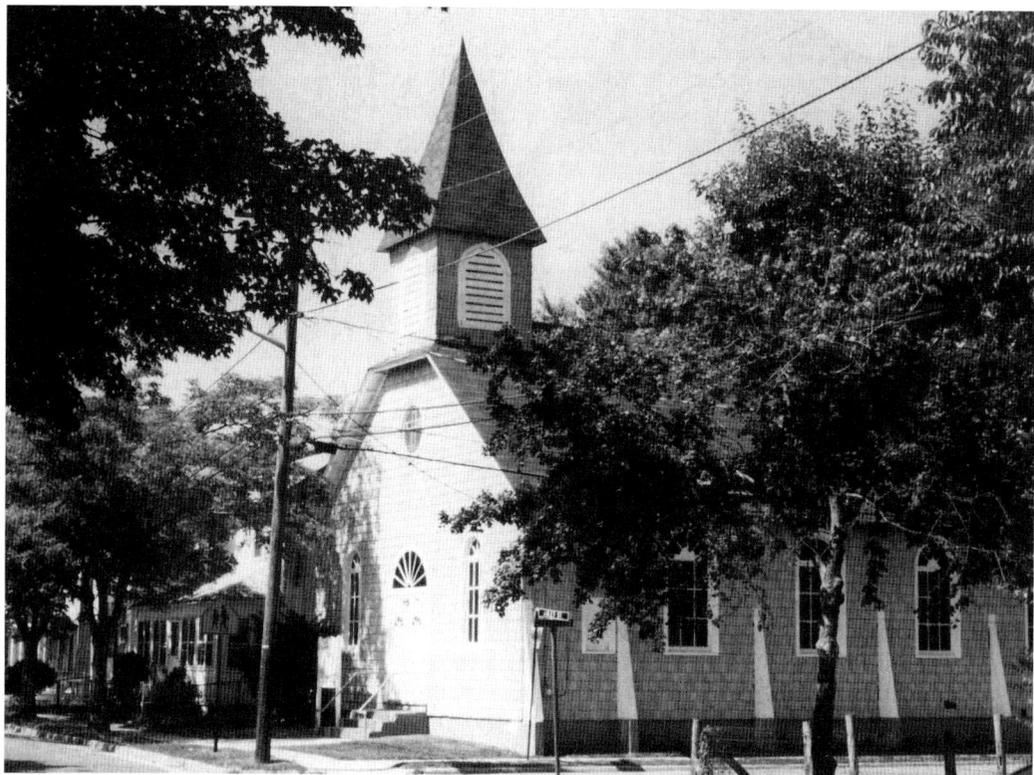

Bethel A.M.E. Church, built 1895. Colonial Revival in style, this church building with buttressed sides was recently the focus of a centennial celebration by the Bethel A.M.E. congregation, which has moved to a new larger facility at the end of Court Street. This building on Haley Street was the second church site for the congregation, the first being just outside of town in an early rural neighborhood known as Squirrel Town, near the cemetery shown on p. 119.

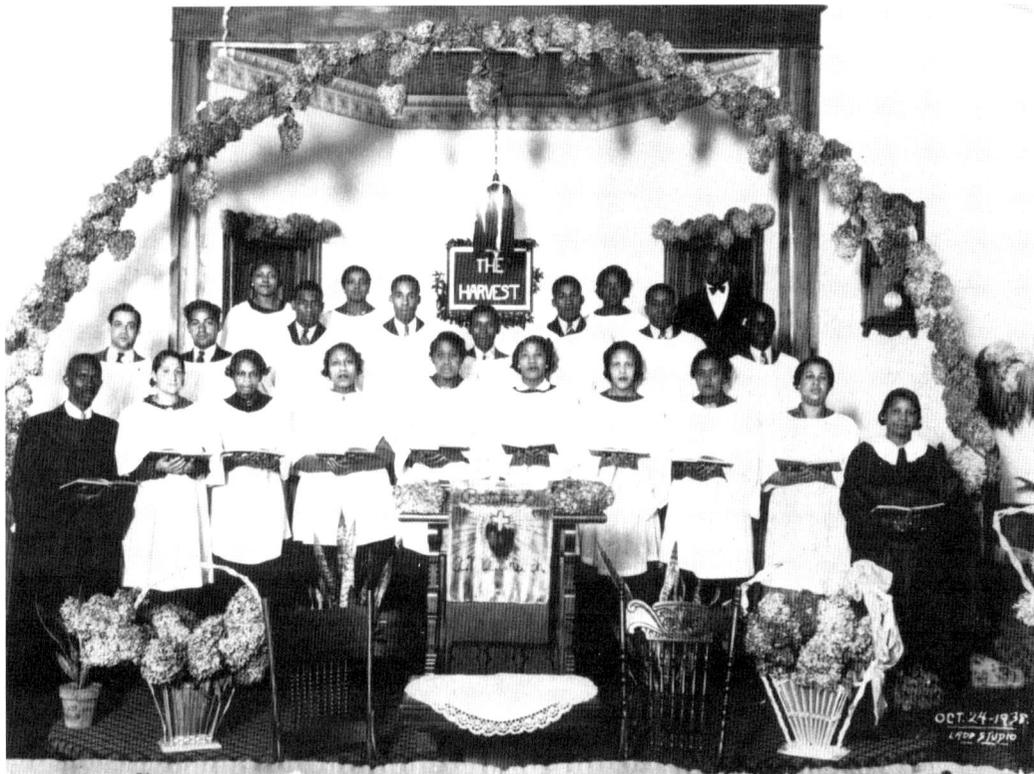

Harvest Home, October 24, 1938. A choral celebration was held at the Haley Street Bethel A.M.E. Church which included choir members Sadie Lewis, Mame Robinson, Lottie Simpson, Sosa Mercer, Alezenia White, Marion VanOrkey, Ida Simpson, Mame Hawkins Ware, Minnie Stevens, Charles Hawkins, John Hawkins, James VanDerveer, Charles White, ? Baber, Vernon White, Josephine White, Walter Ham Sr., Meriable VanDerveer, Catherine Bembry, Buelah Mercer, and Emanuel VanDerveer. This photograph was by Ladd Studio of Freehold. (Courtesy of Marion Russell.)

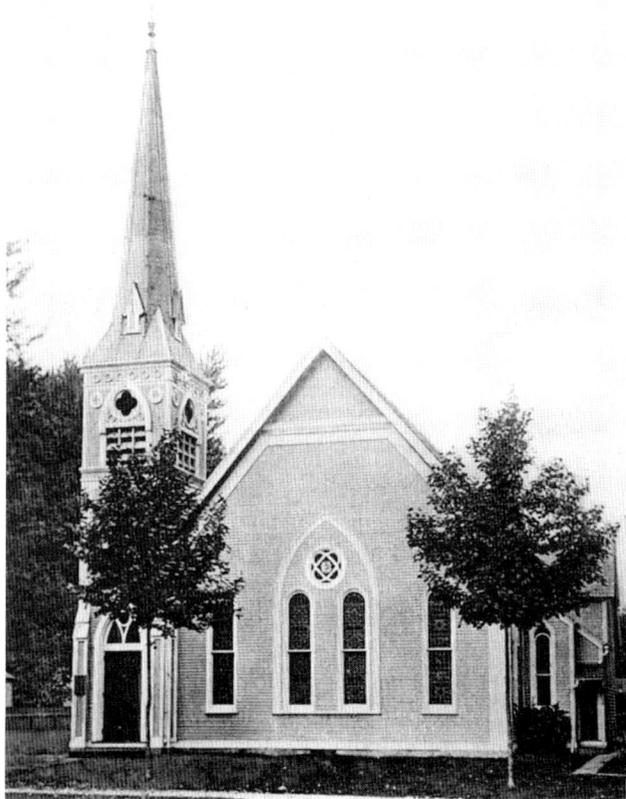

Left: Methodist Episcopal church, built 1857/58. According to period descriptions, this Romanesque Revival wooden building, designed by architect Charles Graham of Trenton, was "finished on the outside in imitation of stone," but later, in 1885, altered to its present appearance. It stands on Main Street between Manalapan and Yard Avenues. (MCHA Archives.)

Below: St. Rose of Lima Church, built 1881. Originally organized as a mission in 1851, the congregation of St. Rose has grown dramatically since then. The present church, located at Randolph and McLean Streets, no longer has the tall spire that appears in this view because it began to fail structurally and had to be replaced with the present-day bell tower. (MCHA Archives.)

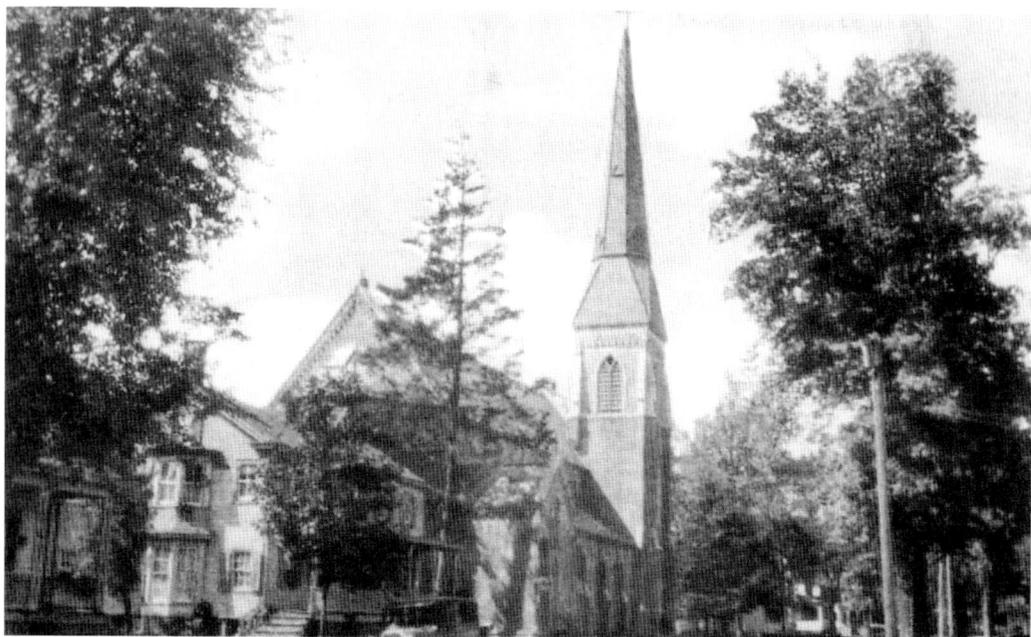

three

Sports and
Leisure

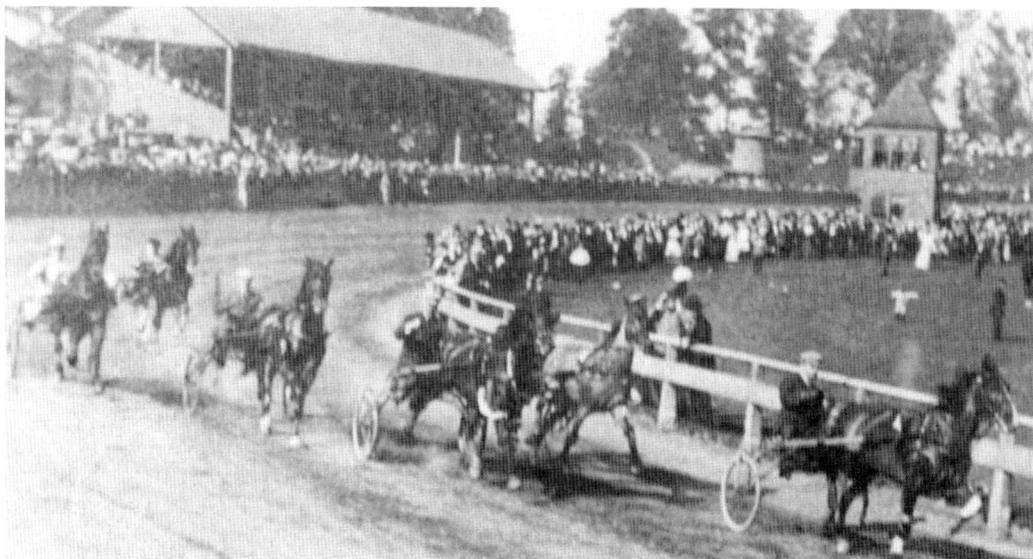

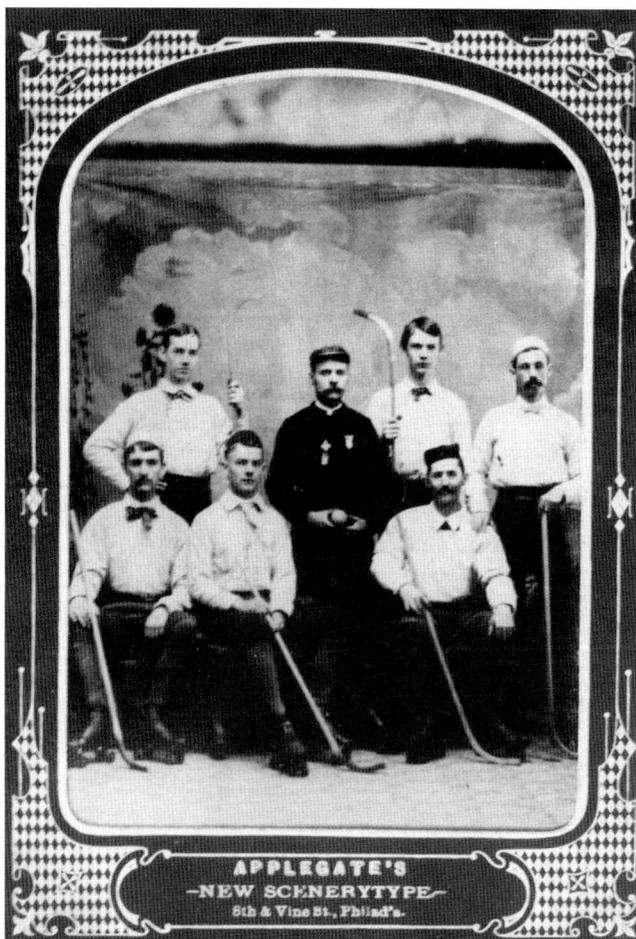

Above: The Freehold Raceway in the 1940s. At its start, the raceway in Freehold was a site for fairs and race meets and was rented by the Freehold Driving Club, founded in 1896, until the group was able to purchase the track in 1902. In 1921 the track was sold to Joseph L. Donahay, who found himself up against a prohibition on gambling that caused him to change the focus of his facility to the new sport of golf. It was not until 1936, when Harry S. Gould purchased the track, that horse racing regained its popularity in Freehold. (Courtesy of Carl N. Steinberg.)

Left: The Freehold Hockey Team in the 1850s. A rare daguerreotype portrait of the Freehold Hockey Team was taken by a photographer in Philadelphia named James R. Applegate. (Courtesy of Lydon Hendrickson.)

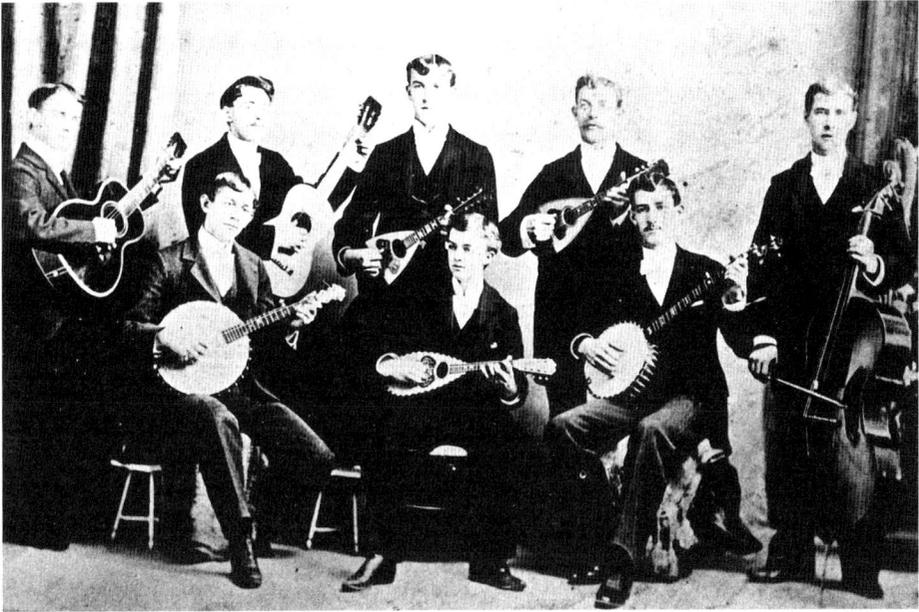

Freehold String Band in the 1890s. Pictured from left to right are: (front row) Al Pettit, William Bawden, William Hankins, and Vela Bacon on base fiddle; (back row) Charles Bawden, Thad Walling, Fred Keener, and John T. McChesney. (Courtesy of Freehold Public Library.)

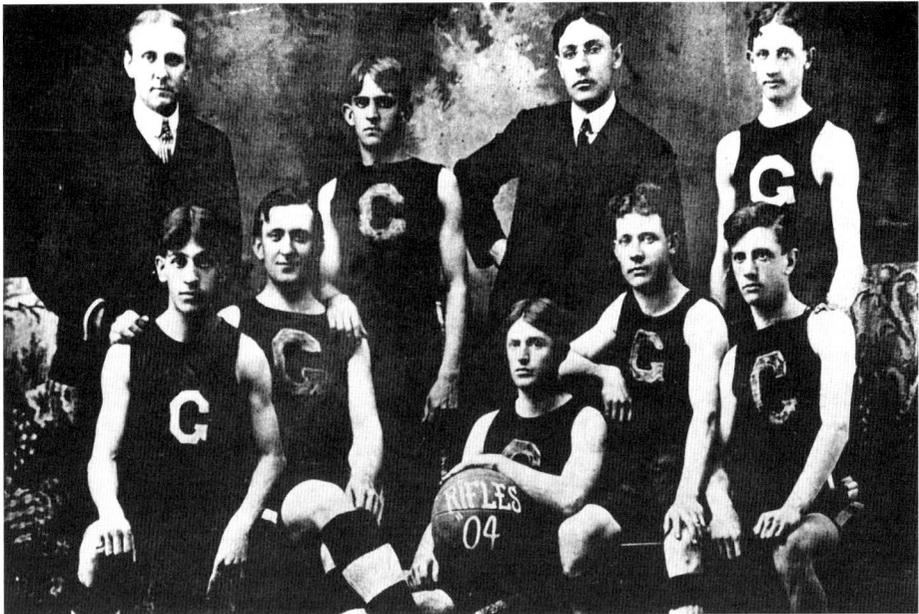

Vredenburgh Rifles Basketball Team, 1904. The basketball team of Company "G" Vredenburgh Rifles, which was an organization named after local Civil War hero Major Peter Vredenburgh, poses for the camera. Pictured from left to right are: (front row) Frank Hurley, Harry Bailey, George Quigg, Dr. Harvey S. Brown, and Al Mooney; (back row) Joe Thompson, John Feiser, William Freeman, and Edward Collins. (Courtesy of Freehold Public Library.)

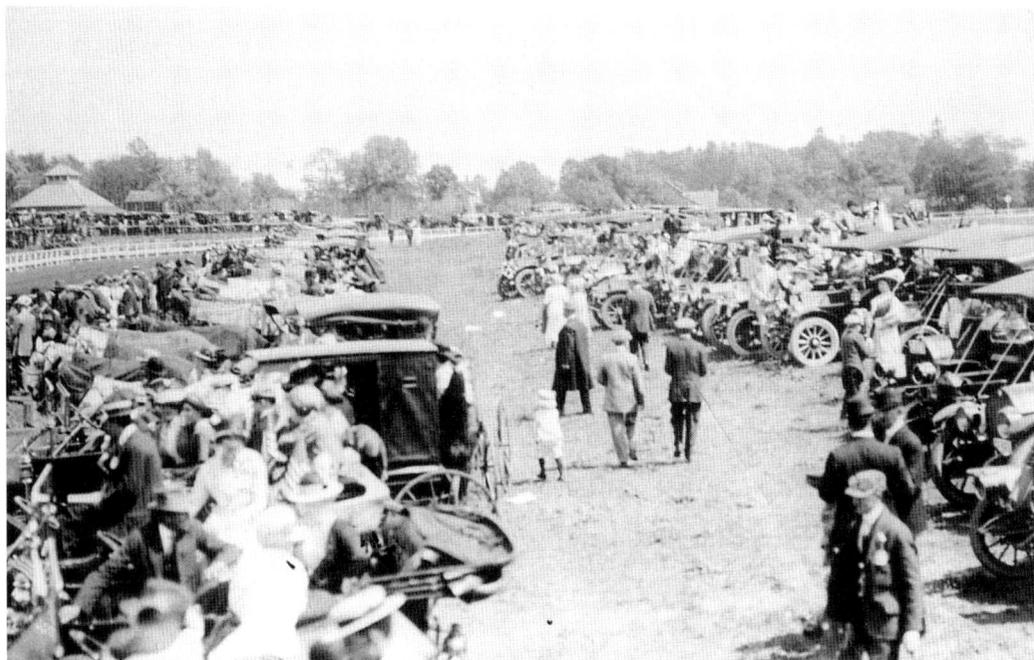

Freehold Driving Club, *c.* 1909. The driving club, which purchased the Freehold Raceway and was instrumental in the promotion of harness racing in this area, disbanded in 1909 for financial reasons and was replaced by the Freehold Driving Association, which operated the track until it was sold in 1921. This image was photographed by Ted Hansom of New York. (MCHA Archives.)

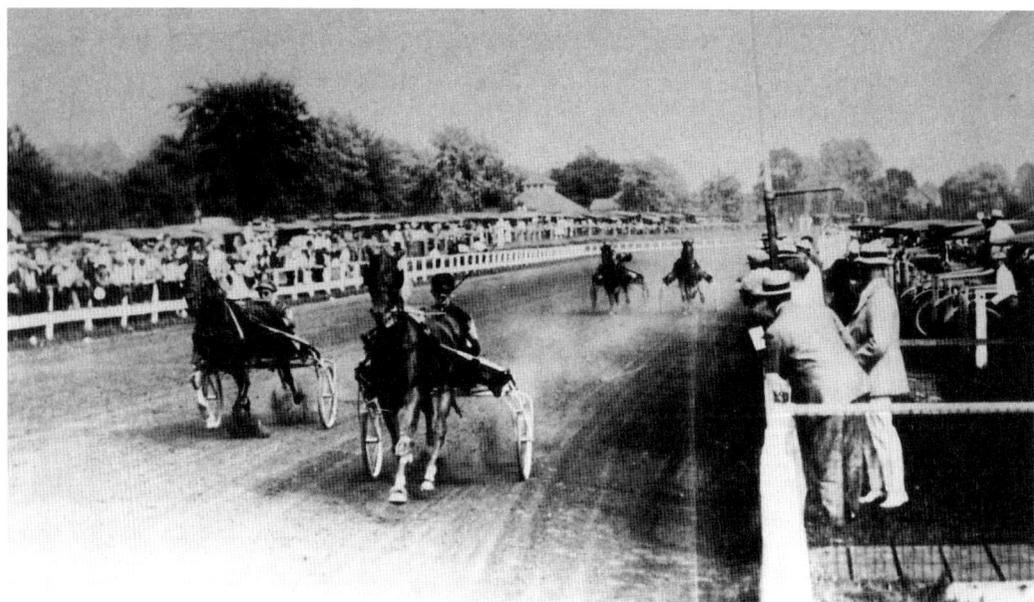

Freehold Raceway in the 1940s. Ruben Hal is winning the second heat. Harness racing in Freehold enjoyed a great revival after betting was again legalized by a statewide referendum in 1941, although for a year during the war it was suspended. (MCHA Archives.)

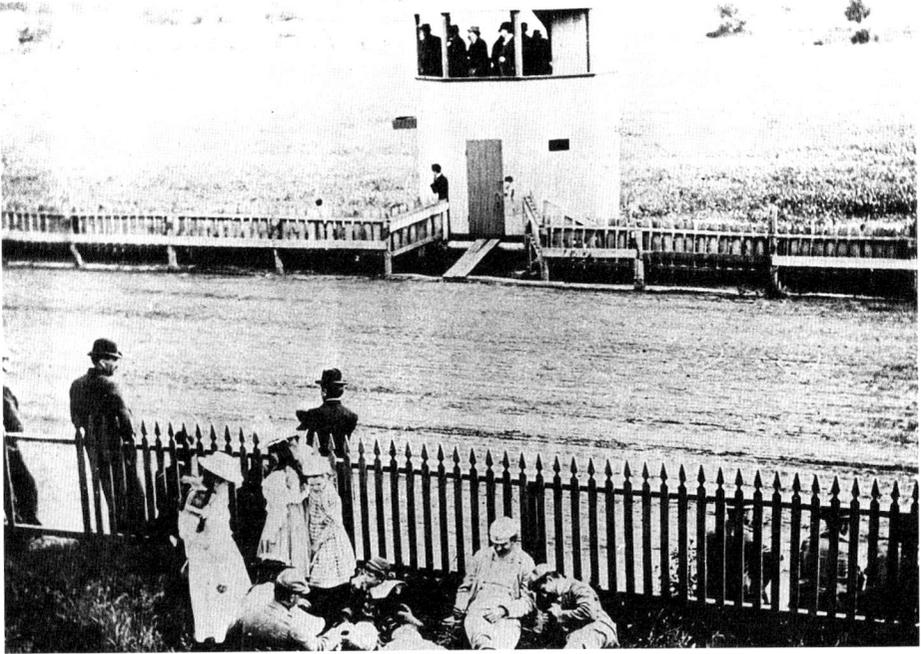

Spectators at Freehold Raceway, c. 1920. A day at the races was considered a pleasant outing; the races were suspended, however, as a result of the ban on gambling. (Courtesy of Freehold Raceway.)

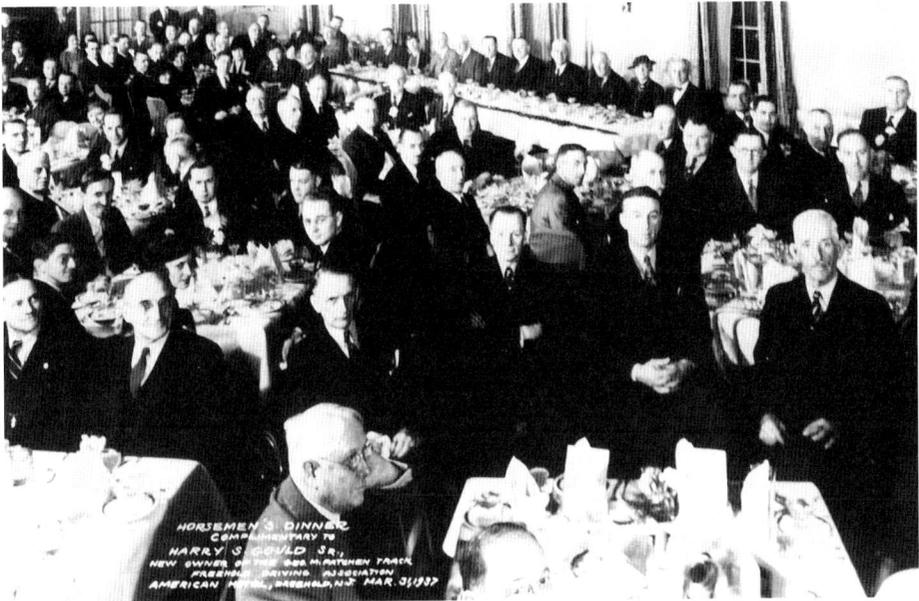

Freehold Driving Association dinner, March 31, 1937. A dinner held at the American Hotel honored Harry S. Gould Sr., the new owner of the George M. Patchen Track of the Freehold Driving Association. (MCHA Archives.)

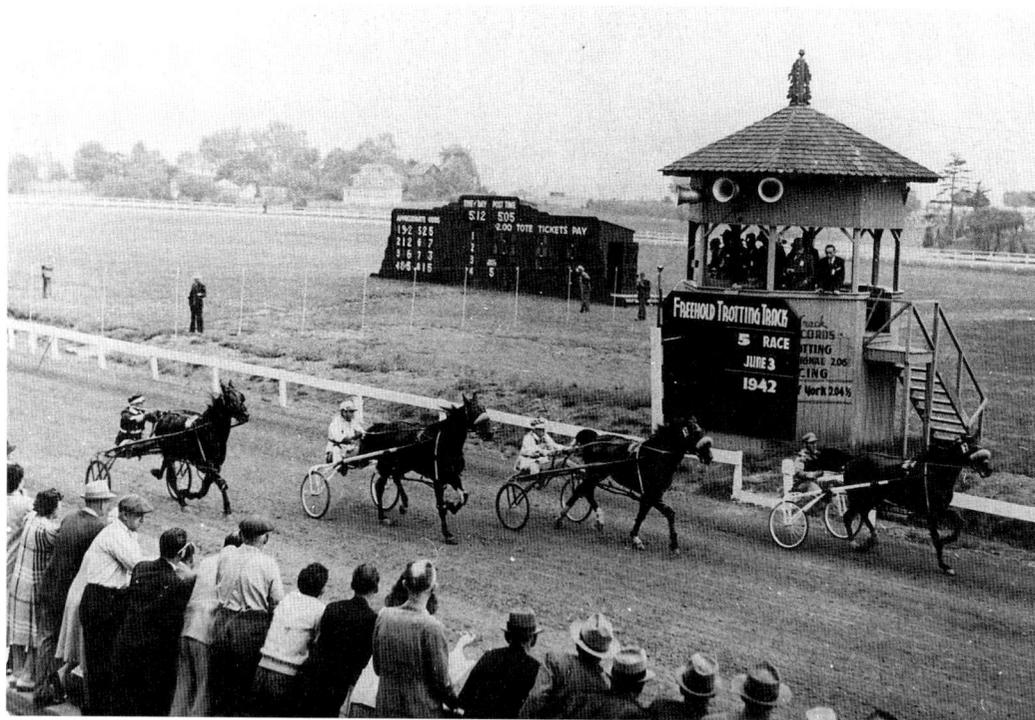

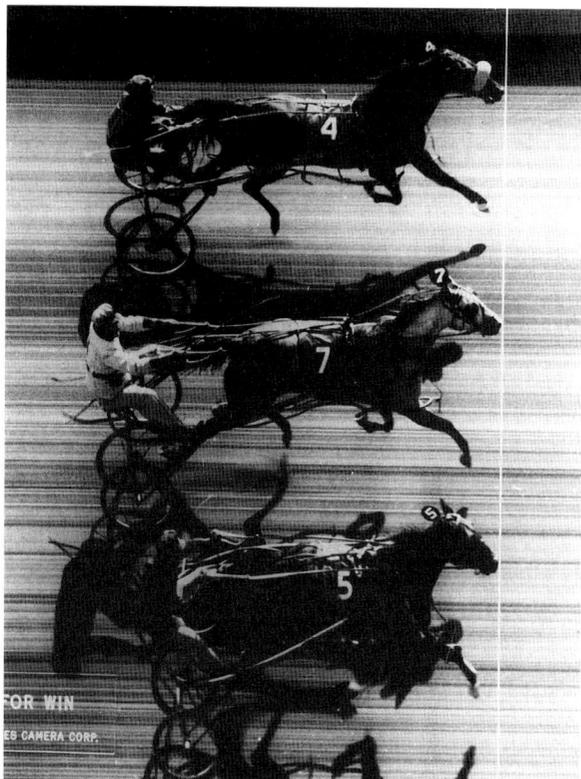

Above: Freehold Raceway, 1942. The old judges' stand is shown as spectators watch the fifth race on June 3, 1942. (Courtesy of Freehold Raceway.)

Left: Triple dead heat, October 3, 1953. One of two triple dead heats in the history of harness racing occurred at the Freehold Raceway between No.4 (Patchover), No.5 (Penny Maid), and #7 (Payne Hal). (Courtesy of Freehold Raceway.)

Opposite, below: Freehold High School Baseball Team, 1922. An inscription on the reverse of this photograph gives the nicknames of the players, some of which have a very "20s" flavor. Shown left to right from the top are: "Spec" McCue, Grant Davis, "Slat" Carney, "Duke" Burke, "Bottle" Quinn, "Slim" McChesney, H.J. Witman (coach), Louie Foosaner, Jack McMurtrie, "Nels" Freeman, Ed King, and "West" Walling. (Courtesy of Freehold Public Library.)

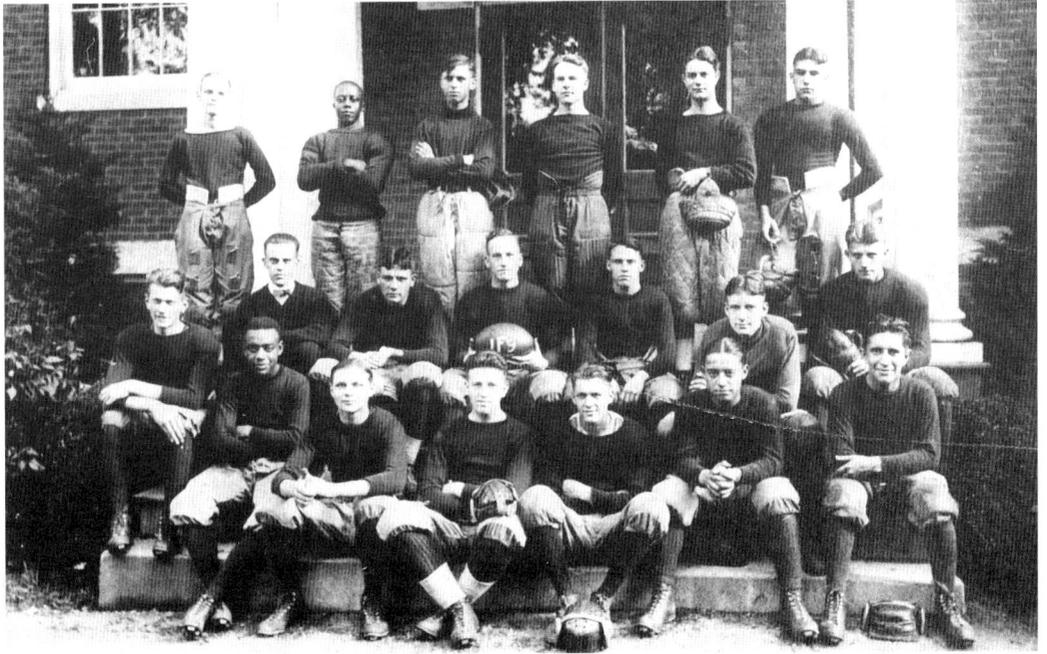

Above: Freehold High School Football Team, 1919/20. The photograph is signed on the reverse by each of the team members, pictured from left to right as follows: (front row) Ira VanDerveer, Alfred Mahachik, Stanley Brower, Francis VanDerveer, Joseph Brown, and Jacob Goldstein; (middle row) Charles Brower Jr., Coach John Whitman, Nels Freeman, Arthur E. Bound (captain), William E. Rhodes, Robert A. Bar, and Joseph Laird III; (back row) John MacMurtrie, unknown, Wesley Walling, Herbert Winsor, Harold Freedman, and Arhol Reese; Absent team members are William Willett and Reginald Stokes (MCHA Archives.)

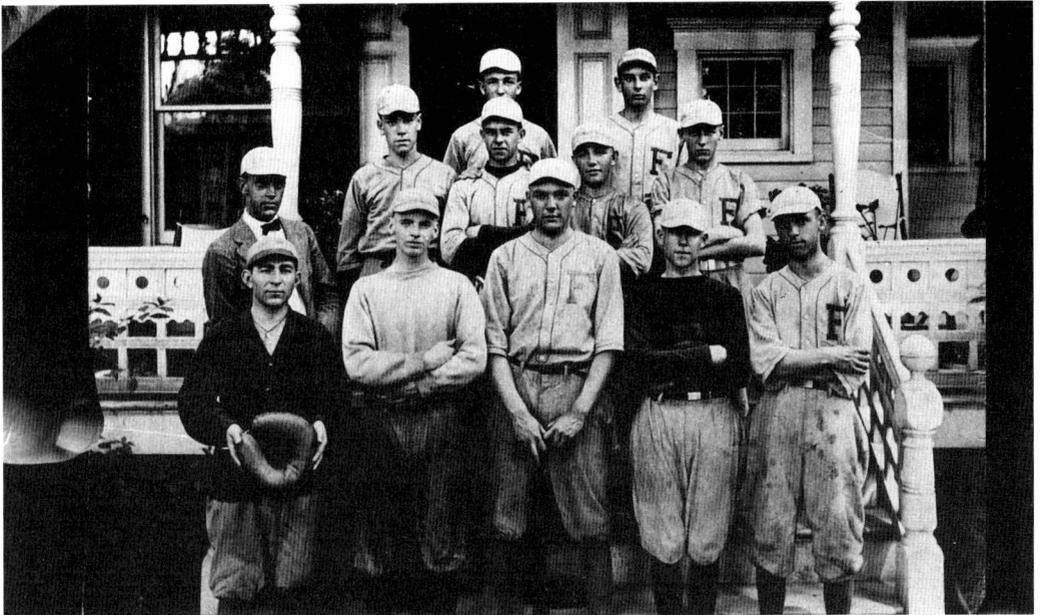

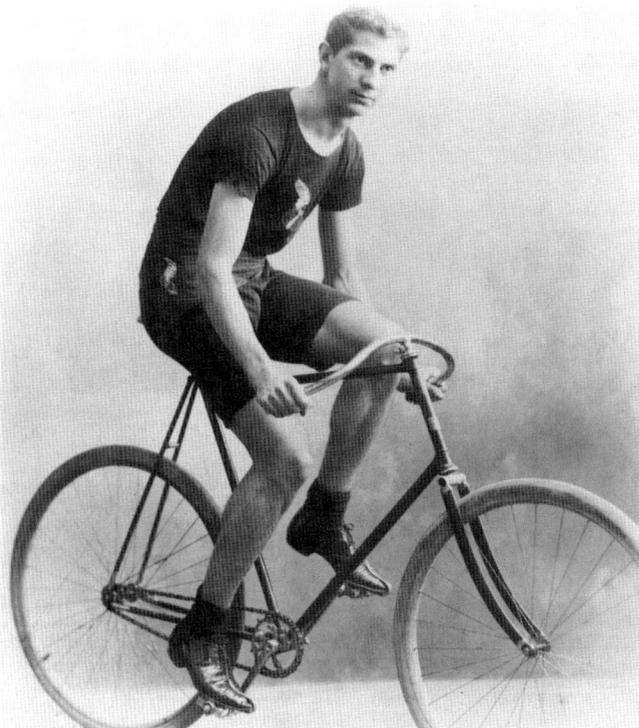

Arthur Zimmerman, *c.* 1890. Born in Camden in 1869, Arthur Augustus Zimmerman came to Freehold to work in the law office of his brother-in-law, Joseph McDermott. His interest in bicycle racing became his vocation as he entered and won fourteen hundred amateur and professional races here and abroad over the next sixteen years. He formed the Zimmerman Manufacturing Company in Freehold to produce bicycles and accessories, and sponsored a local bicycle racing club, the "Zimmy Cycle Club," which flourished in the late 1800s. (MCHA Archives.)

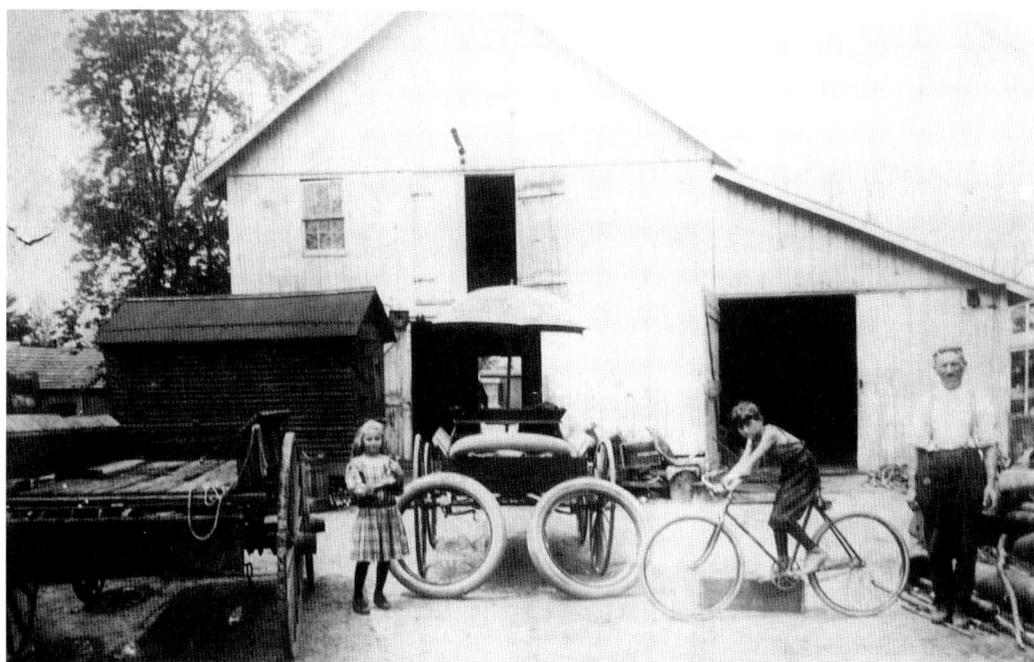

Dr. Carl McDermott's barn, *c.* 1890. The scene is Dr. Carl McDermott's (Arthur Zimmerman's uncle's) barn, which stood on Manalapan Avenue between Main and Broad Streets. Dr. McDermott's son is on the bicycle in front of the barn. (MCHA Archives.)

four

Commerce
and Industry

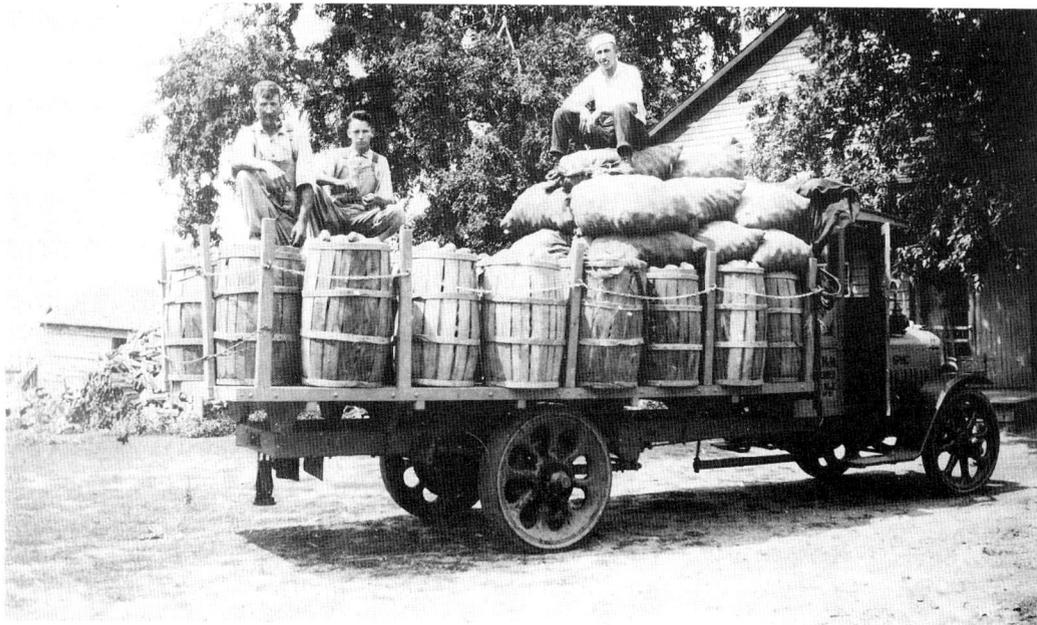

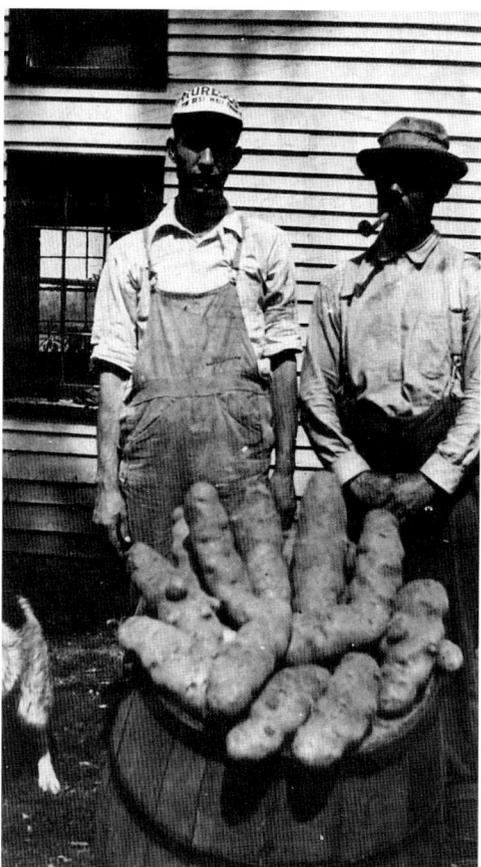

Above: Truckload of potatoes, *c.* 1915. A full load of potatoes from Joseph Smith's farm in West Freehold is ready to be taken to market. Potatoes were typically stored in large barrels like those seen on the flatbed of this truck. (Courtesy of Carolyn Smith Flock.)

Left: White Giant potatoes, *c.* 1915. An old-fashioned variety that is no longer grown, White Giants were desirable for their size, which made processing easier. (Courtesy of Carolyn Smith Flock.)

Opposite, above: Potato field in Freehold, *c.* 1910. Growing potatoes was a principal activity in the agricultural community in and around Freehold because the sand loam soil suited the crop. It is said that at one time you could drive from Freehold to Trenton and see nothing but potato fields. (Courtesy of George H. Moss Jr.)

Opposite, below: Potatoes on the way to market, *c.* 1907. Trucks filled with barrels of potatoes came into Freehold to load the crop onto trains. This image was photographed by George A.M. Morris. (Courtesy of George H. Moss Jr.)

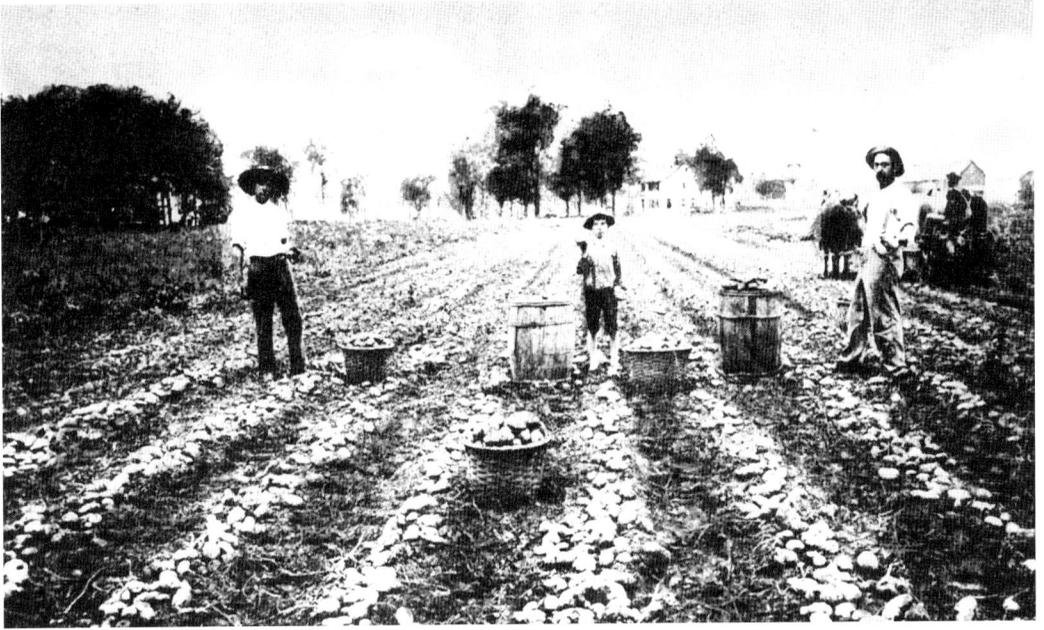

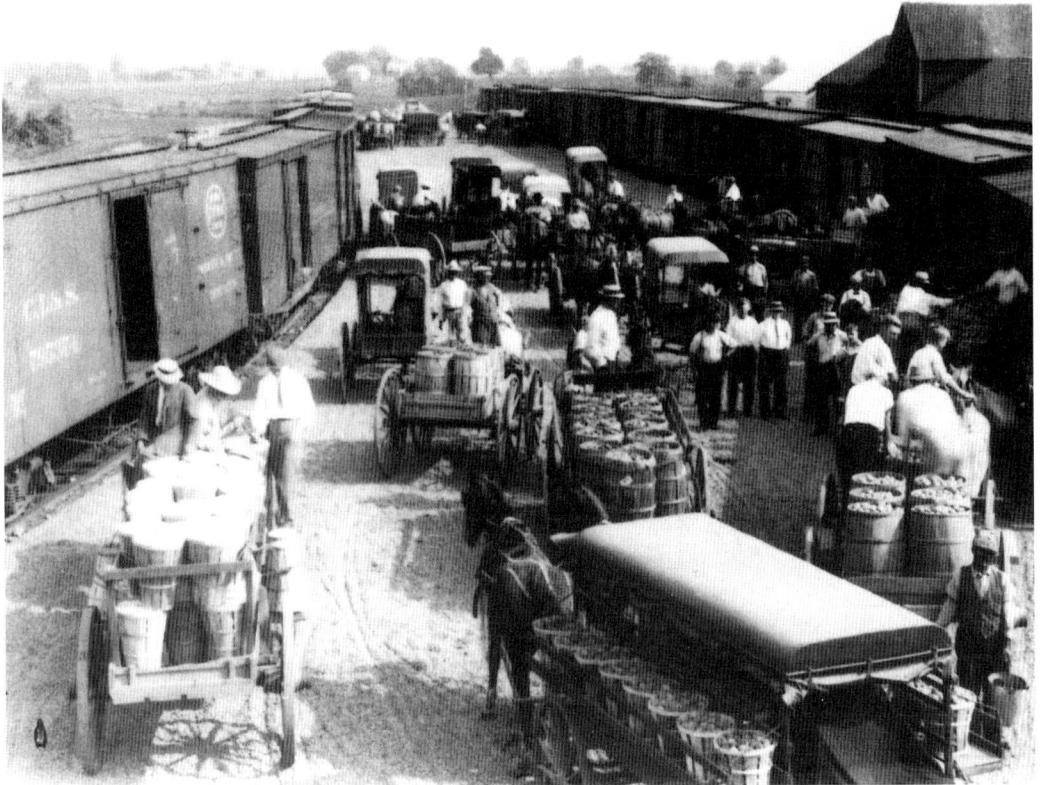

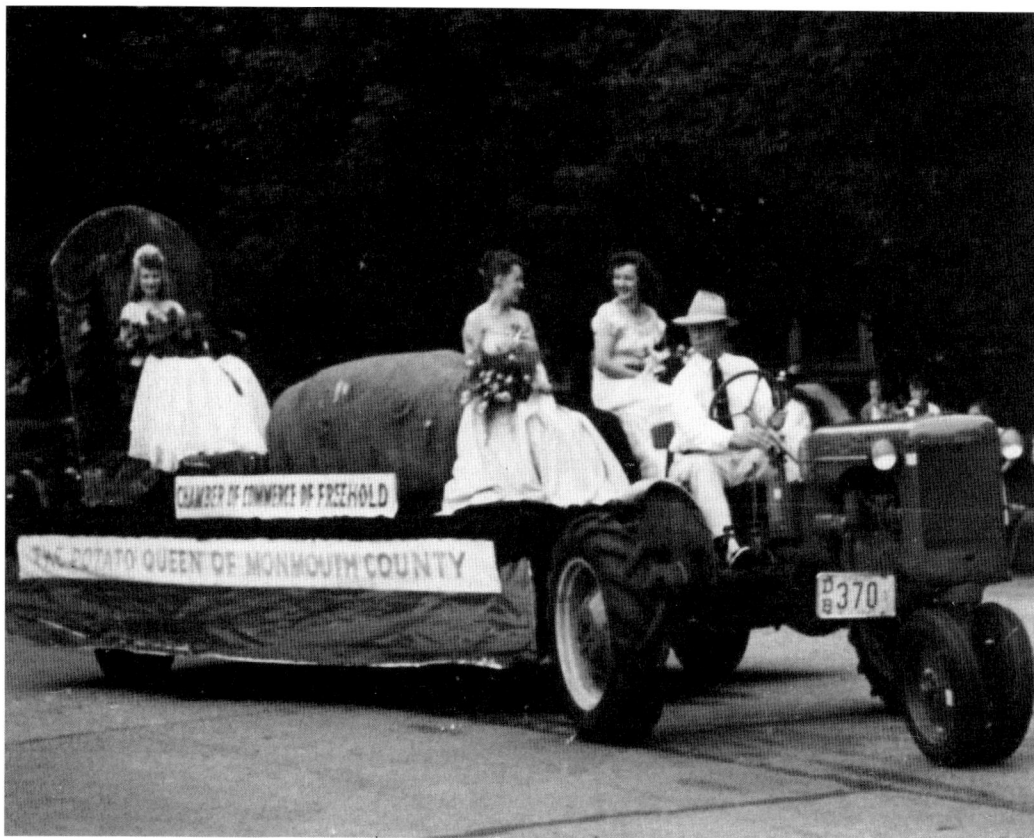

The Potato Queen, 1947. Carolyn Smith, daughter of West Freehold potato farmer Tunis D. Smith, reigned as Monmouth County's Potato Queen in the 1947 parade commemorating the Freehold Fire Department's 75th anniversary. Her attendants were Marjorie Clark and Margaret Wilson. Sidney Ried drove the tractor that pulled the ladies' float which featured an oversized potato—in all probability representing a White Giant. (Courtesy of Carolyn Smith Flock.)

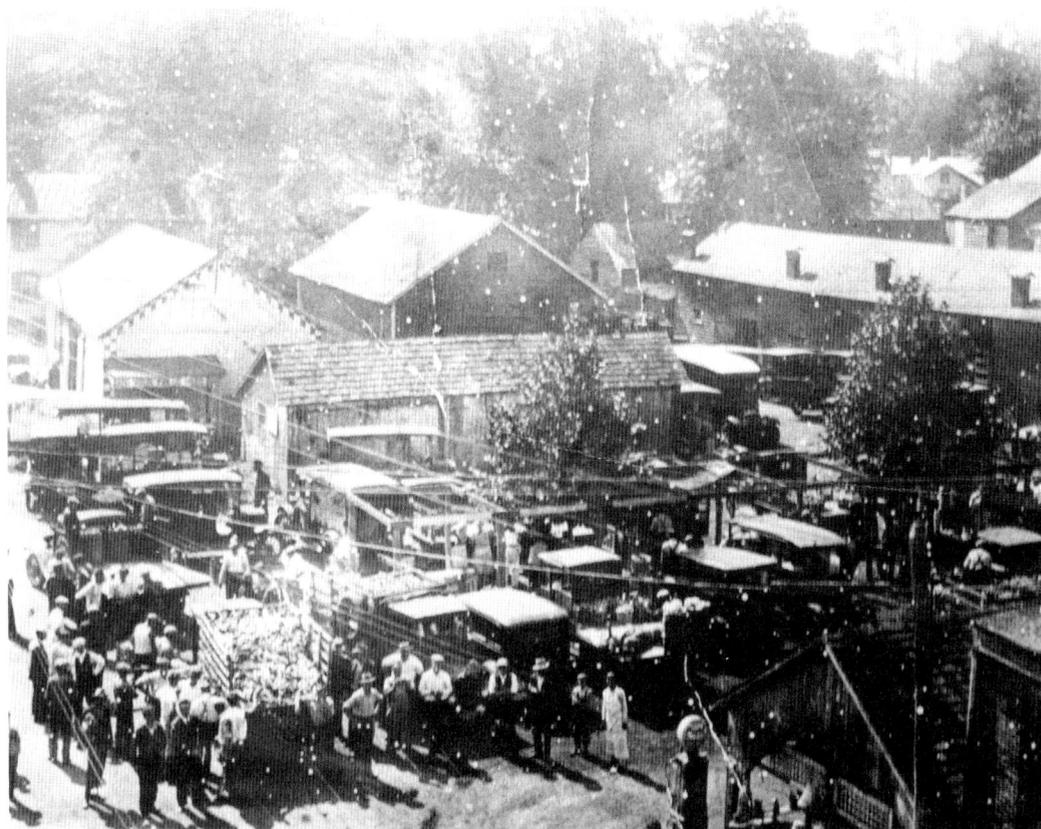

The market yard in the 1920s. Produce trucks filled the market yard behind Main Street where there was once a complex of stables and barns that is visible in this view. (Courtesy of Carl N. Steinberg.)

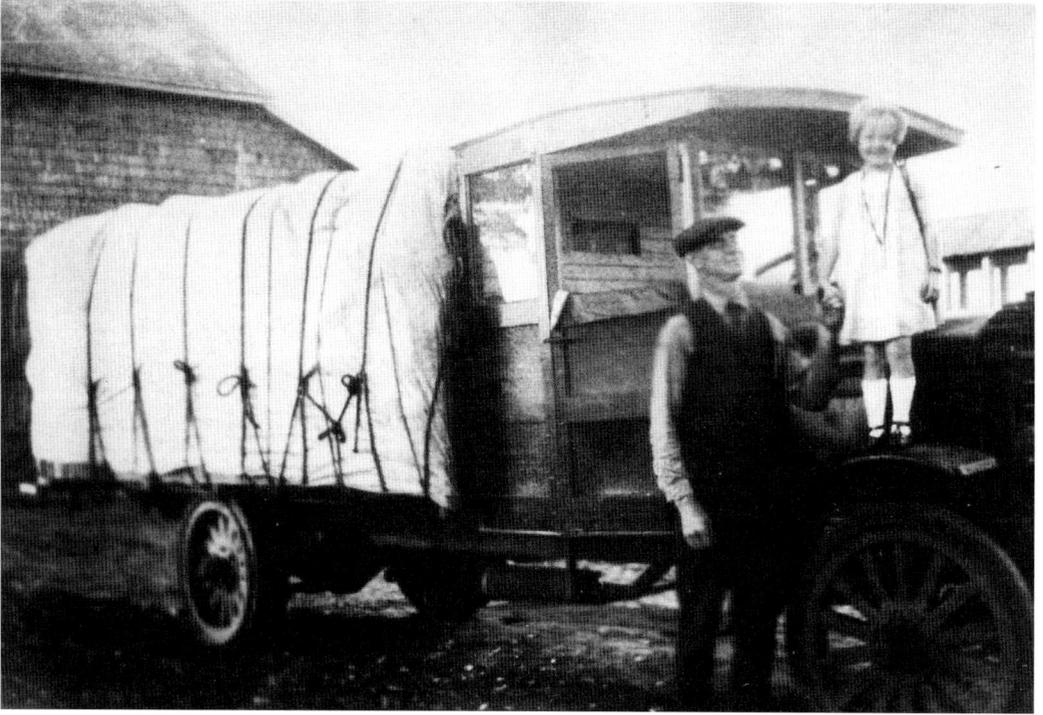

Produce bound for the Newark market in the 1920s. Martin K. Van Sicklin appears with a truck loaded with produce for the Newark market, another outlet besides the local market or those locations reached by train. (MCHA Archives.)

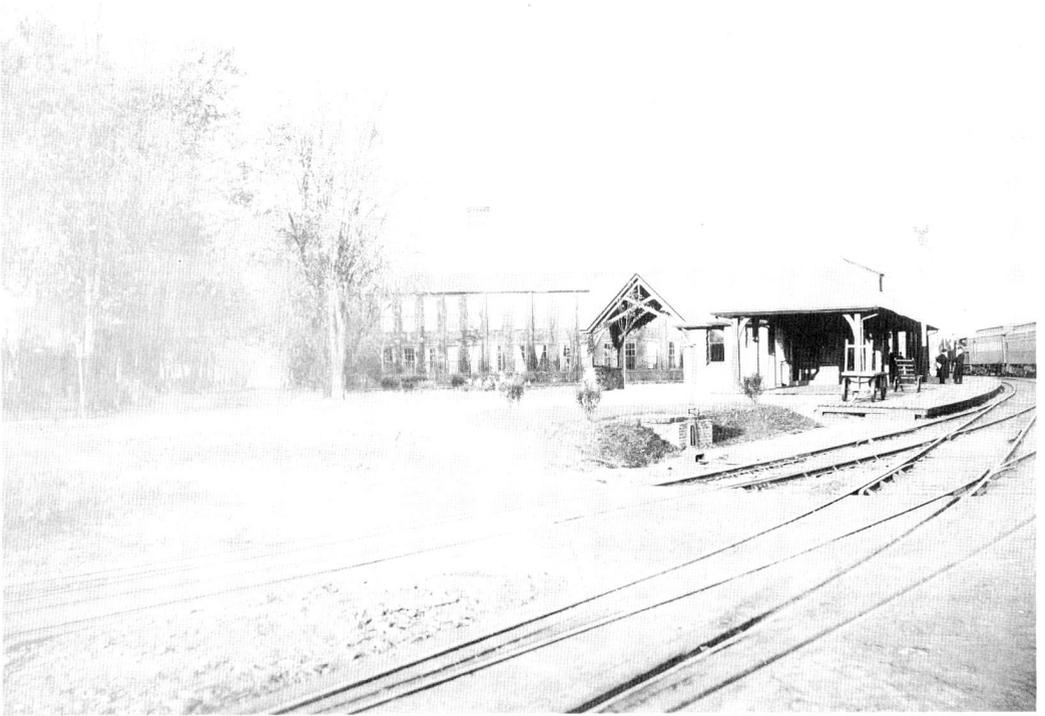

Freehold passenger depot in the 1930s. Built on the old Monmouth County Agricultural Railroad (incorporated in 1867), the central railroad depot at the corner of Jackson and Mechanic Streets was designed by Freehold architect Warren H. Conover and built by Alonzo Brown of Freehold in 1896. The Rothschild shirt factory building (later the Karagheusian Rug Mill) can be seen in the background. Although the railroad line has since been abandoned, the building still stands, having been altered for office use by Holland and McChesney, Inc. (MCHA Archives.)

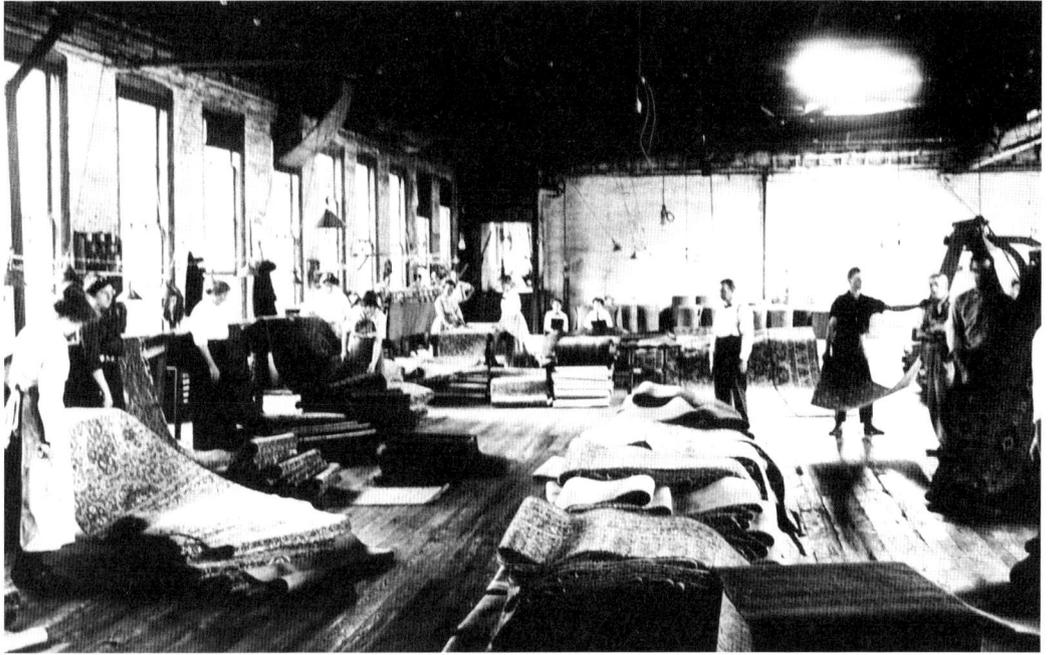

Opposite: Bringing coal in behind the factory, *c.* 1920. The Karagheusian Rug Mill was the largest employer in Freehold in its day. Originally the site of the V. Henry Rothschild & Company shirt factory, the rug mill at the corners of Jackson and Center Streets opened in 1904, with Jacquard Wilton looms and skilled weavers brought from England. By 1918 it provided employment for three hundred persons and continued to expand, becoming nationally known for its Gulistan carpets until it closed in the 1960s. This image was photographed by Hall Studio of Freehold. (MCHA Archives.)

Above: Interior of Karagheusian Rug Mill, *c.* 1920. In a large workroom in the oldest part of the building, employees inspect and prepare rugs for shipment. This photograph was by Hall Studio of Freehold. (MCHA Archives.)

Right: Karagheusian Rug Mill smokestack, 1928. Expansions in the 1910s and 1920s were made in response to increased business. This photograph was taken just after the large smokestack was completed, and celebrated with a flag flying at its top, in 1928. (MCHA Archives.)

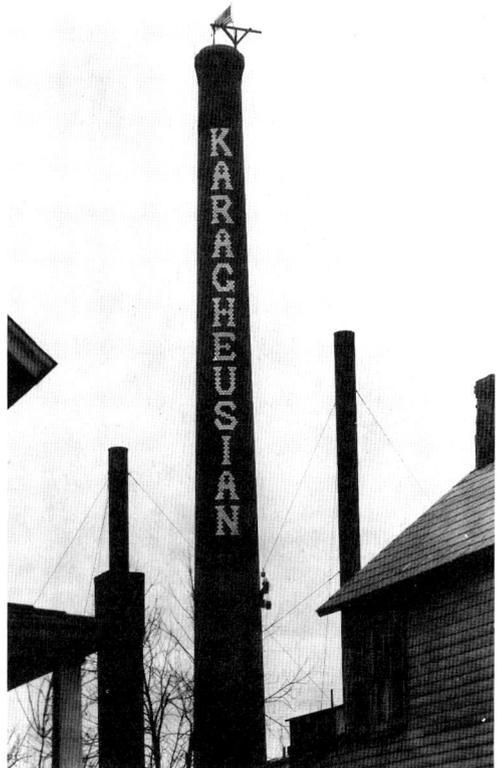

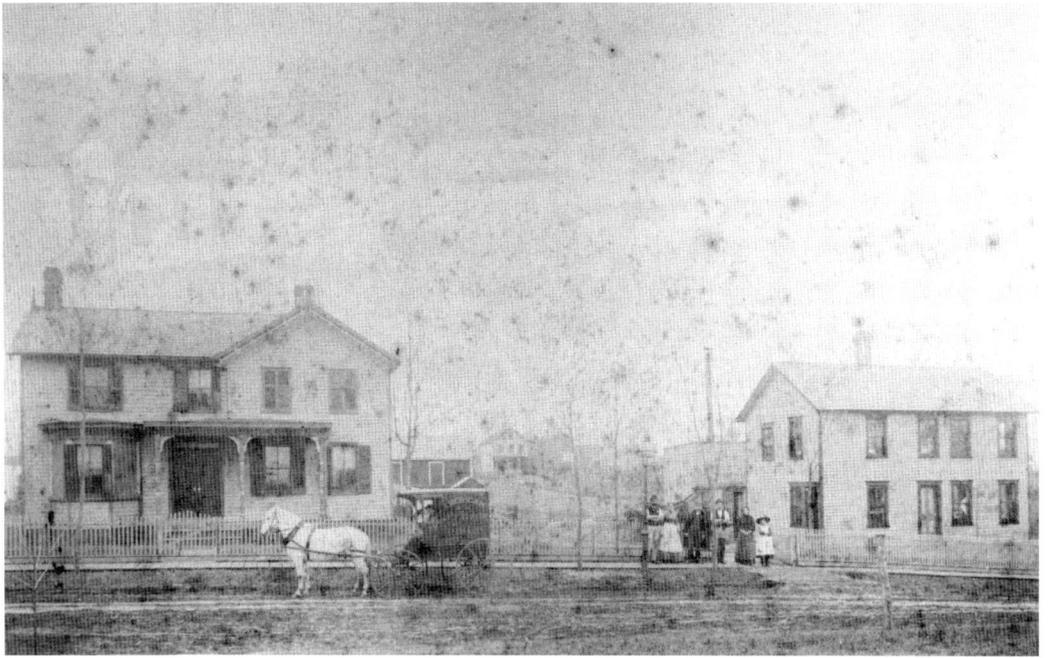

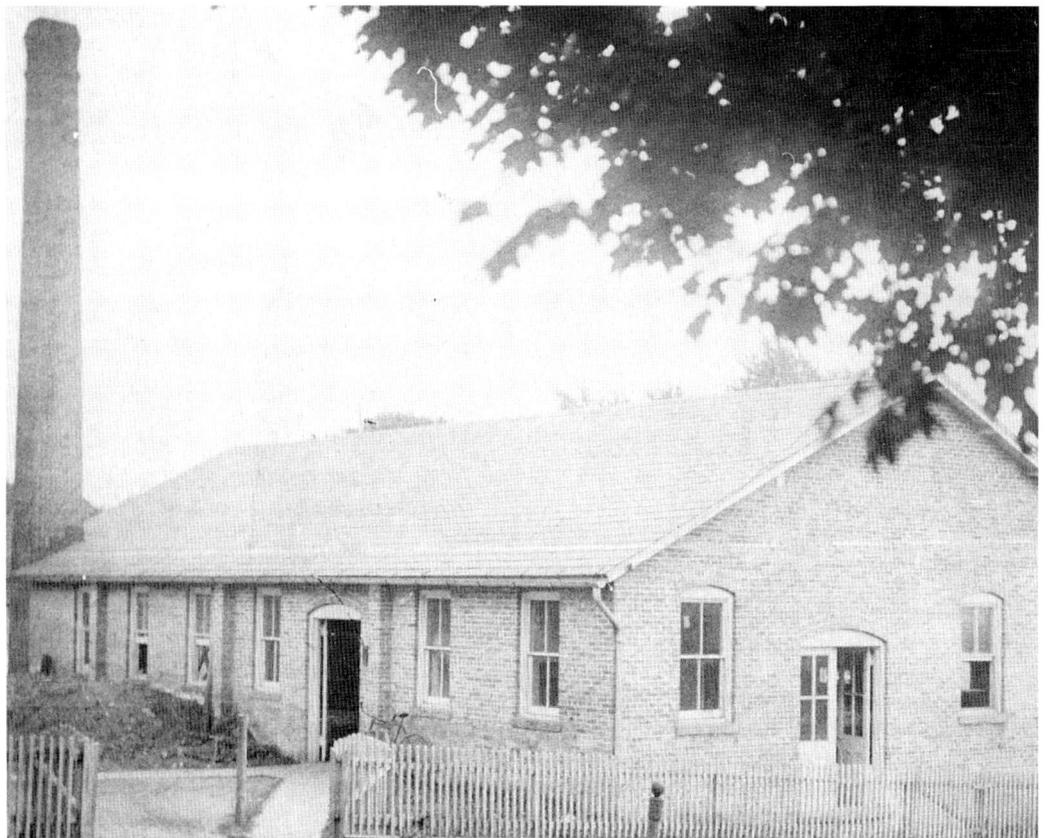

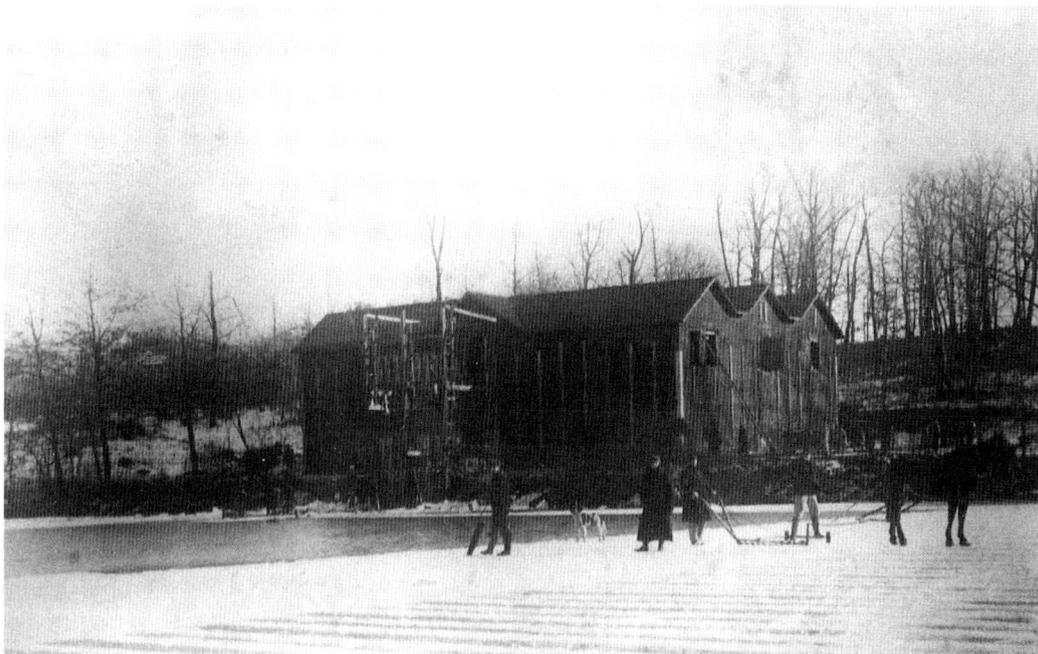

Above: Cutting ice in the 1890s. Ice was cut from Topanemous Pond and stored in the warehouse in the background, which was owned and operated by William N. Thompson. (Courtesy of Mr. and Mrs. James Higgins.)

Opposite, above: Steam laundry in the 1880s. The first steam laundry in Monmouth County was owned and operated by William E. Curley on Bowne Avenue. The family lived in the house shown next door, in front of which is the laundry wagon pulled by "Dolly." (MCHA Archives.)

Opposite, below: American Steam Laundry, 1910-1913. The steam laundry shown in the top photograph burned in 1904 during a labor strike and perhaps an act of arson, and was replaced by this brick building. When this photograph was taken, the owner was J. Elmer VanDerveer. (Courtesy of Howard I. VanDerveer.)

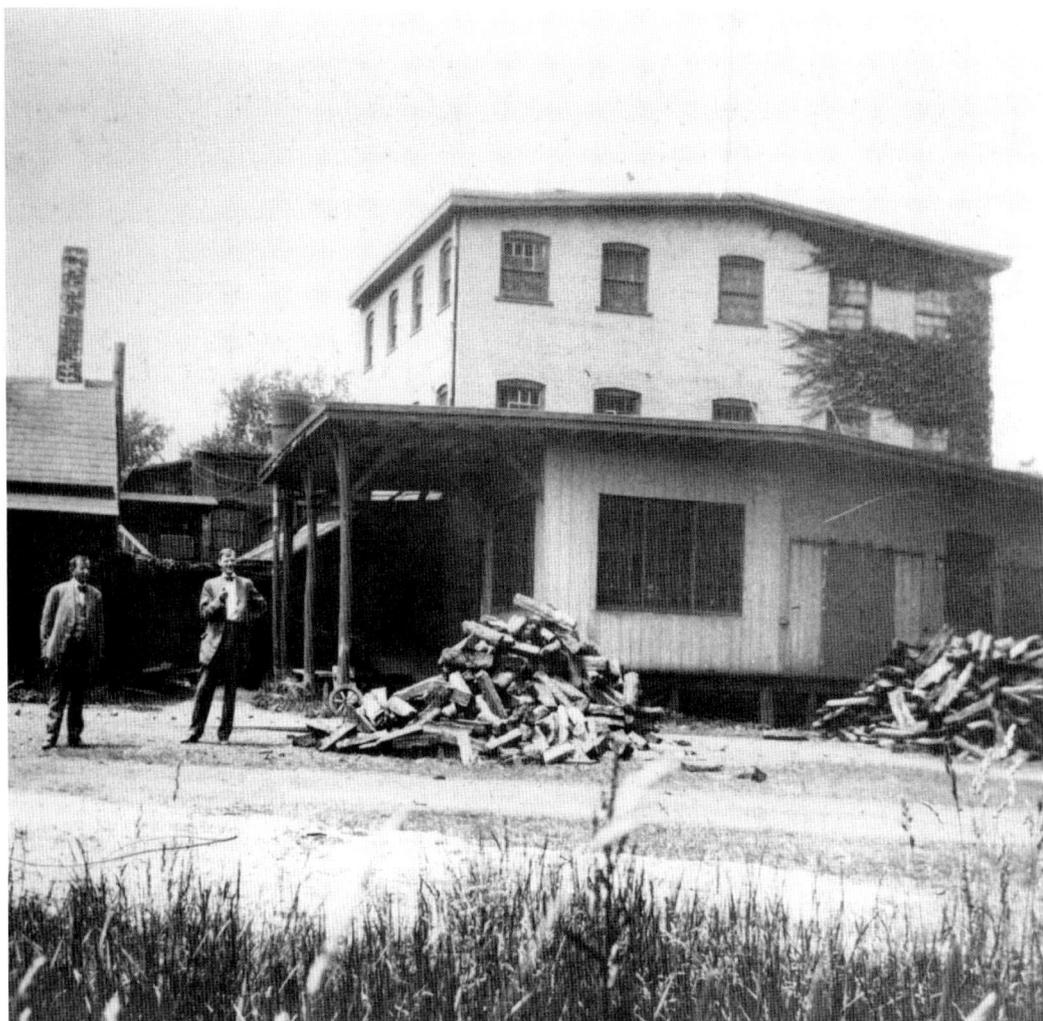

Freehold Iron Foundry, *c.* 1870. The proprietor of the foundry, John Bawden, is most likely one of the gentlemen in this picture. He opened the business in 1856, and in 1858 advertised iron fencing, posts, and other castings "at city prices." Soon afterward, he took Gilbert Combs on as a partner, and after a slow start the business eventually thrived, engaging extensively in the manufacture of Franklin stoves and all other cast-iron goods. (MCHA Archives.)

Residents and Residences

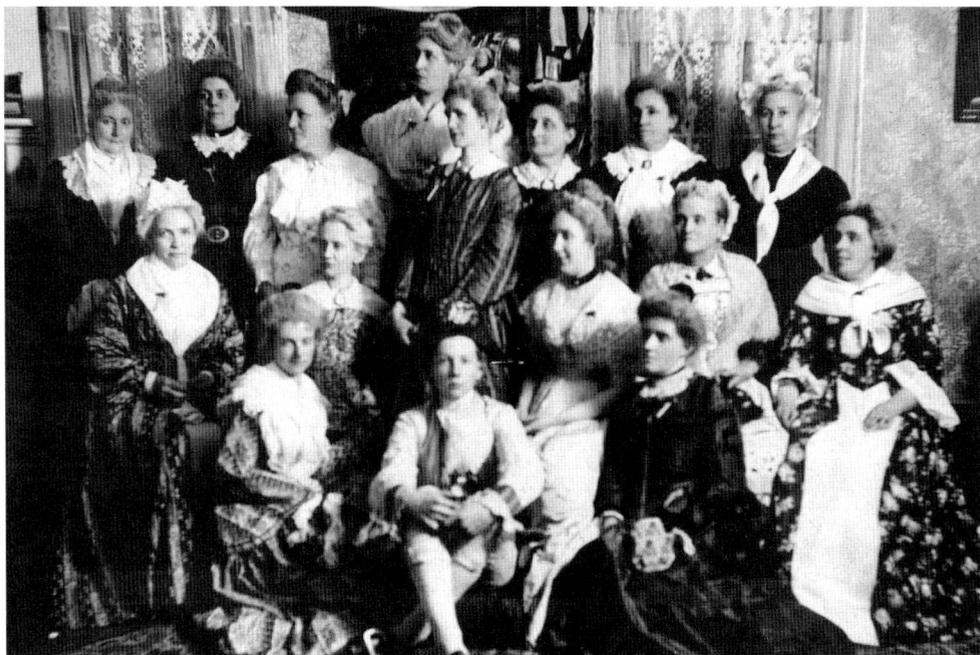

Martha Washington's tea party, *c.* 1910. A costumed theme tea party to benefit the Ladies Aid Society of the Presbyterian church was held by Mr. and Mrs. William M. Moreau at their home, now known as Covenhoven House ($48 was raised). The popularity of Colonial Revival in this period was evident in activities as well as in decorating styles. Among the guests pictured are: Mrs. Joseph A. Yard, Mrs. Ella Combs, Mrs. William E. Truex, Mrs. Alex. L. Moreau, Mrs. Sidney H. Conover, Mrs. D. Craig Bowne, Mrs. Herbert J. McMurtrie, Mrs. Arthur W. Remington, Mrs. Elizabeth Probasco, Mrs. John M. Paxton, Mrs. Ella Thompson, Mrs. E.P. Baird, Mrs. Charles R. Applegate, and Mrs. William F. Rue. Frank Moreau is seated and his mother, Mrs. William M. Moreau, stands behind him. (MCHA Archives.)

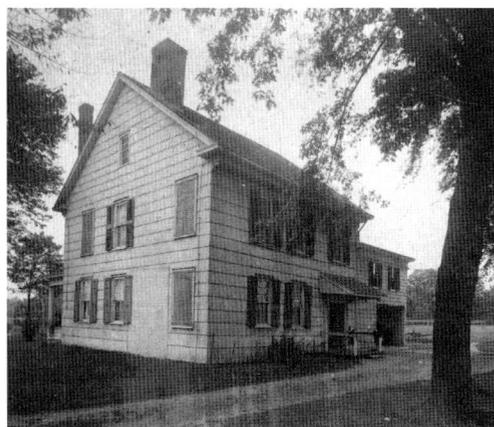

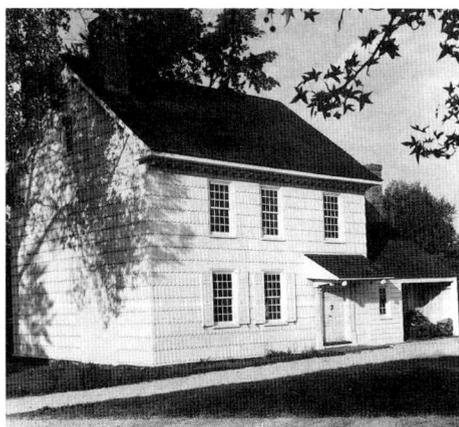

Above, left: Covenhoven House, *c.* 1914. Before restoration, the Covenhoven House retained much of its eighteenth-century character and detailing, but had been altered by the additions of several windows on the west end as well as a porch on the side not visible in this picture. Some changes had also been made to the interior associated with the new windows. The property came to the Monmouth County Historical Association from the Moreau family in 1969. (MCHA Archives.)

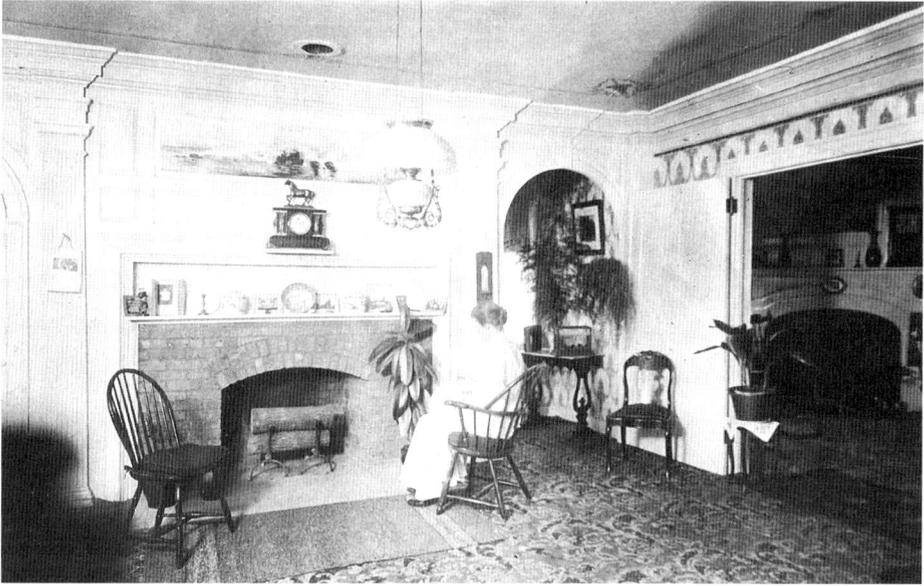

Covenhoven House interior, c. 1914. Lizzie Gaunt Jones Moreau (Mrs. William Moreau) sits before the fireplace in the parlor. (MCHA Archives.)

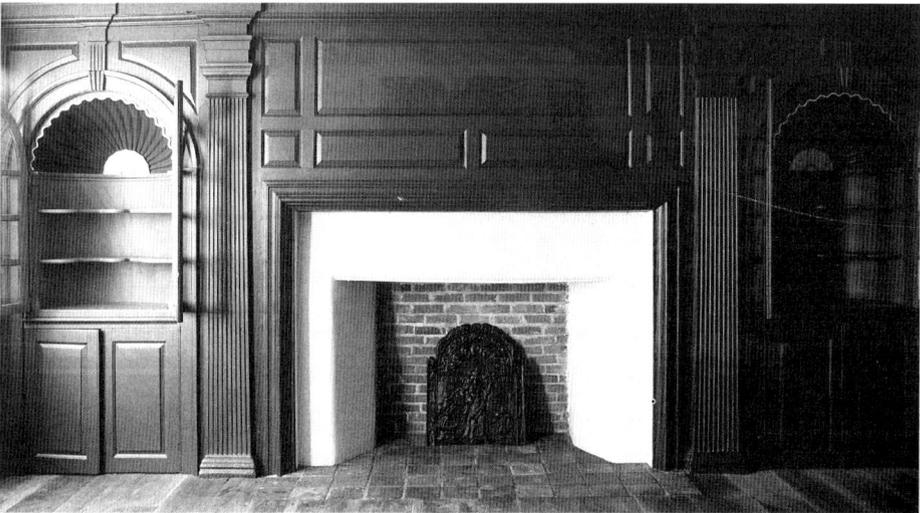

Covenhoven House interior, c. 1969. During the restoration process, the original carved shell cupboards were still in the house and were restored to their original location. The fireplace was brought back to its original appearance, and analysis of the underlying layers of paint revealed the first paint color, a dark green, which was duplicated. (MCHA Archives.)

Opposite, below, right: Covenhoven House, c. 1978. Restored in 1969, the Covenhoven House reflects the period of time just before and after the Revolutionary War. At the time it was built in 1752/1753, in the new Georgian style, William and Elizabeth's home was perhaps the grandest house in Monmouth County. Before the Battle of Monmouth in June of 1778, the house served as headquarters for the British general Henry Clinton, who despite promises to the contrary, plundered Elizabeth's possessions and killed her livestock. (MCHA Archives.)

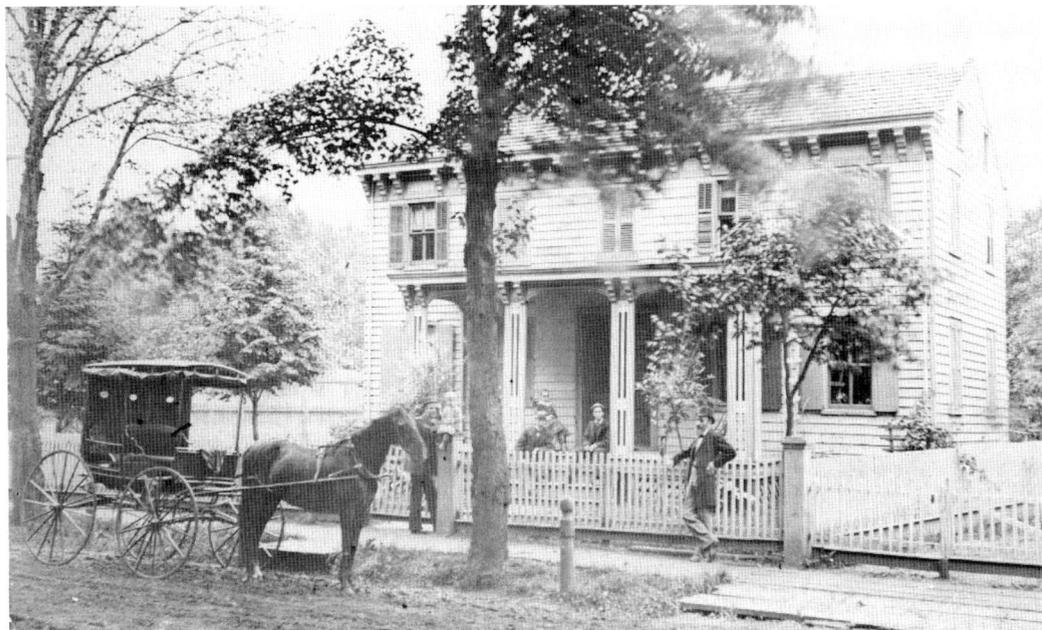

Charles Truex's house, c. 1880. Charles Truex stands at the gate of his home at 90 South Street with his family. Helen and Abraham and Alex McClees are on the porch; William is by the middle fence post and little Anna is perched on top. Charles was the proprietor of the harness shop shown on p. 19 and lived near his work in this Victorian house with Italianate detailing. (MCHA Archives.)

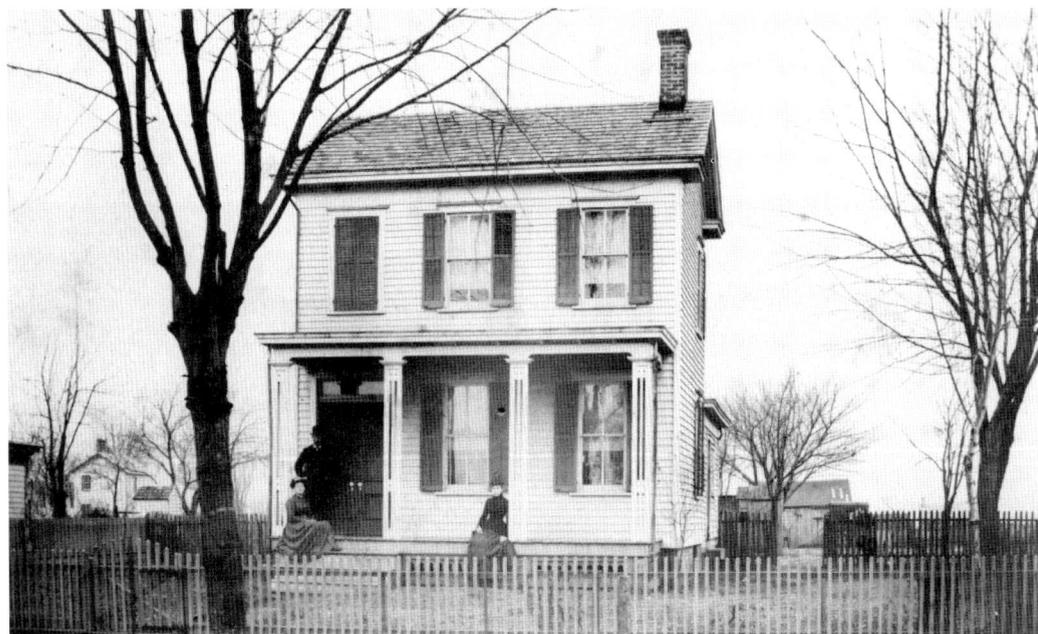

George H. Mount's house, c. 1880. Similar in style and design to the house above, George Mount's more modest home incorporated two thirds of the floor plan of Charles Truex's house, and fewer decorative details. (MCHA Archives.)

James S. Yard, *c.* 1860. Publisher of the *Monmouth Democrat* (see p. 18), James Yard was elected to the office of county freeholder in 1863, and shortly thereafter served as a major of the Third Regiment of the militia. After the war, he continued in his business with the newspaper, assumed responsibilities of public service in various positions, and also was licensed as a local preacher at the Methodist Episcopal Church in Freehold. Major Yard served as the president of the Monmouth Battle Monument Association, and with former Governor Joel Parker was responsible for organizing the effort for the monument. (MCHA Archives.)

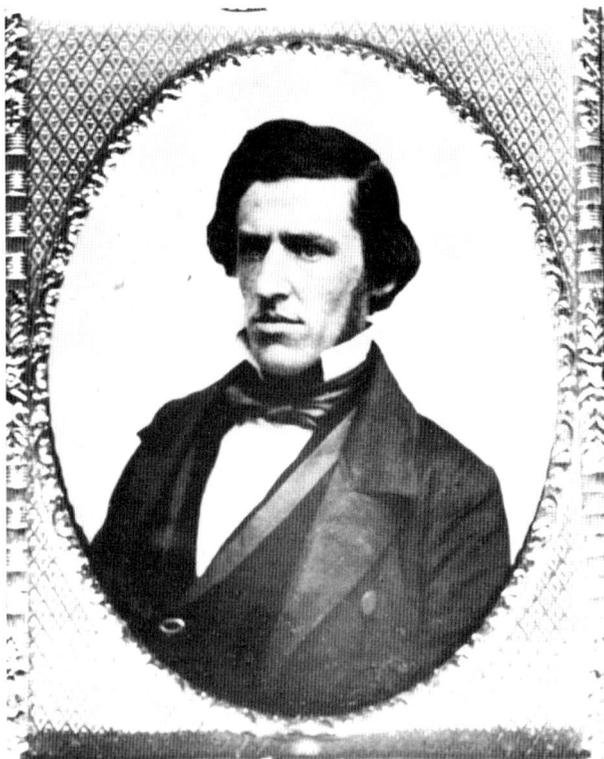

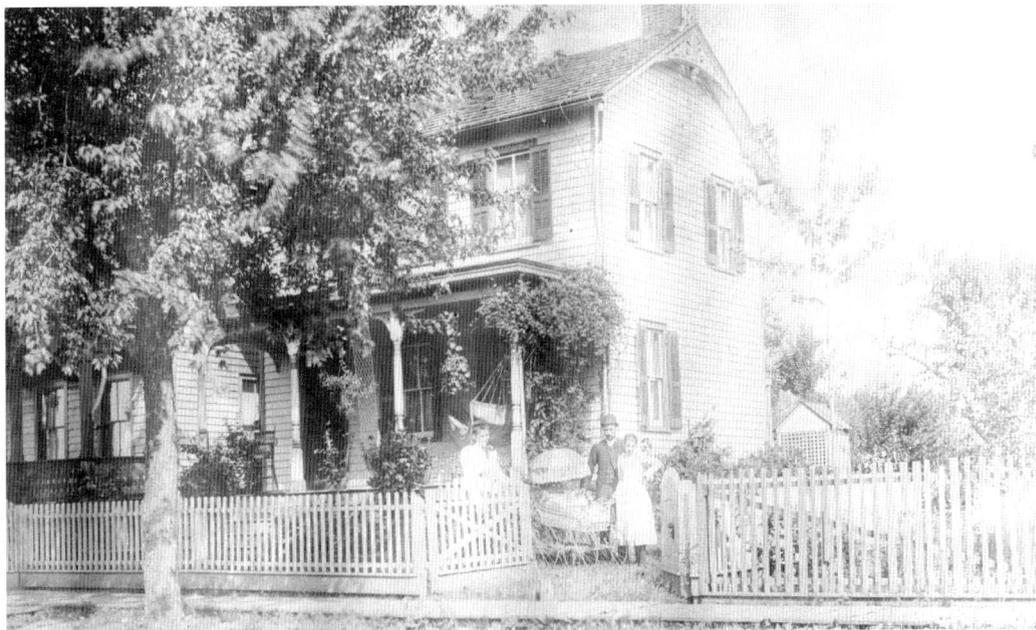

John J. Curley's house, *c.* 1890. The John Curley family resided on Bowne Avenue near the family's business (see p. 58). Little Viola, who was the first of three daughters, all of whom became teachers in the Freehold schools, can be seen in the wicker baby carriage. (MCHA Archives.)

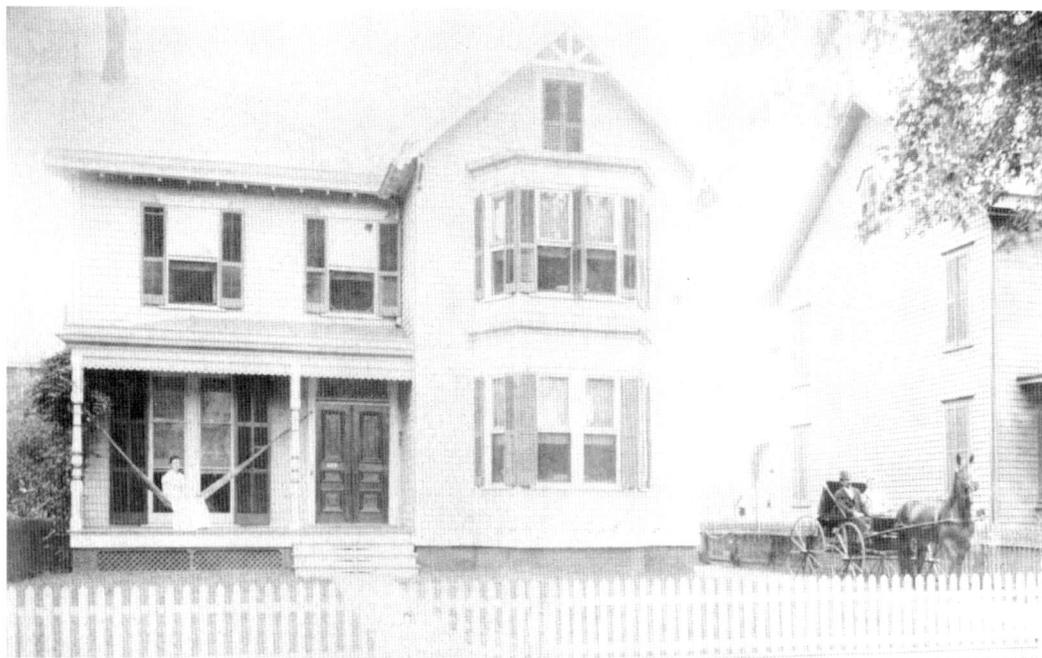

George W. Truex's House, c. 1880. A horse and carriage emerges from the rear of George Truex's house. It was common for a barn and carriage house to be located behind the houses on Freehold's main streets, many of which have deep lots to accommodate them. (MCHA Archives.)

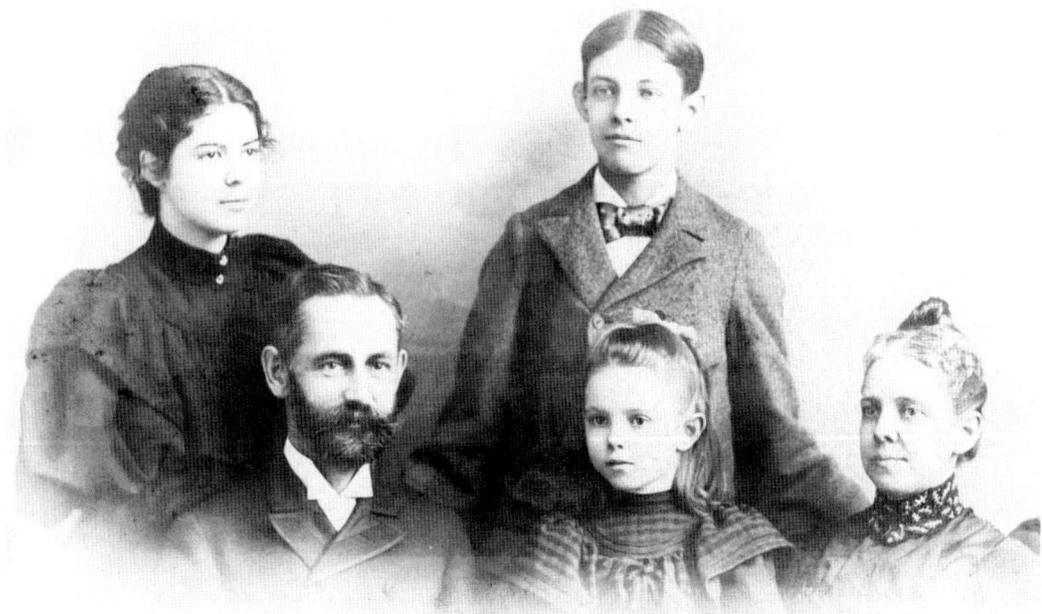

Reverend Isaac Brokaw and family, c. 1890. Reverend Brokaw served the Freehold Reformed congregation beginning in 1879 and was active in the church community, heading the Monmouth Bible Society in 1881. This image was photographed by Scott Studio of Freehold. (MCHA Archives.)

John Roth, *c.* 1862. Photographer John Roth occupied a storefront on East Main Street, where he also carried on a watchmaker's business. He was the earliest photographer working in Freehold, having immigrated to this country in 1848 and setting up shop as a watchmaker almost immediately. In an 1853 advertisement in the *Monmouth Democrat* he announced that he had opened a "Daguerrean Room." By 1858, he advertised in the *Monmouth Inquirer* that he had a good workman employed for watch repairing, so that he could pay proper attention to his ambrotyping. Presumably, this is a self-portrait. (MCHA Archives.)

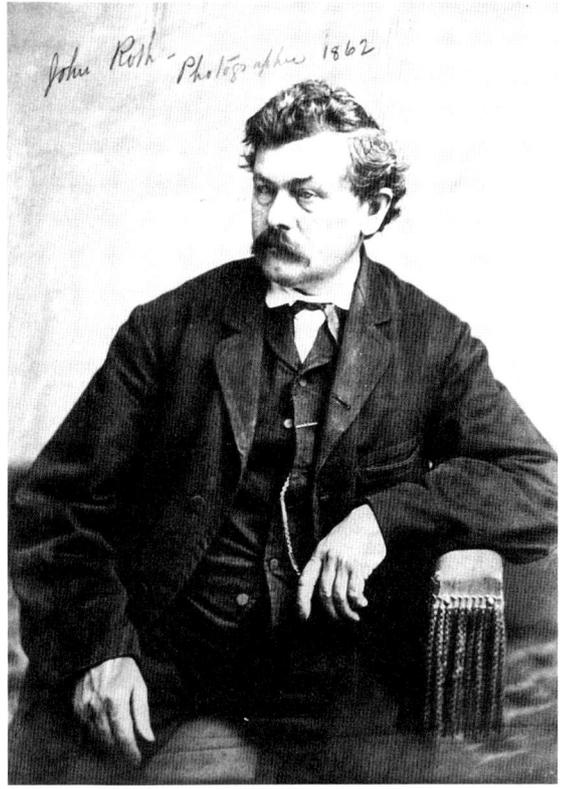

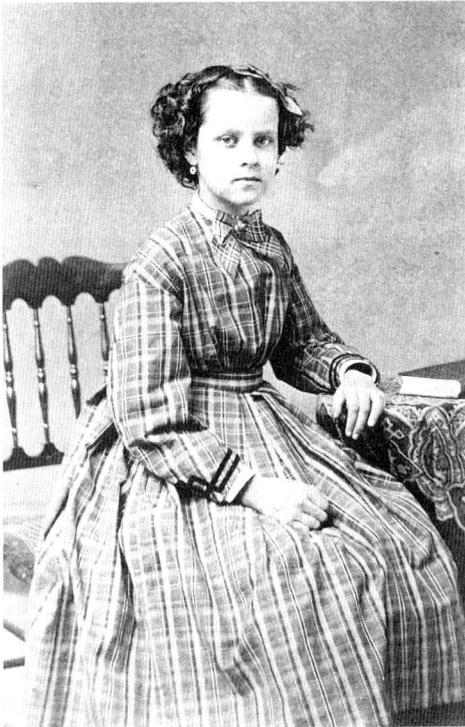

Maggie Truex, *c.* 1869. John Roth captured this image of Maggie and a nearly identical one of her older sister, Libbie, both of whom died on the same day in 1870 from scarlet fever. On that day, another daughter, Helen, was born to Charles and Matilda Truex, whose home appears on p. 64. The photographer was John Roth. (Courtesy of Margaret Buck Bergen.)

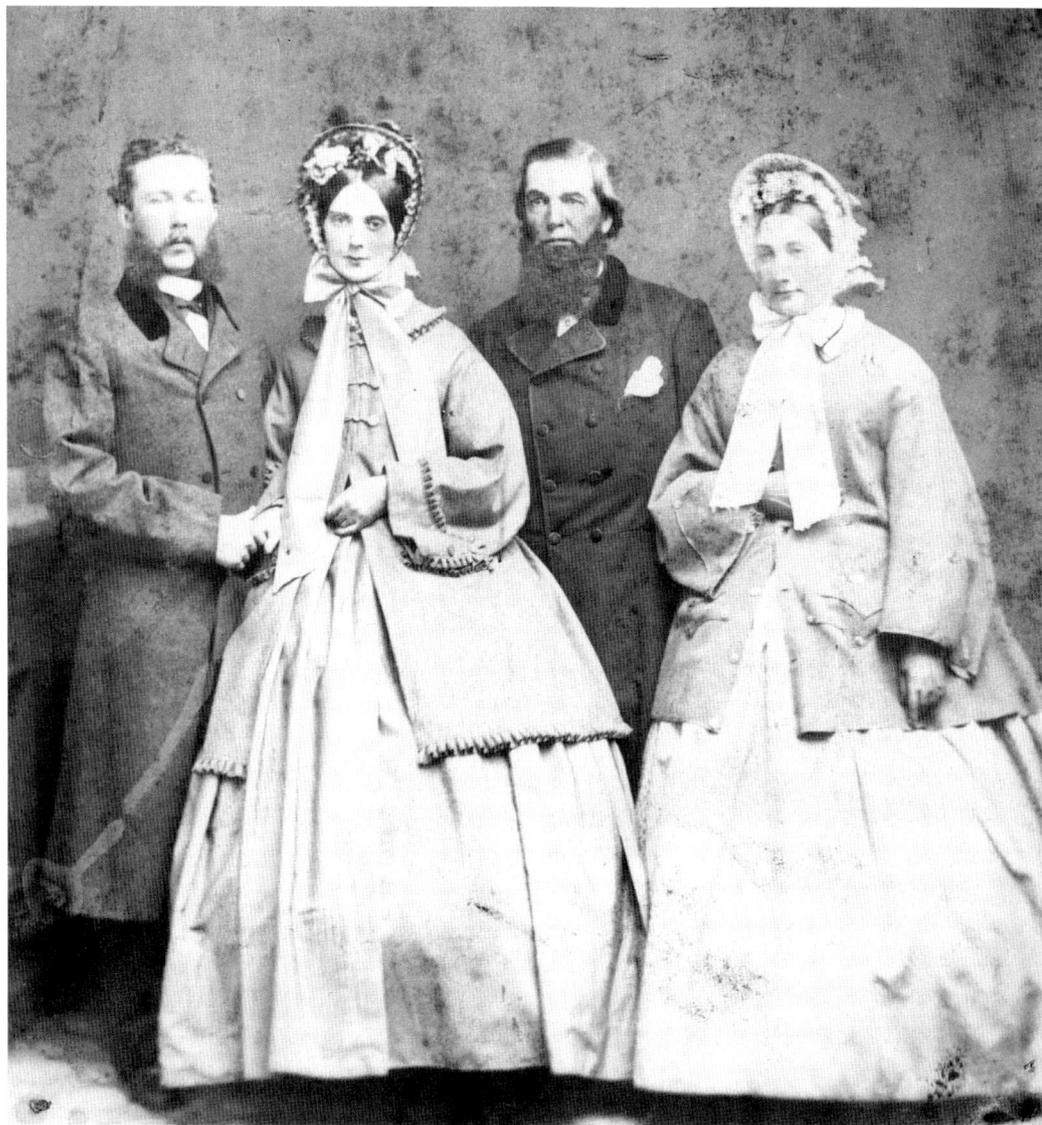

Wedding portrait of Mr. and Mrs. James T. Burtis, 1862. Witnesses Mary Bunting and Henry Bennett join the happy couple, who are posing to the left in this photograph taken on the day of their marriage, May 14, 1862. (MCHA Archives.)

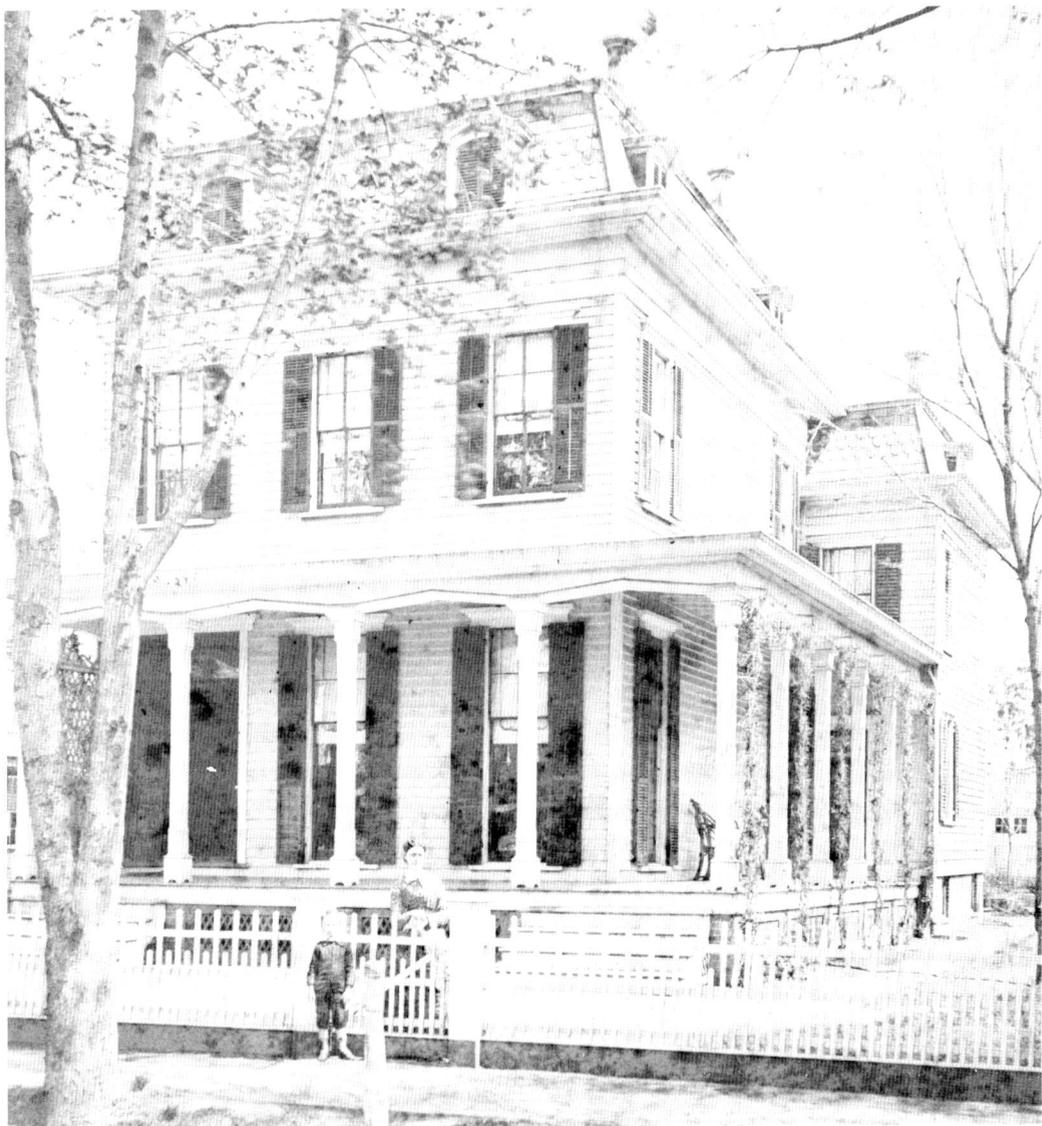

James T. Burtis's house, *c.* 1875. Mrs. Burtis and her son Ryall stand in front of their home on East Main Street at Center Street, a site now occupied by a New Jersey Bell office building. The photographer was G.A. Powelson of Matawan. (MCHA Archives.)

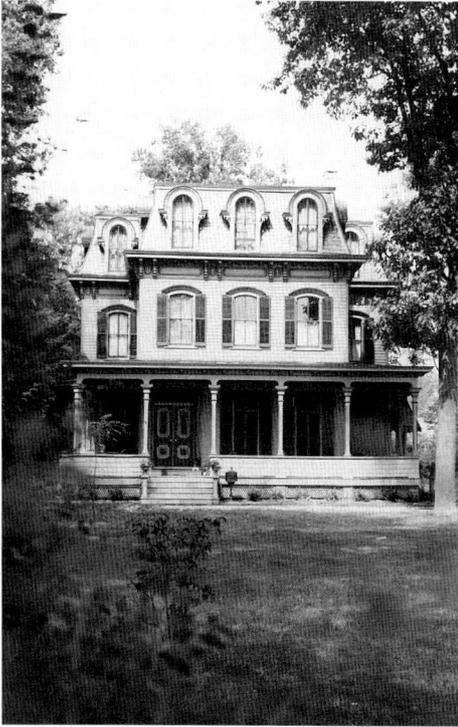

Left: George Taylor house, built *c.* 1870. This large French Second Empire style house with its mansard roof and lavish detailing is located at the intersection of Broadway and Dutch Lane Road and is one of Freehold's finest examples of Victorian domestic architecture.

Below: Players in the Mother Goose Kirmess, April 14 and 15, 1899. A "kirmess" is defined as a festival for charitable purposes, and this event sponsored by the "King's Daughters" was presented at the opera house and featured Mother Goose and Her Children. The *Freehold Transcript* reported that "the costumes were fearfully and wonderfully made." Dressed up as Mother Goose characters are: Miss Ellen S. Conover as "Betty Pringle," Mrs. Fred Bennett as "the Little Girl with the Curl," Frederick D. Bennett as "Simple Simon," Miss Caffrey as "Old Mother Hubbard," and Emily Burtis. (MCHA Archives.)

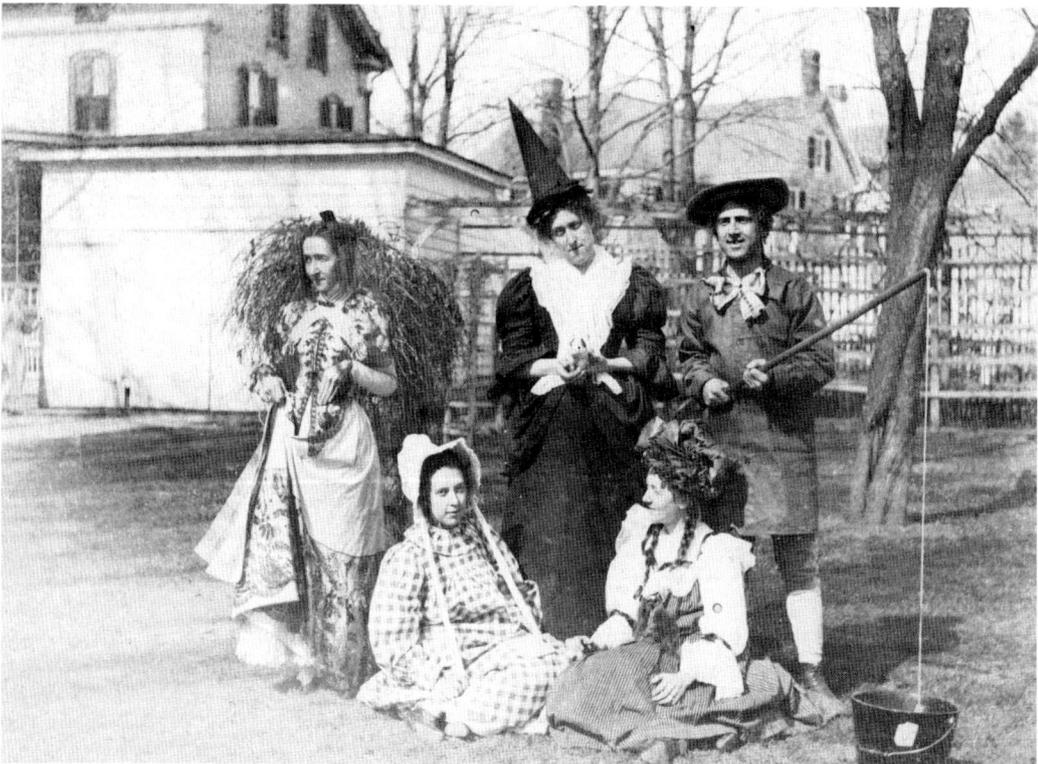

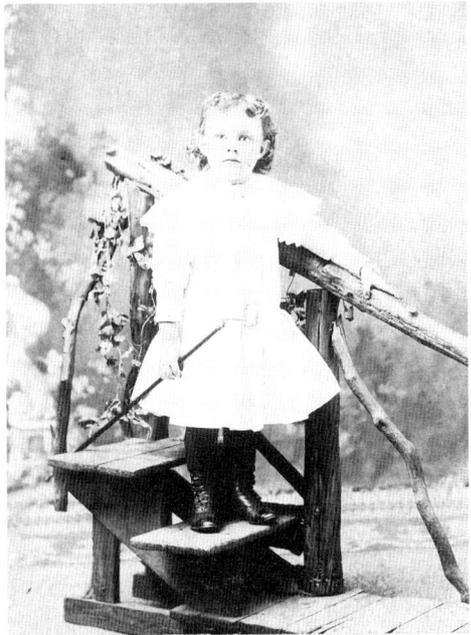

Right: Ira Corlies Tilton, 1901. Three-year-old Ira was dressed up for his portrait to be taken at Arthur Hall's Studio on West Main Street, which clearly had no shortage of props and backdrops. This image was photographed by Hall Studio of Freehold. (MCHA Archives.)

Below: Group of friends, July 15, 1891. Pictured are: Genevieve Schanck, Holmes A. Wheeler, Lyndon Morris, Josie Walters, May Ely, F. Conover, John Laird, L. Anderson, Sarah Parker, Lillie Woodhull, Nellie Conover, and Lizzie Forman. (MCHA Archives.)

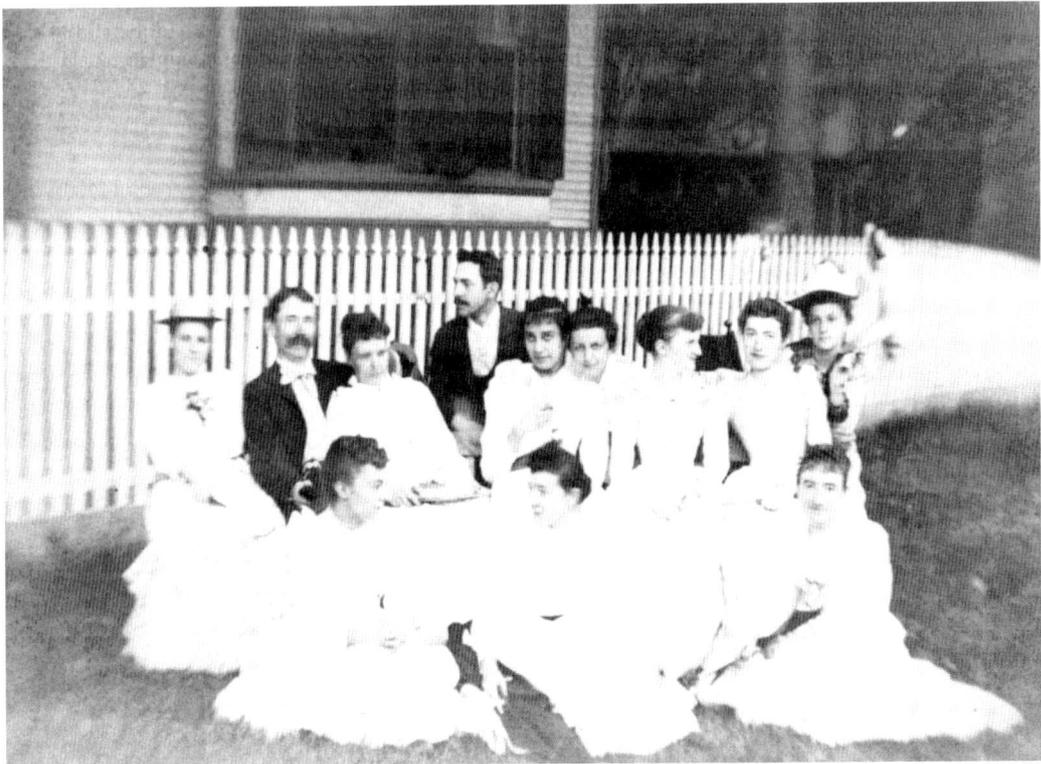

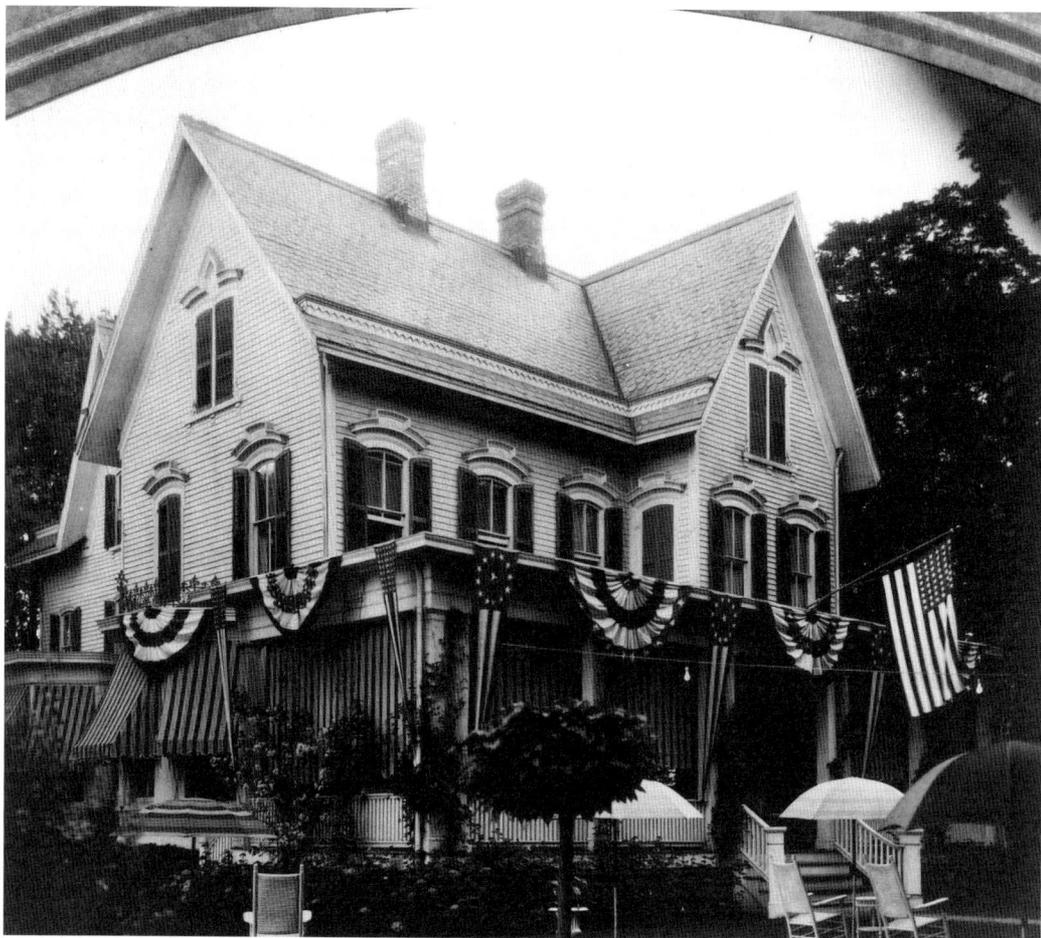

Edmund Parker house in the 1920s. Edmund Parker's home at 22 Brinkerhoff Avenue was festooned in red, white, and blue for a summer holiday, probably the Fourth of July. Porches are shaded by striped awnings, and wicker furniture was brought onto the lawn for a sociable afternoon. This image was photographed by Ladd Studio of Freehold. (MCHA Archives.)

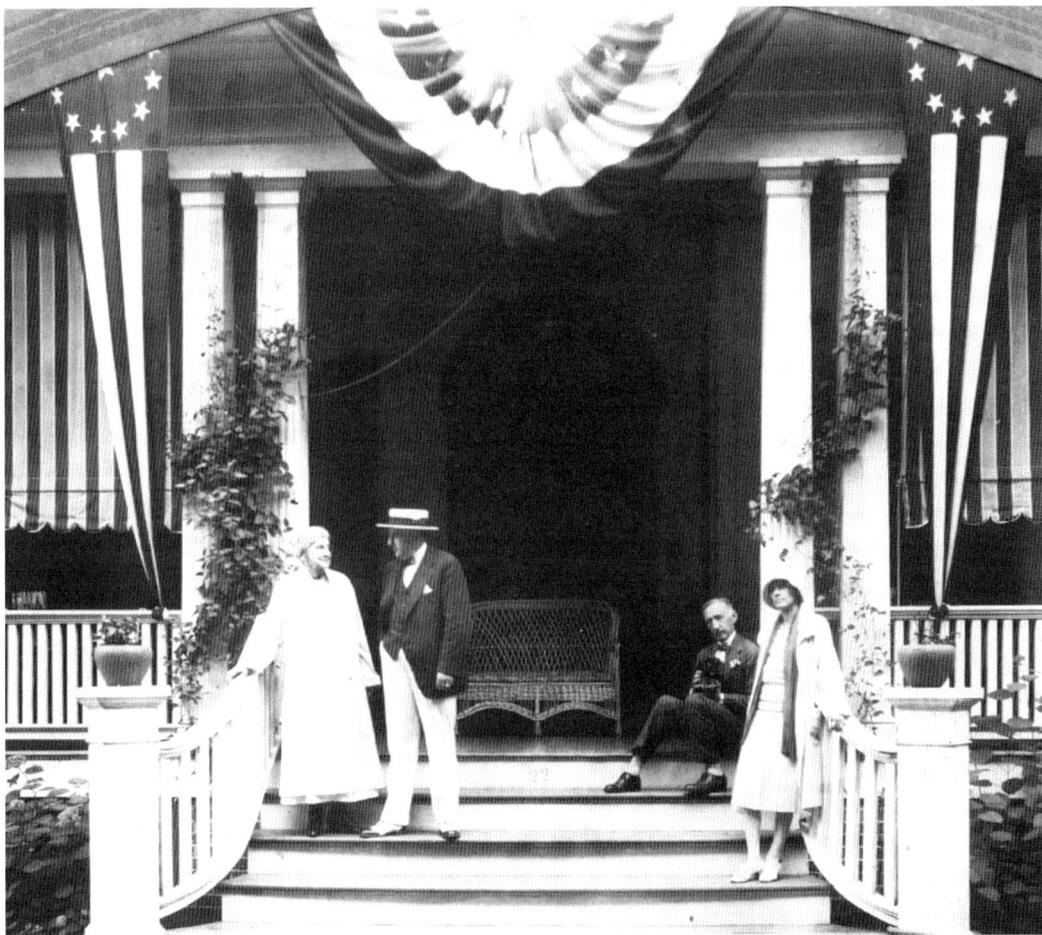

Above: Edmund Parker house porch in the 1920s. Among those posing on the steps are Edmund Parker, Dr. Ely Parker, and Miss Lydia Parker. This photograph was taken by Ladd Studio of Freehold. (MCHA Archives.)

Right: Governor Joel Parker, *c.* 1865. Freehold native Joel Parker was elected to the governor's office twice and served one term from 1863 to 1866, and another from 1872 to 1875. He returned to Freehold where he practiced law and in 1880 was appointed justice to the New Jersey Supreme Court. This photograph was by Moses of Trenton. (MCHA Archives.)

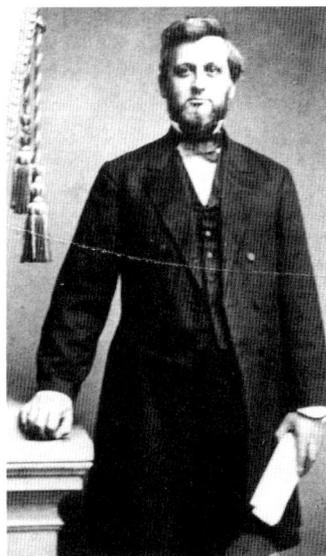

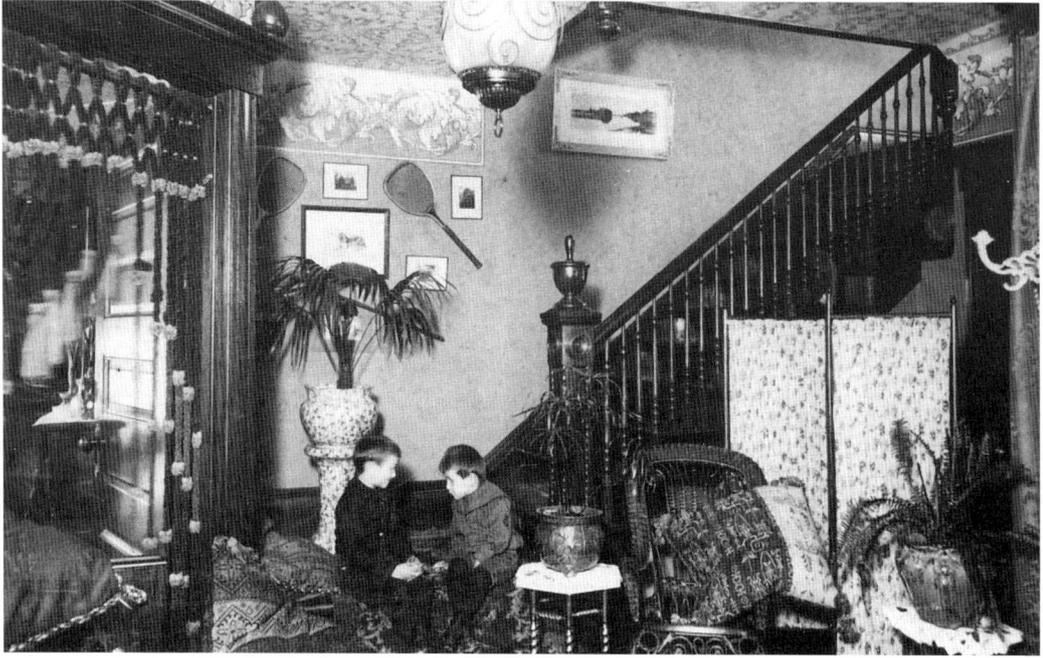

Barkalow house interior, *c.* 1900. These two rare views of interiors decorated in the style of the turn of the century are rich in detail and reveal a lush setting full of complex patterns and heavily trimmed textiles. (Courtesy of Cheryl Wolf and Wayne Mason.)

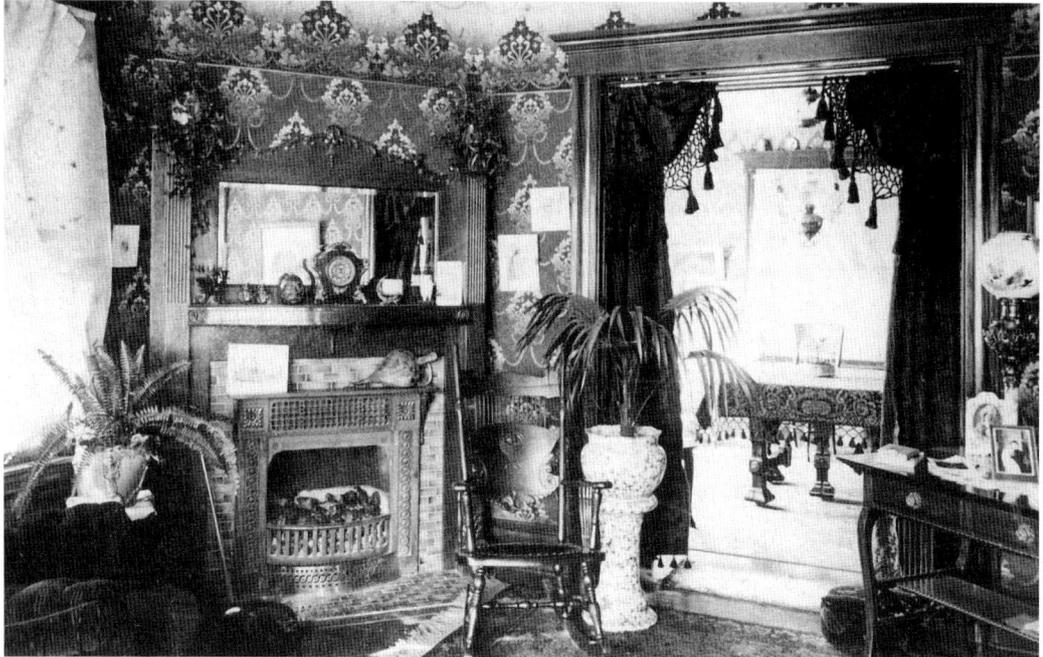

Barkalow house interior, *c.* 1900. (Courtesy of Cheryl Wolf and Wayne Mason.)

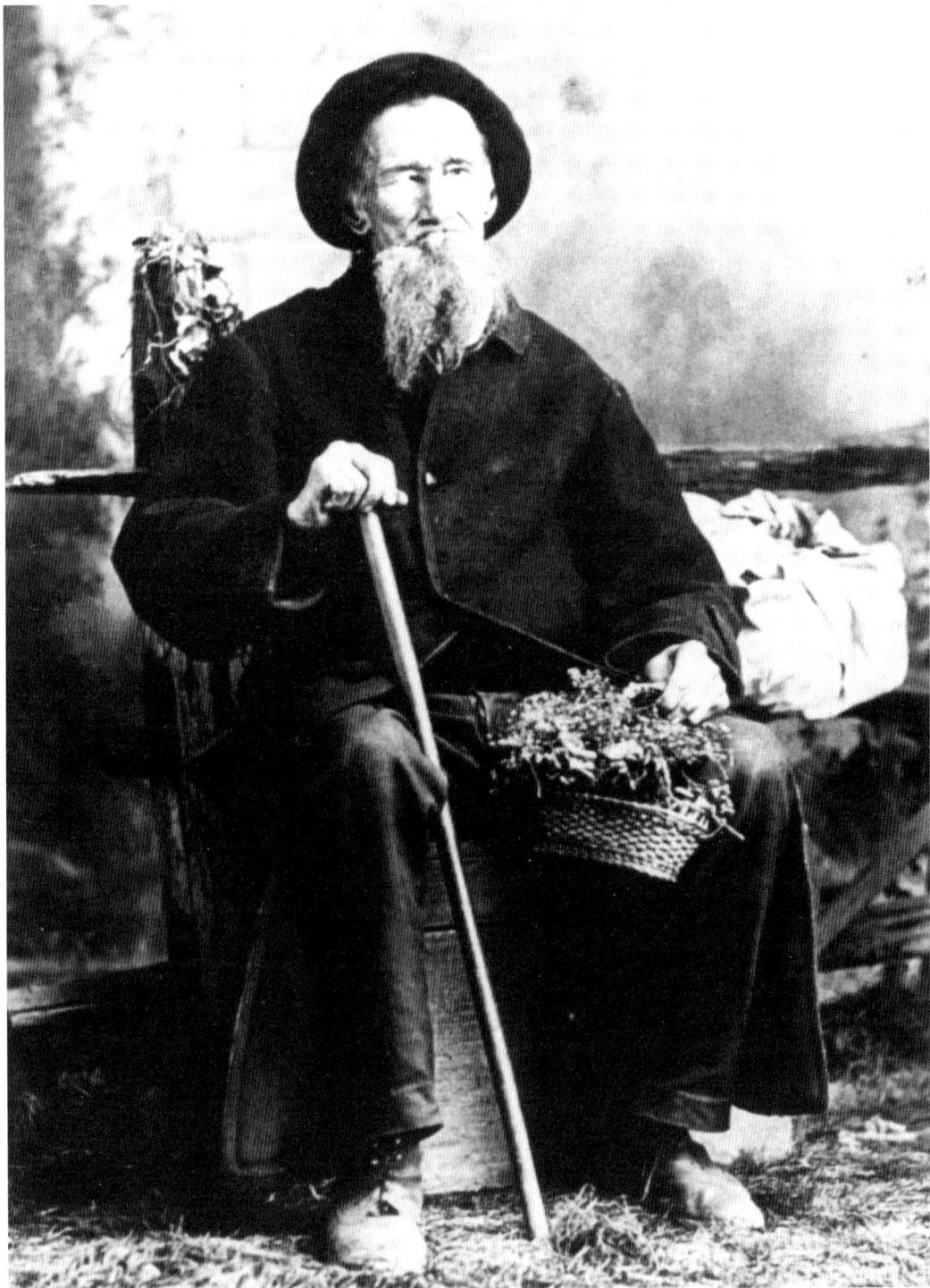

Fritz Heinish, *c.* 1902. A Freehold "character," Fritz was a German immigrant who made and sold mouse and rat traps and lived on Court Street. (Courtesy of Freehold Public Library.)

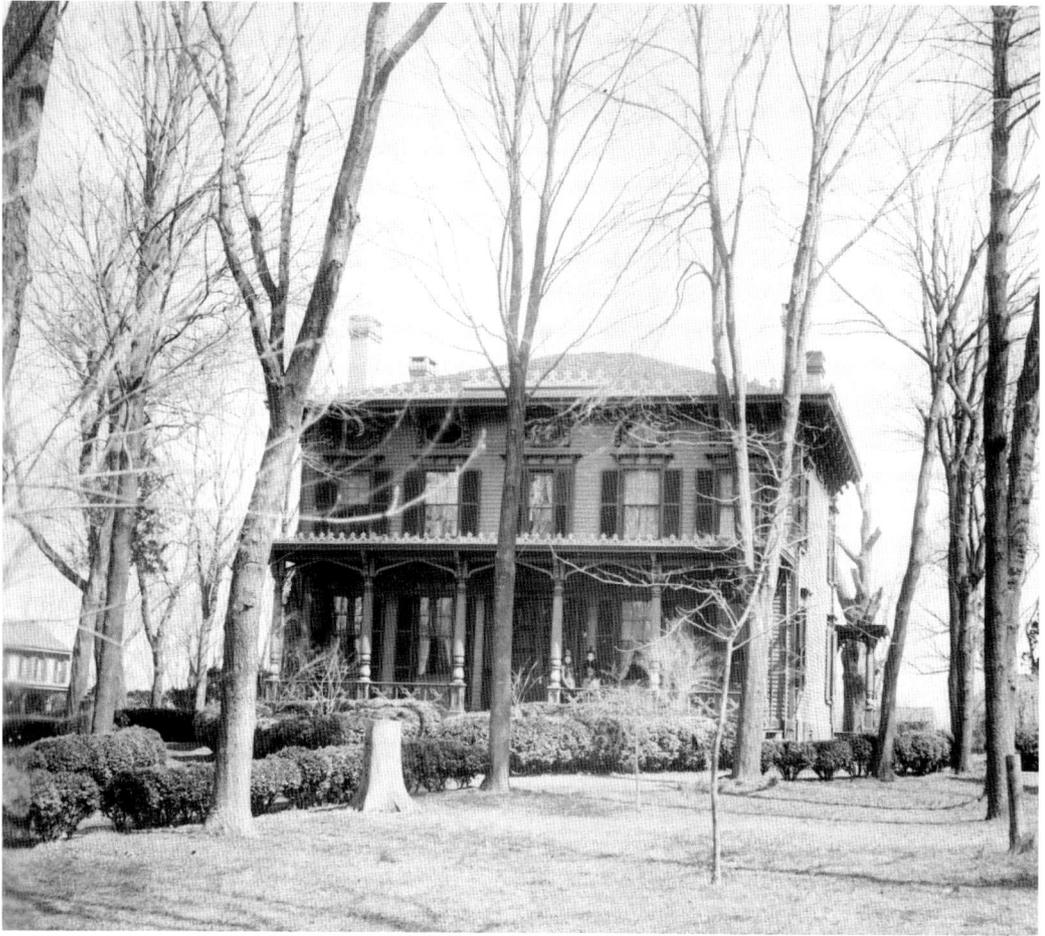

Dr. Arthur Conover's House, *c.* 1876. Built by Major Enoch Lloyd Cowart *c.* 1854, this structure was altered to be the current Elks' clubhouse. Samuel Craig Cowart, who later owned the Craig House (p. 116), was born here. (MCHA Archives.)

six

A Freehold Family

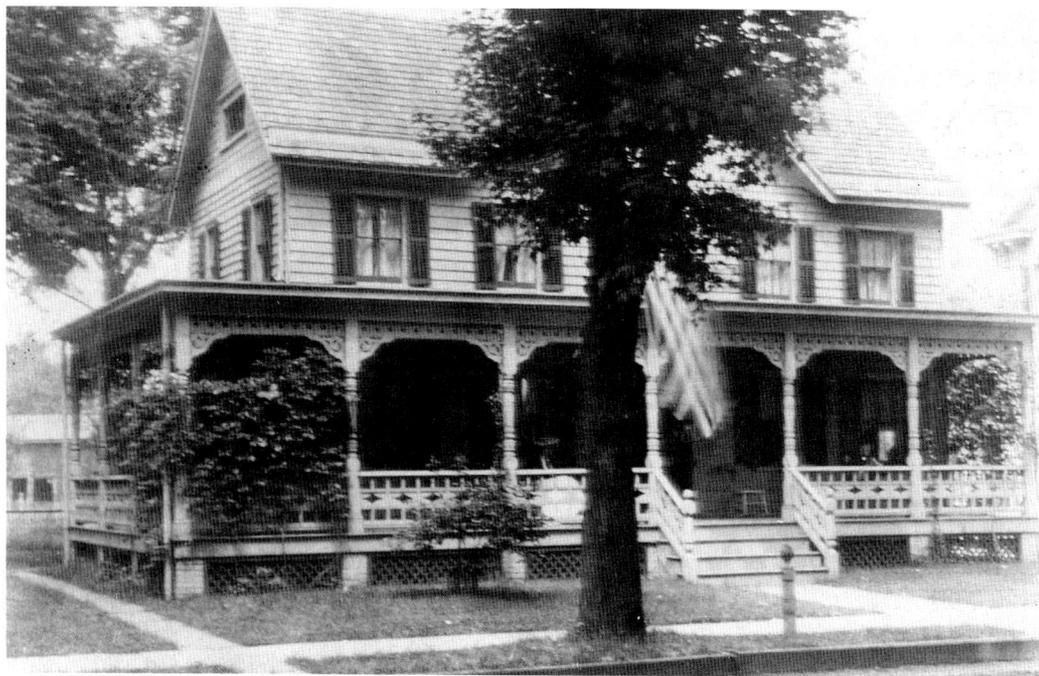

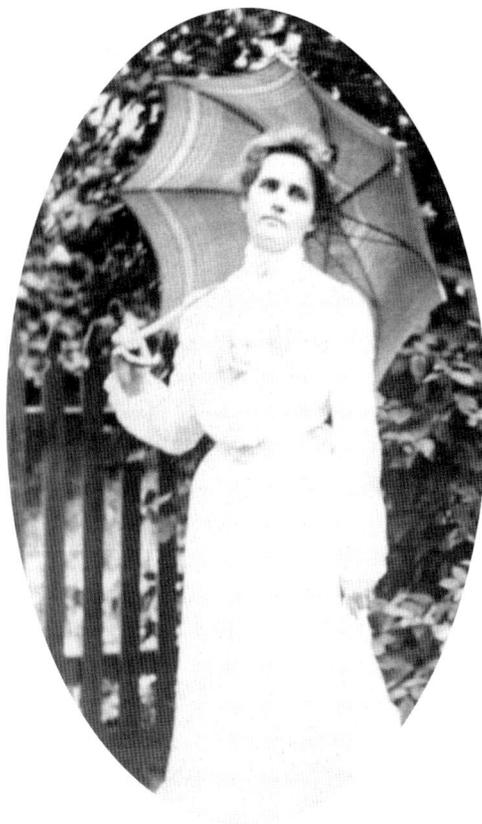

Above: Charles Truex's house, *c.* 1895. Recently updated and enlarged when this photograph was taken, the Truex house at 90 South Street is shown before alteration on p. 64. Note the removal of Italianate detailing in favor of a plainer style dominated by a wraparound porch. (MCHA Archives.)

Left: Helen Simpson Truex, *c.* 1900. The photographs in this section, with two probable exceptions, were taken by the talented amateur photographer Helen Truex, the oldest of four daughters of Charles Truex, whose self-portrait is shown here. Her work focused on her family and surroundings and offers a compelling and intimate portrait of family life at the turn of the century. (MCHA Archives.)

Right: Truex backyard, *c.* 1895. The four Truex sisters are posing at the back of 90 South Street on a two-board walkway through the garden. Helen, the photographer, worked with a timer on her camera so that she could be in many of the photographs with her sisters and their friends. (MCHA Archives.)

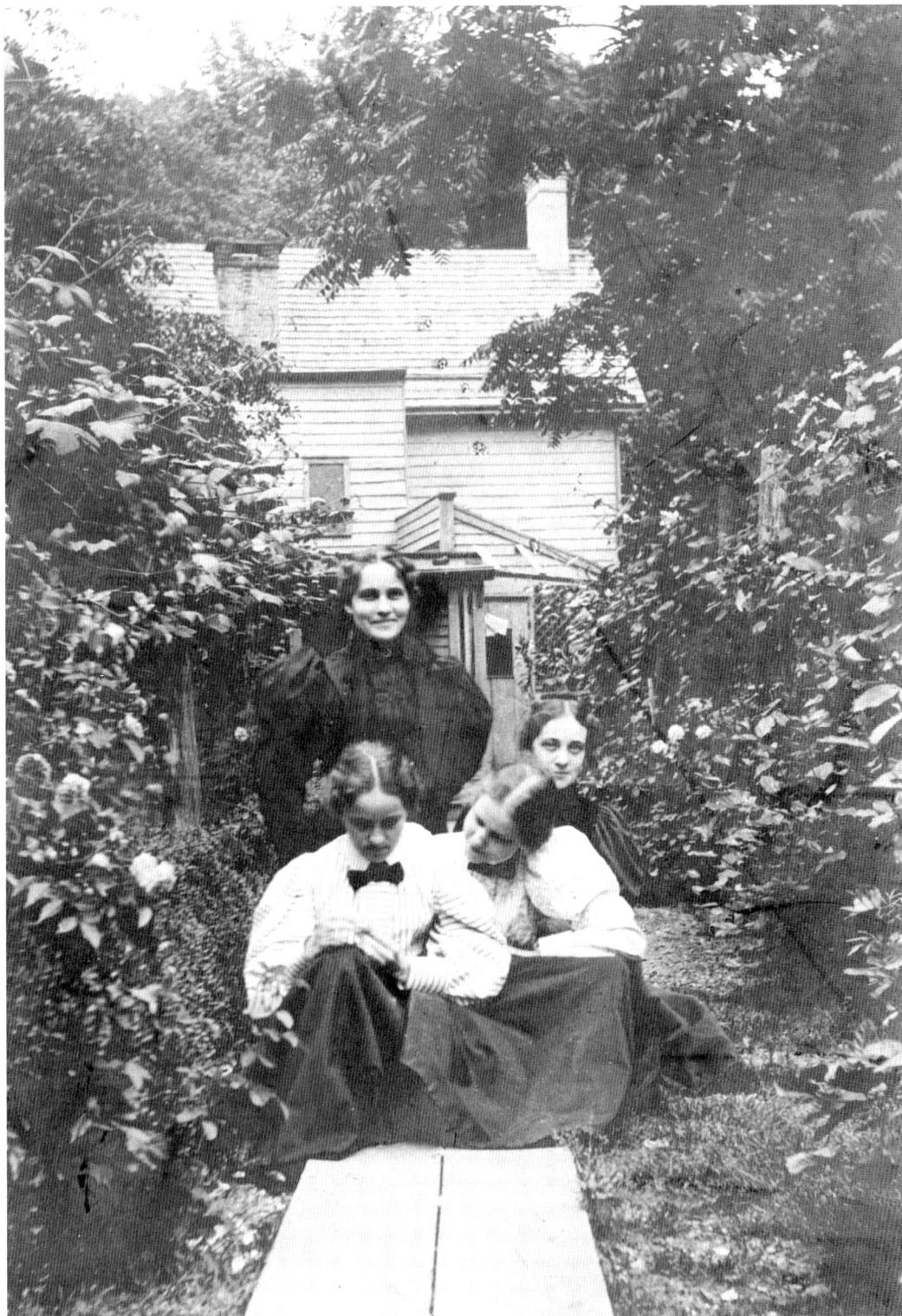

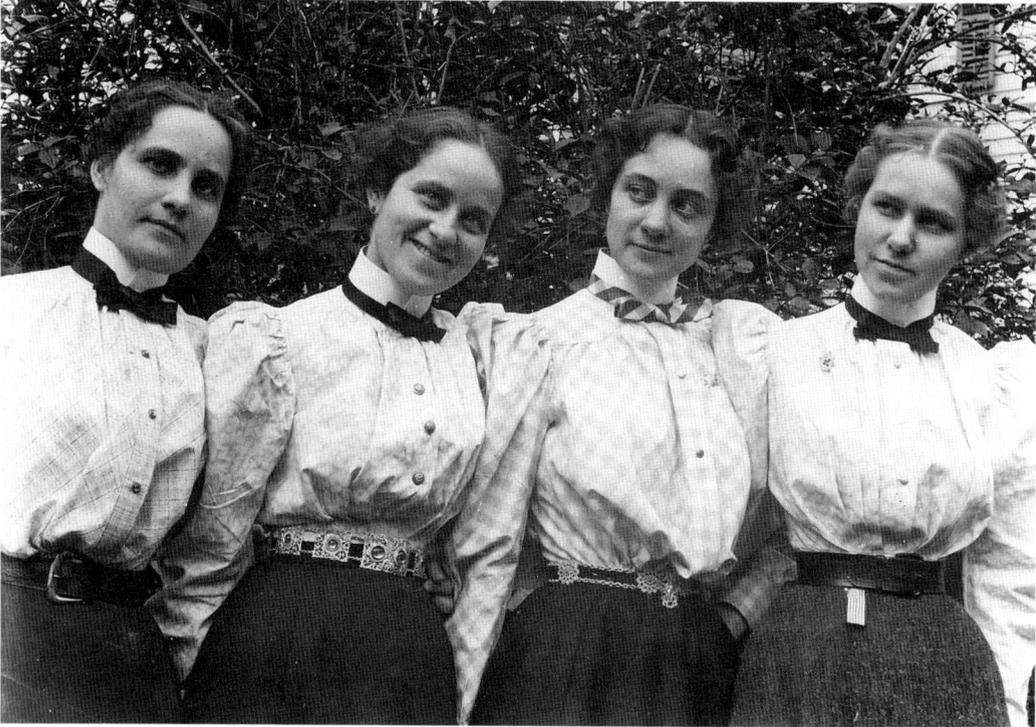

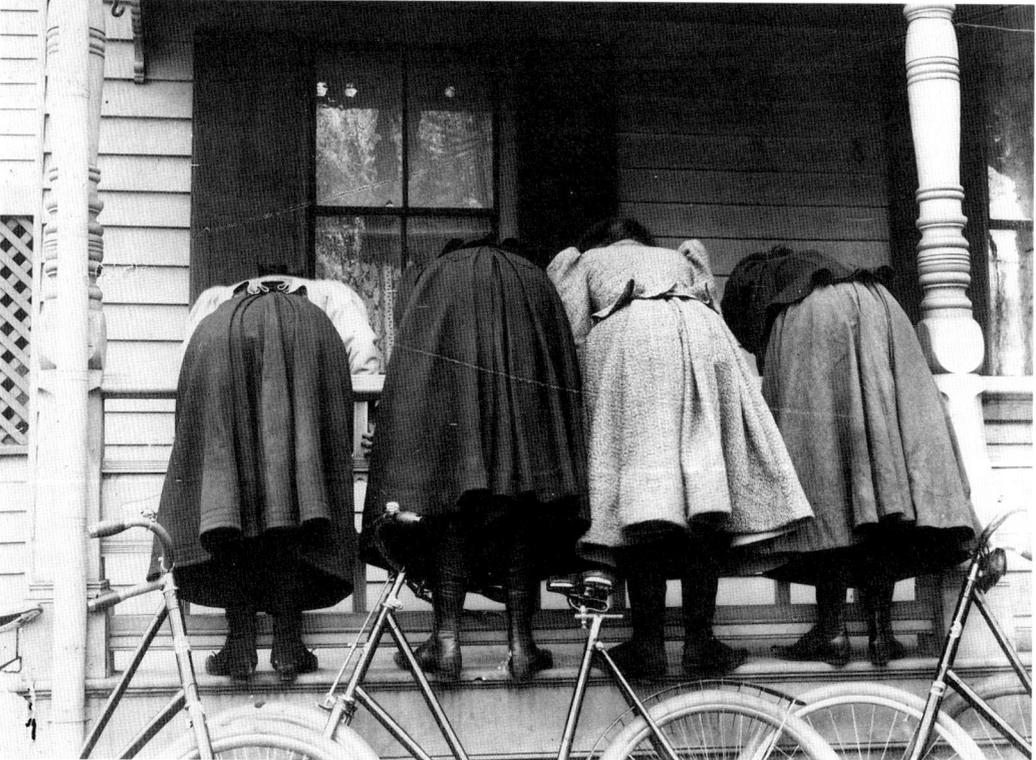

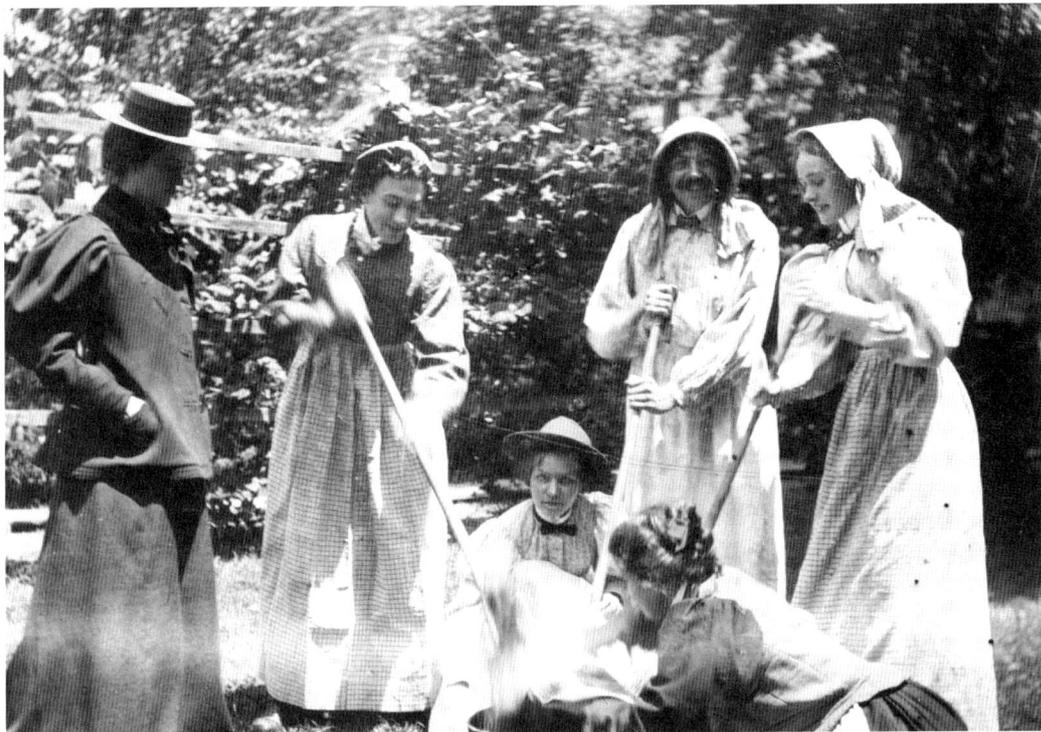

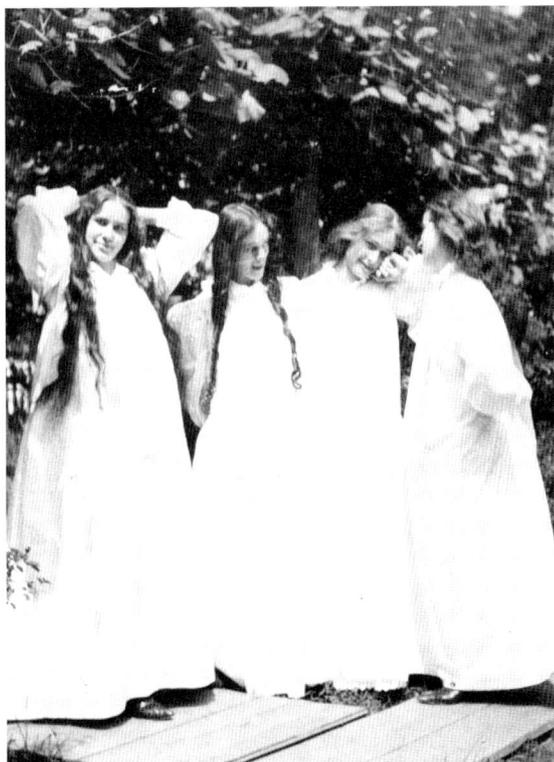

Opposite, above: Truex sisters, *c.* 1895. Shown from left to right are: Helen Simpson Truex, Gertrude H. Truex, Katherine Ward Truex, and Anna Gersenheimer Truex, all dressed in stylish 1890s fashion. (MCHA Archives.)

Opposite, below: Truex sisters, *c.* 1895. The girls enjoyed a risque sense of humor for their time and played it up for the camera. (MCHA Archives.)

Above: June 23, 1897. The girls and two male friends have dressed up as washerwomen for this tableau. (MCHA Archives.)

Right: June 21, 1987. This rare depiction, in early morning light, shows the young ladies in their nightclothes. (MCHA Archives.)

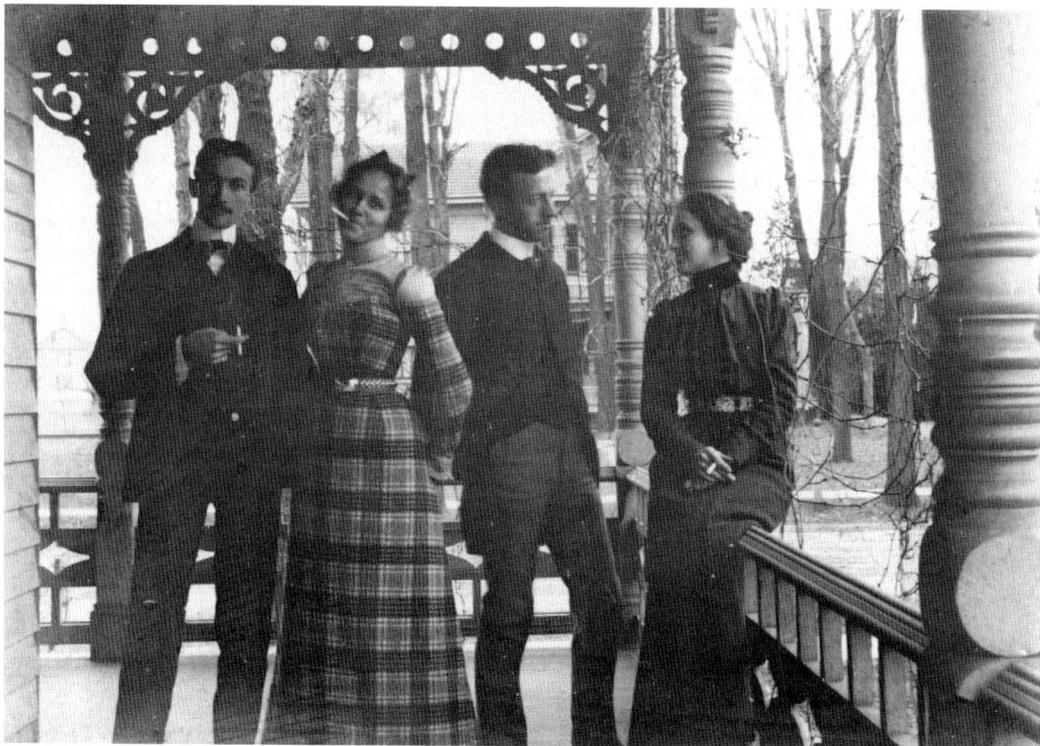

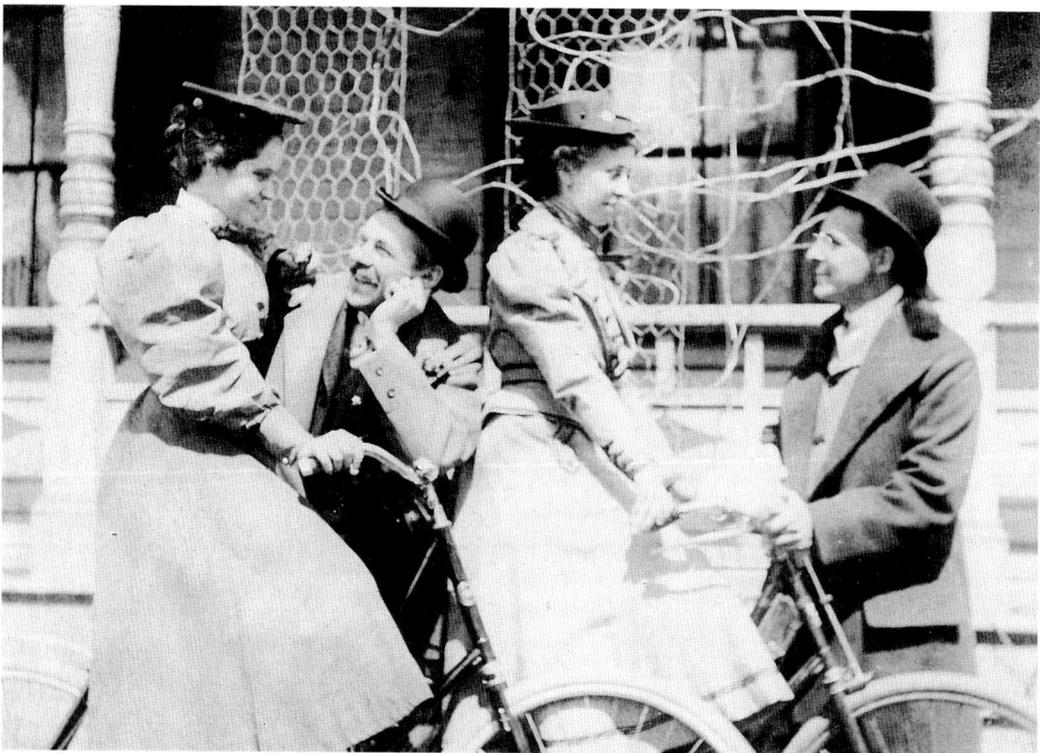

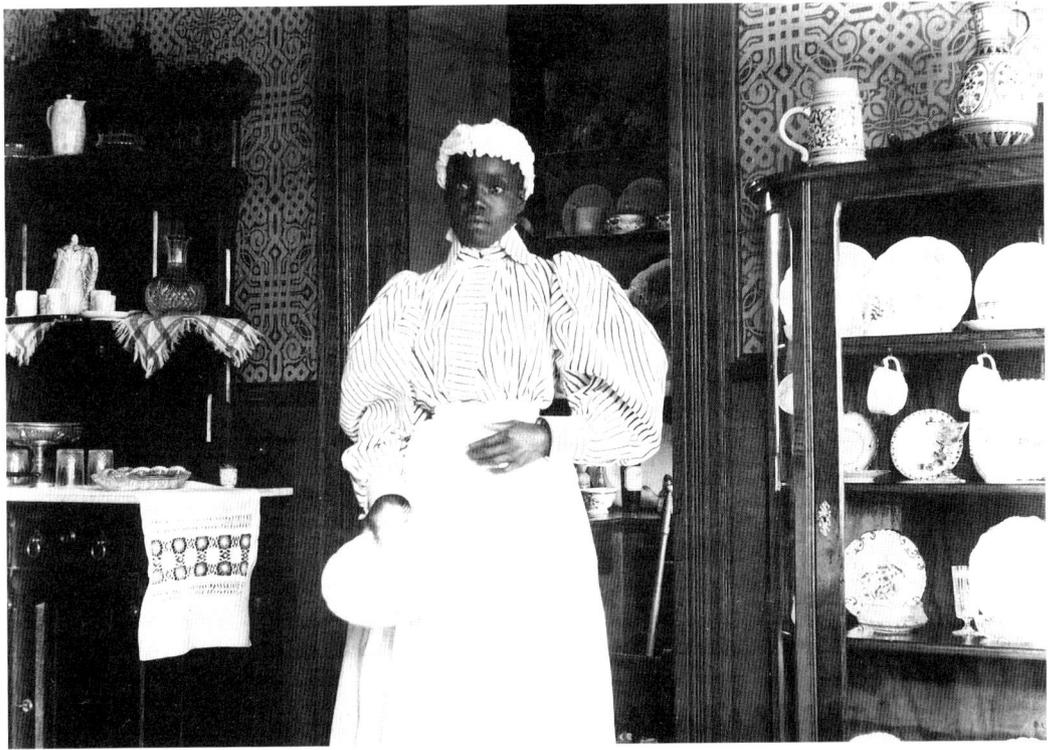

Opposite, above: Smoking on the porch, *c.* 1897. Depicted from left to right are: Will Sharp, Helen Buck, William Buck, and Gertrude Truex pretending (let's give them the benefit of the doubt) to smoke cigarettes on the porch at 90 South Street. William Buck and Gertrude Truex married in 1901. (MCHA Archives.)

Opposite, below: April 9, 1898. Gertrude Truex and friend Will Robinson are on the left, and Anna is with a friend on the right. Gertrude was the first girl in Freehold to own a bicycle and had earned the money to buy it by working at Reusille's (now Ballew's) Jewelers. (Courtesy of Margaret Buck Bergen.)

Above: Domestic worker, *c.* 1895. An unidentified domestic worker is pictured in a dining room, presumably that of the Truex family. (MCHA Archives.)

Right: June 22, 1897. Gertrude on the left, and Kate dressed as a man on the right, pose as a charming couple. (MCHA Archives.)

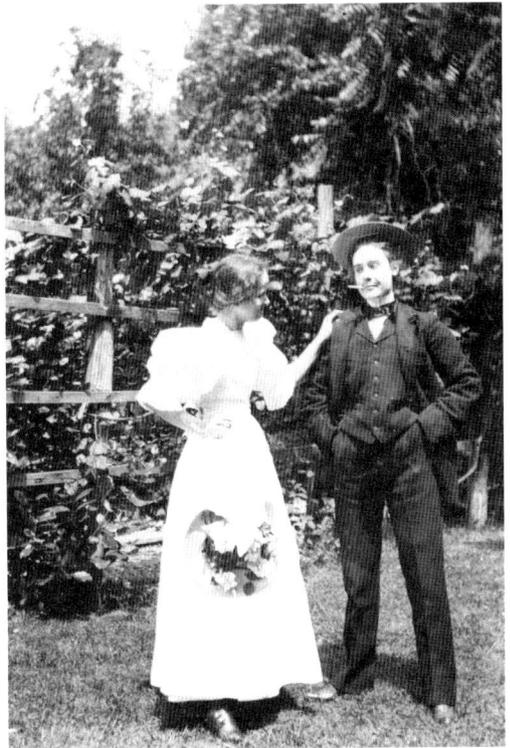

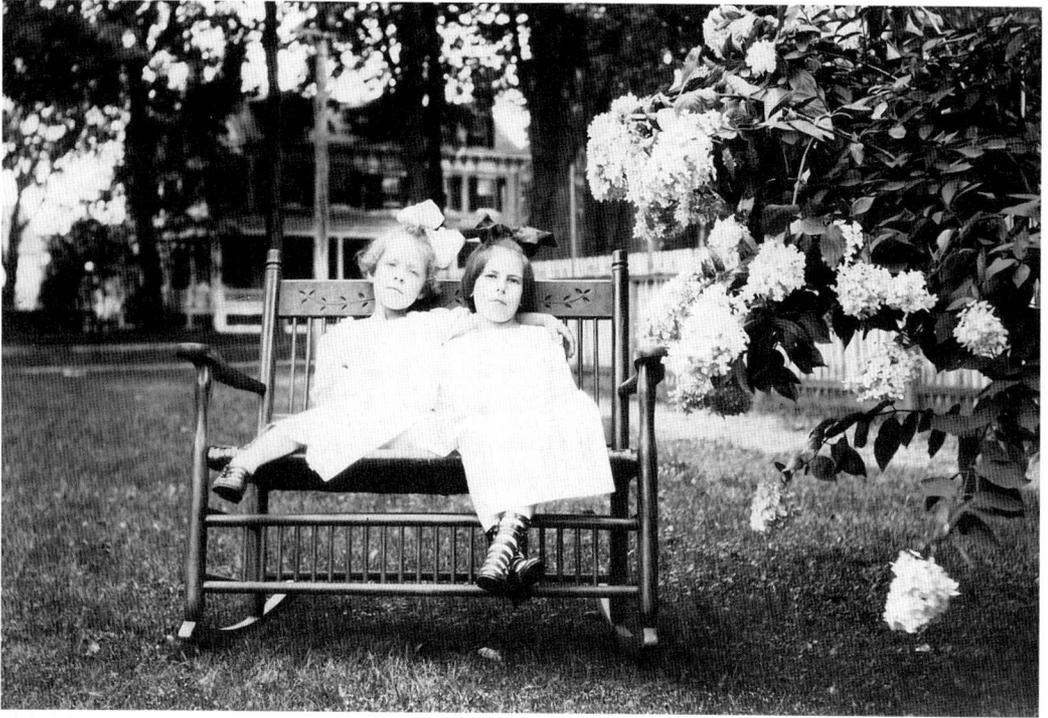

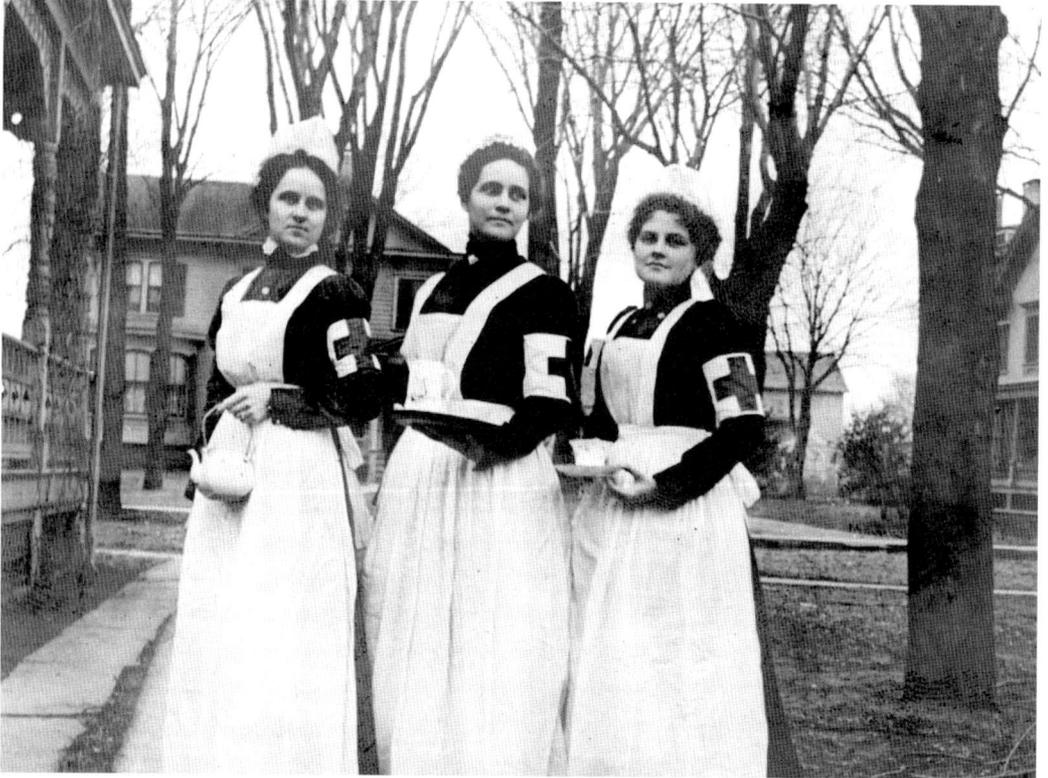

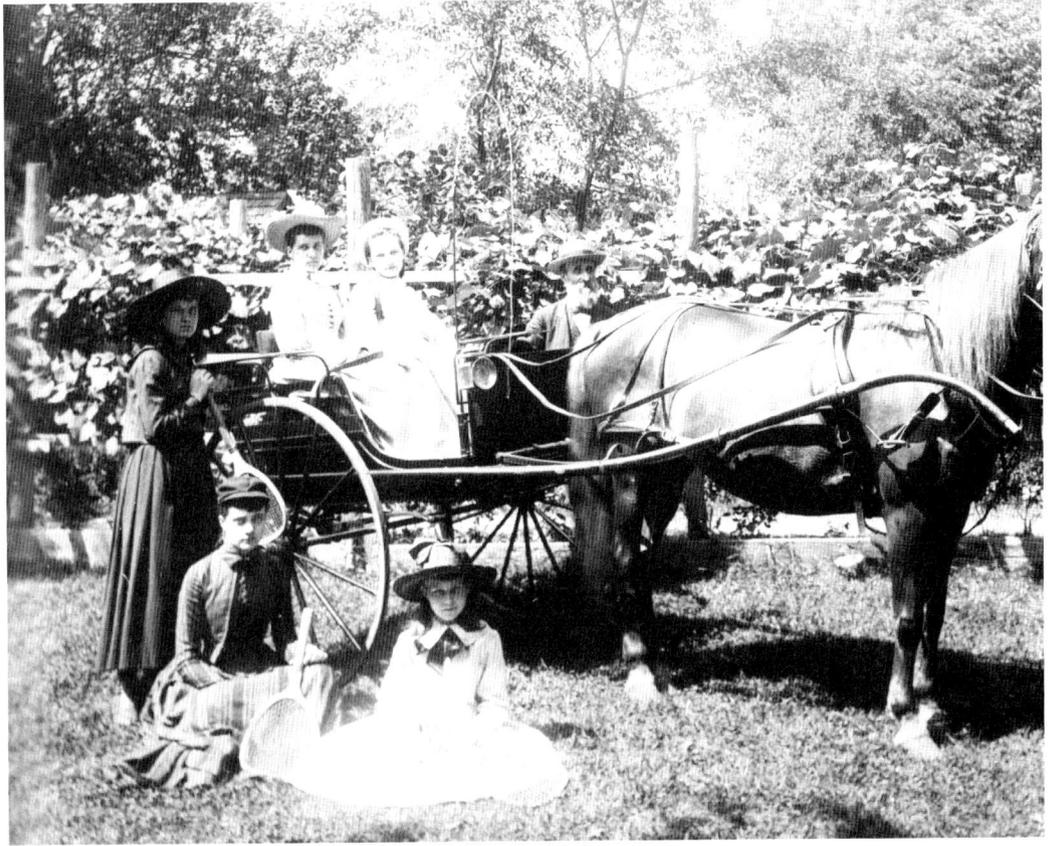

Opposite, above: Summer 1912. Margaret Buck (Gertrude Truex and William Buck's daughter) and her friend Anna Van Horn were photographed in the backyard of 90 South Street in a beautifully composed and touching study. (MCHA Archives.)

Opposite, below: Red Cross girls, *c.* 1917. Gertrude, Helen, and Anna in their Red Cross uniforms show a more serious side in their support of the World War I effort. (MCHA Archives.)

Above: Truex family and friends, *c.* 1890. Posing in their backyard with a pony and carriage are: Charles Truex (near the center of the photograph), Helen and friend Jamie Downs (in the carriage), and Gertrude, Katherine, and Anna (with tennis racquets). (MCHA Archives.)

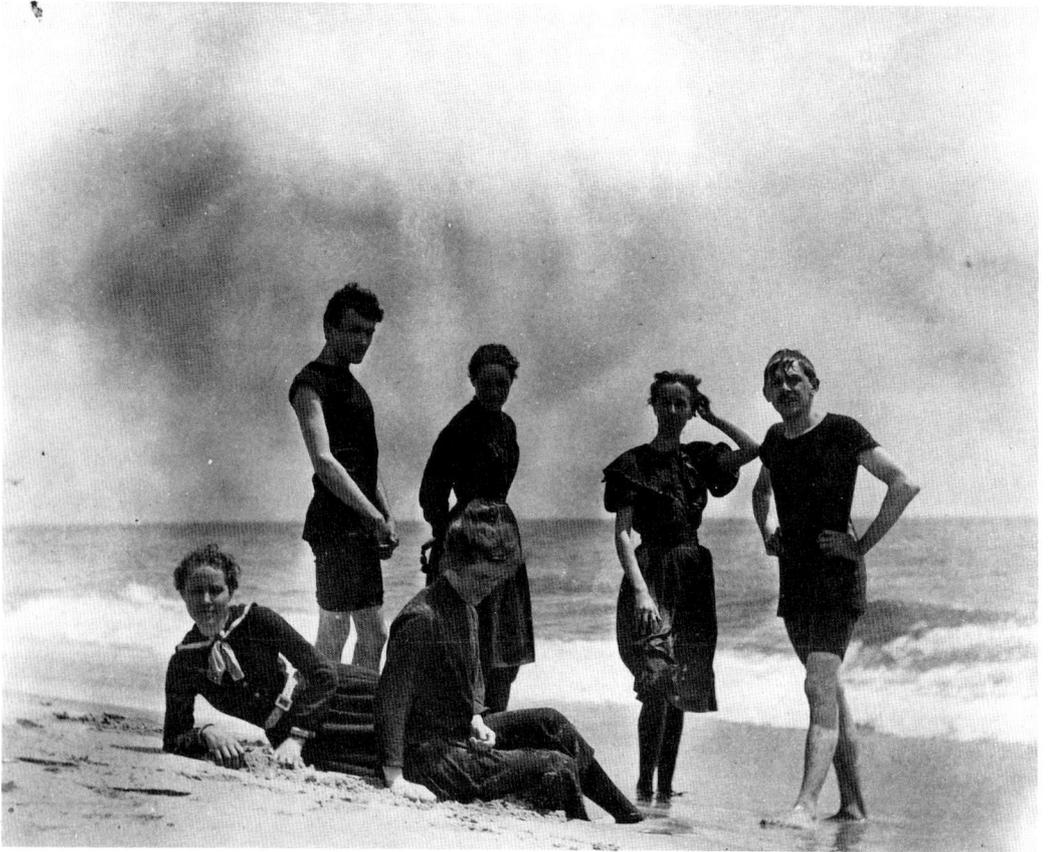

Above: At the beach, 1898. The Truex girls and friends relax at the beach in bathing costumes. In 1880, William C. Vlyat, an English writer, advised, "Bathing suits should consist of twilled flannel, strong and colored brown or grey. It should be loose . . . of light goods . . . be buttoned not tied, and have no unnecessary appendage." (MCHA Archives.)

Opposite, above: On the Manasquan River, *c.* 1910. David and Margaret Buck, with their mother, Gertrude Truex Buck, and their aunt, Helen Simpson Truex, relax on a wharf on the Manasquan River. (MCHA Archives.)

Opposite, below: Trip to the beach, *c.* 1910. In the early twentieth century, a trip in an automobile to the beach over the dirt roads from Freehold was a day's adventure. William Buck, David Truex, Gertrude Truex, and friends are pictured after a long drive to Manasquan beach. (MCHA Archives.)

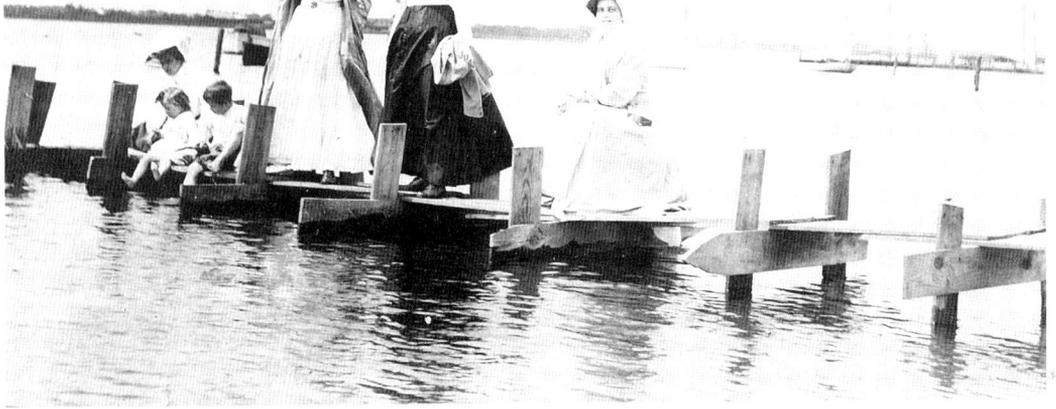

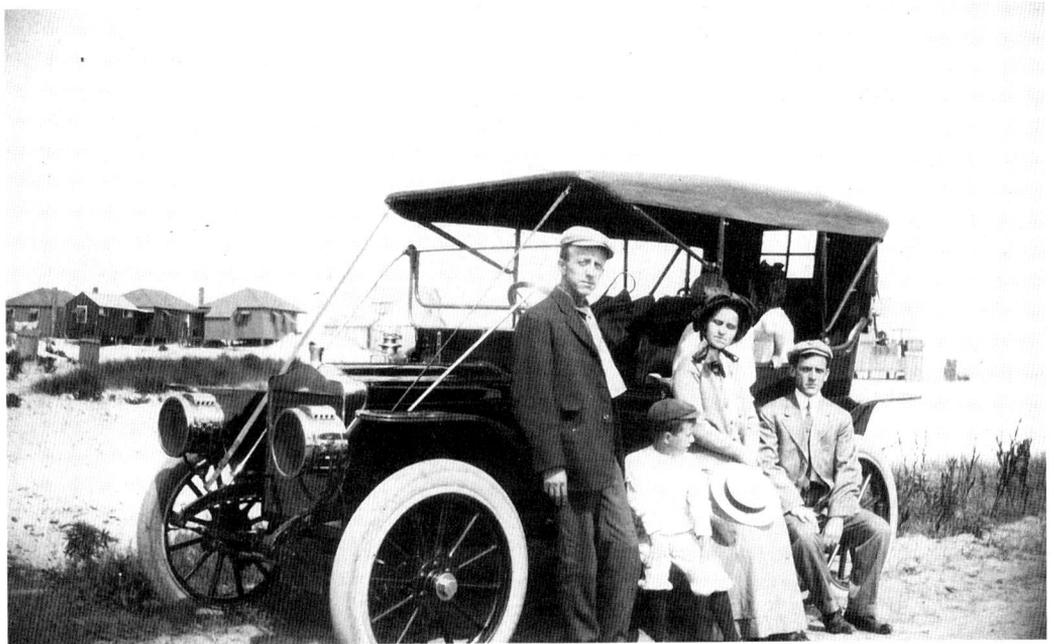

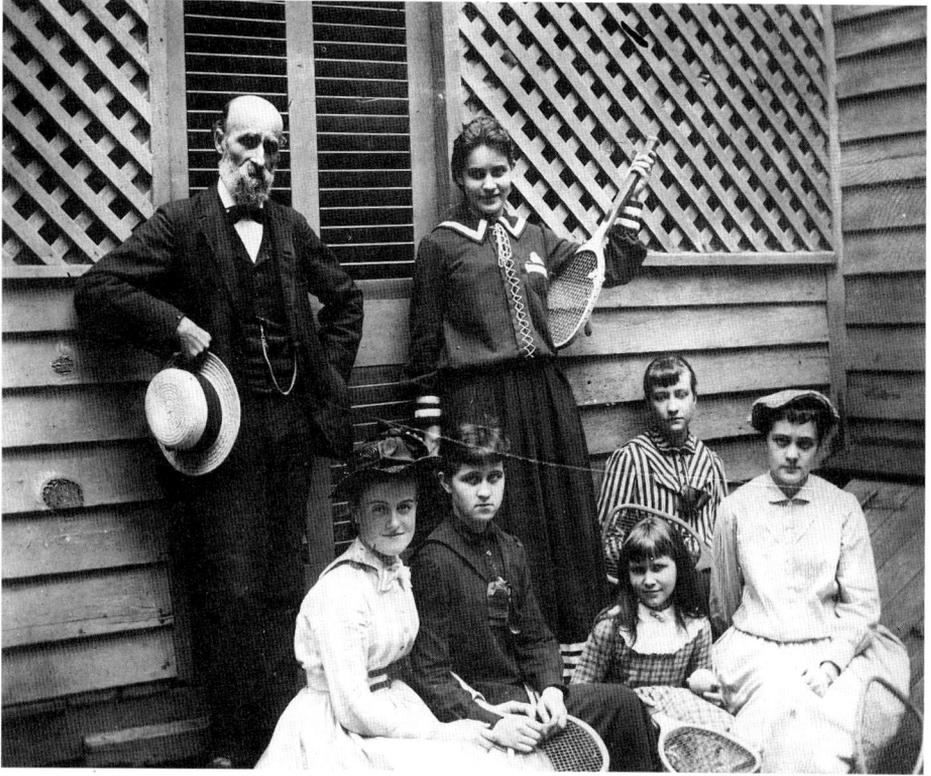

Ready for tennis, c. 1895. Charles Truex appears here with his daughters, who are ready to play tennis with a friend, Lizzie Caffery. (Courtesy of Margaret Buck Bergen.)

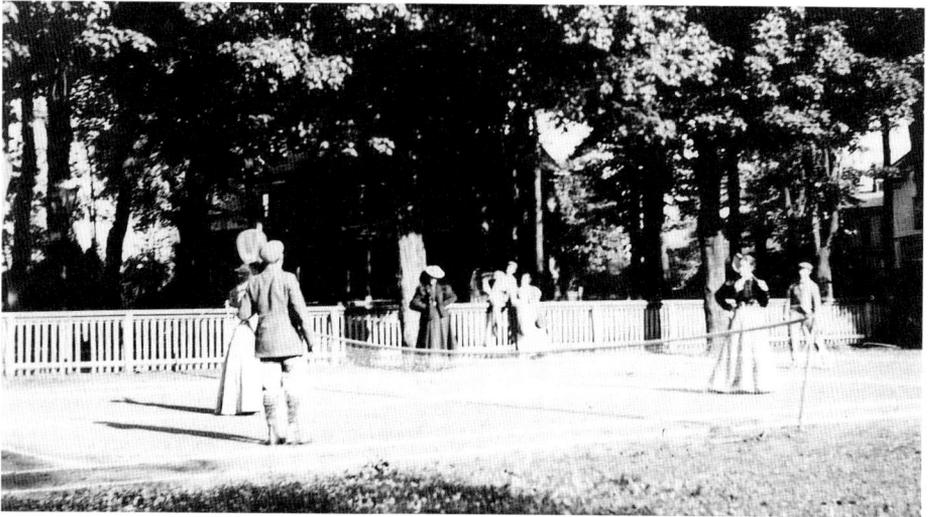

Tennis game, c. 1895. The tennis courts of the Freehold Military Institute, which was next door to the Truex residence on South Street, were often used by the family for a game of tennis. Imagine the challenge that the ladies faced, playing this game of doubles wearing long skirts. (Courtesy of Margaret Buck Bergen.)

Community
and Education

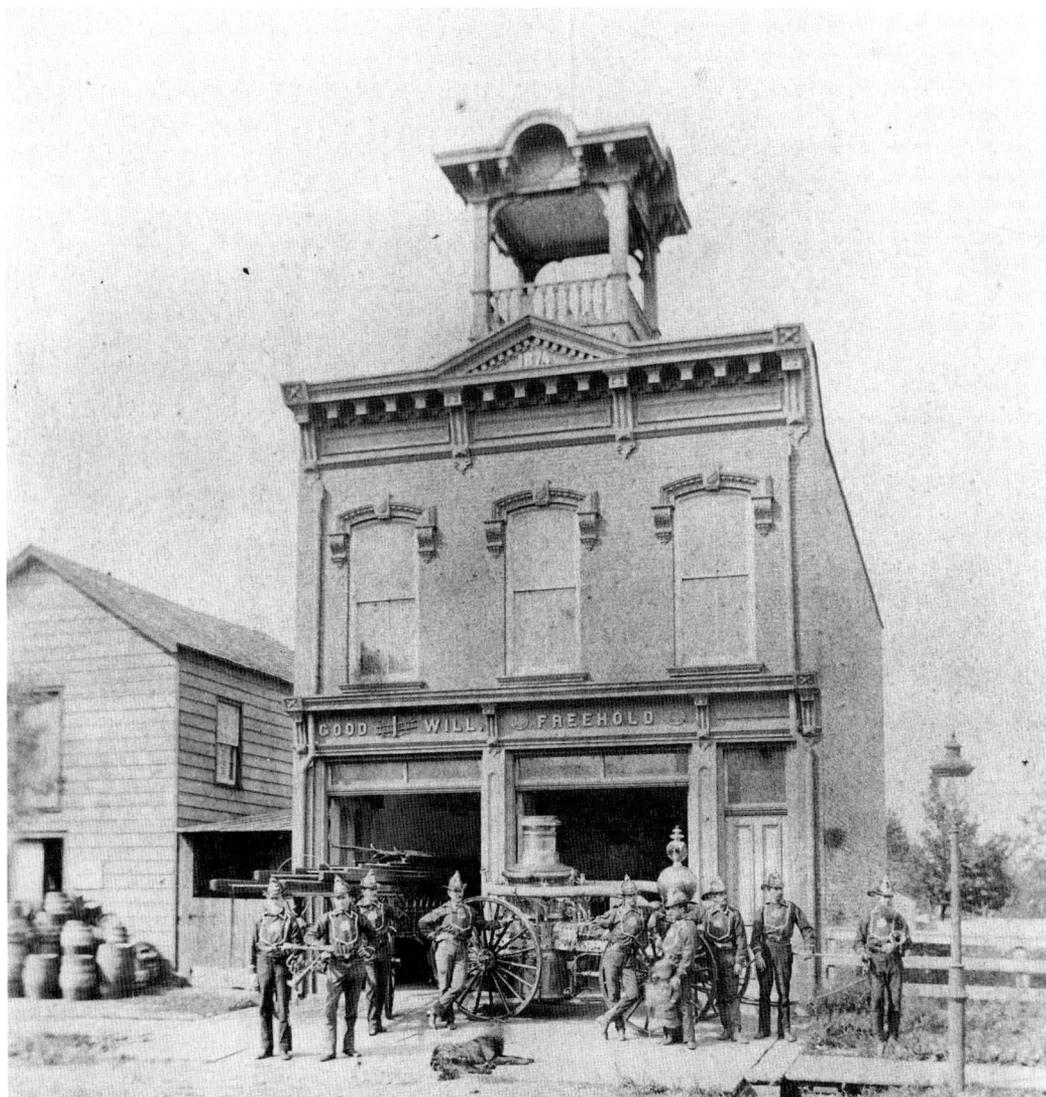

Above: Freehold Goodwill Fire Department, *c.* 1890. Organized in 1872, the Freehold Good Will Hook and Ladder Company had to face a devastating fire after only one year in service. The company's efforts to stop the raging flames were successful, and over the following year they worked toward acquiring additional equipment and building the fire house that appears above. The building, completed in 1874, still stands, minus the bell tower, on Throckmorton Street. (MCHA Archives.)

Opposite, above: Steamer No. 1, *c.* 1911. This group picture shows the fire department members in parade dress, with the old steamer engine in front of a frame barn or garage located behind the courthouse, which can be seen in the background. The painted banners were typical of those commissioned for parades, and the larger one is signed, "Laggren Bros Co., Elizabeth." The photograph was taken by Hall Studio of Freehold. (MCHA Archives.)

Opposite, below: "Freehold, No. 1," *c.* 1928. This American LaFrance pumping engine was placed in service on May 7, 1928. John Throckmorton is in the passenger seat. (Courtesy of Freehold Public Library.)

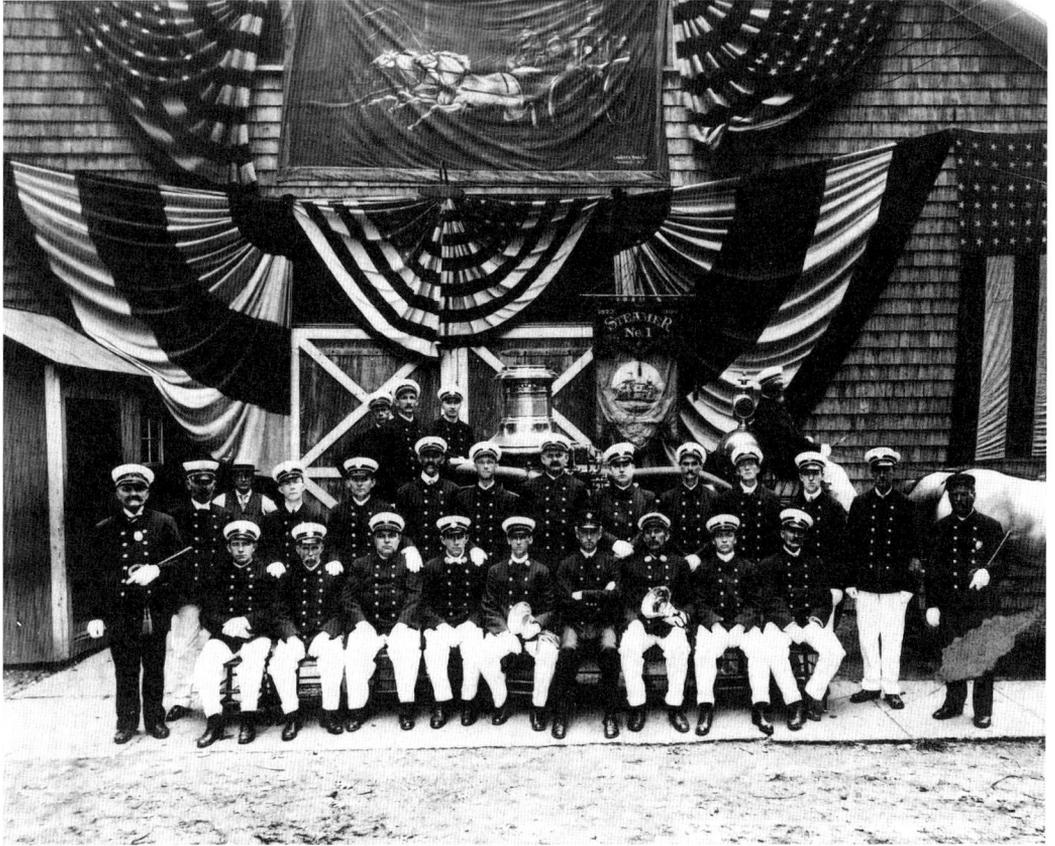

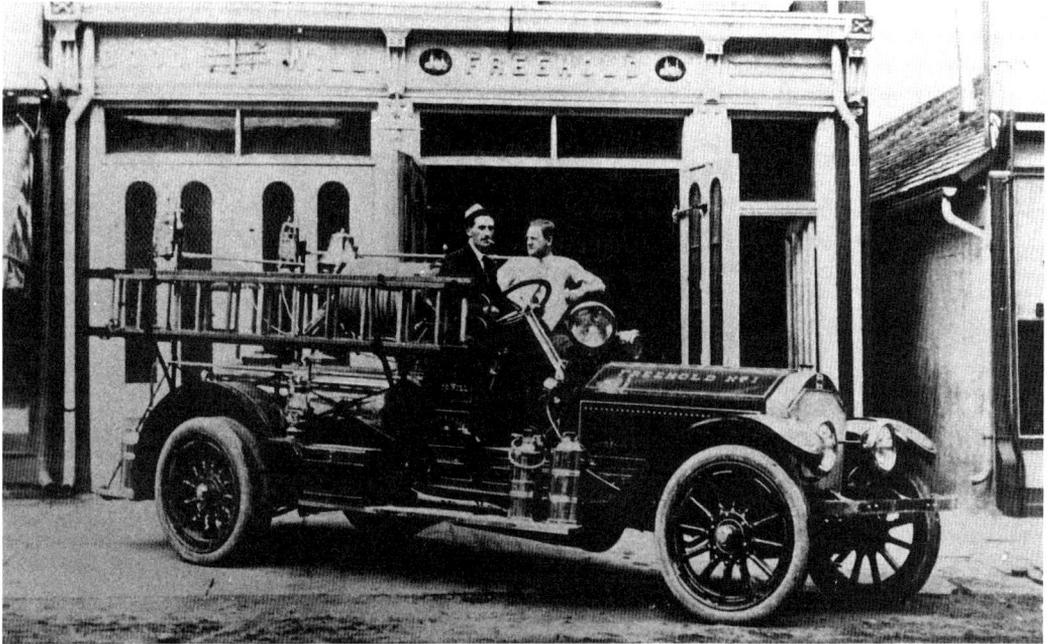

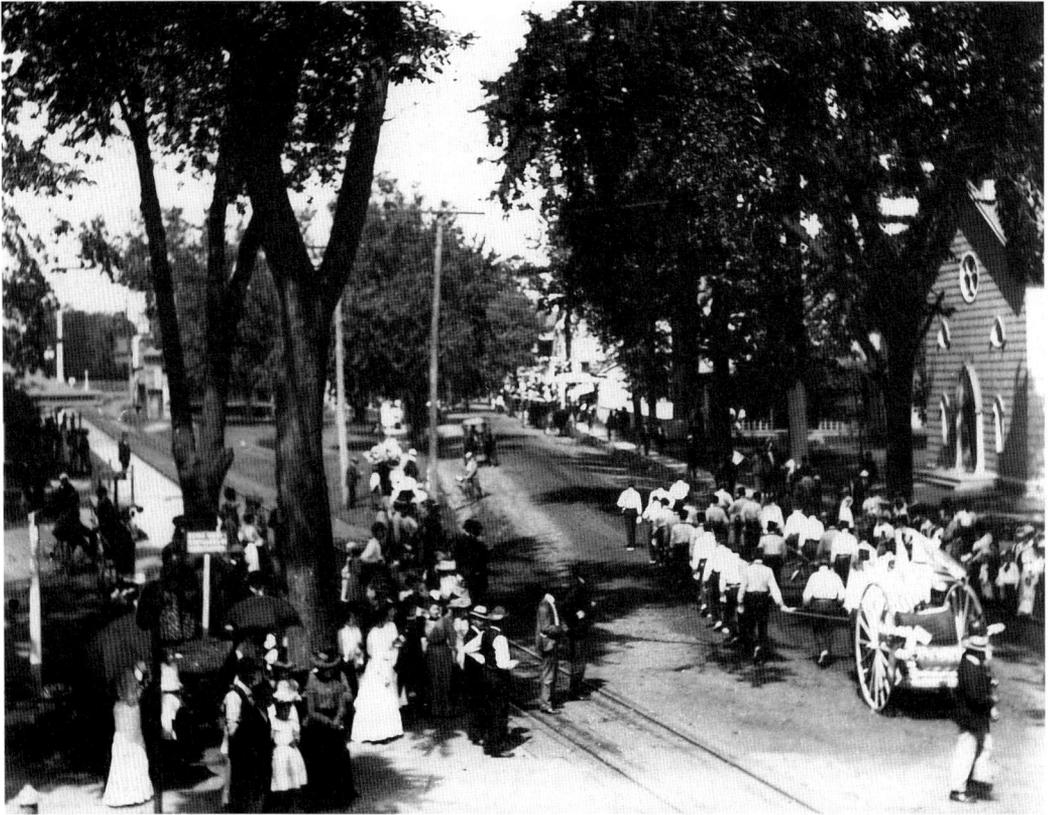

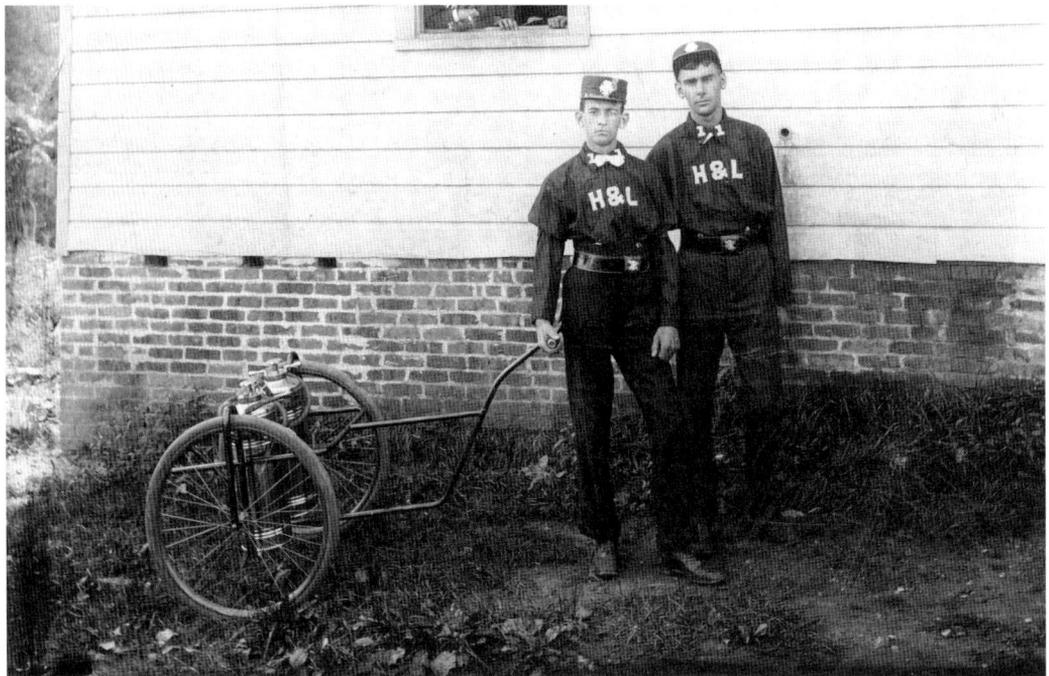

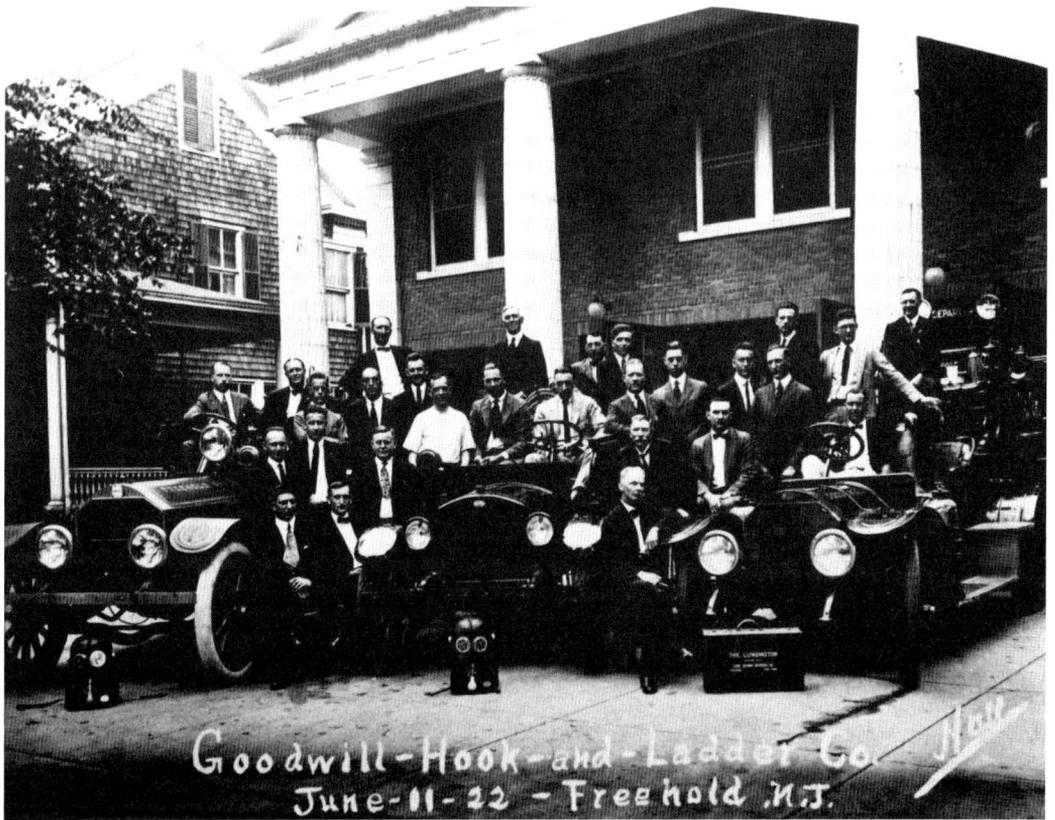

Goodwill-Hook-and-Ladder Co.
June-11-22 - Freehold .N.J.

Opposite, above: Fire department parade, *c.* 1900. Headed down Throckmorton Street past St. Peter's Church, the Freehold Good Will Fire Department, with the steam engine illustrated on the previous pages, is cheered by the local crowd. The photographer was probably Helen Simpson Truex. (Courtesy of Margaret Buck Bergen.)

Opposite, below: Chemical fire extinguishers, *c.* 1901. The *Monmouth Democrat* noted in 1901 that the fire department had purchased a bicycle extinguisher cart to haul two chemical fire extinguishers. Frederick A. White is the fireman on the right. (MCHA Archives.)

Above: Good Will Hook and Ladder, 1922. Posing for a portrait in front of the new fire department building on West Main Street are the members of the Good Will Hook and Ladder Company with their equipment. This photograph was taken by Hall Studio of Freehold. (Courtesy of Freehold Public Library.)

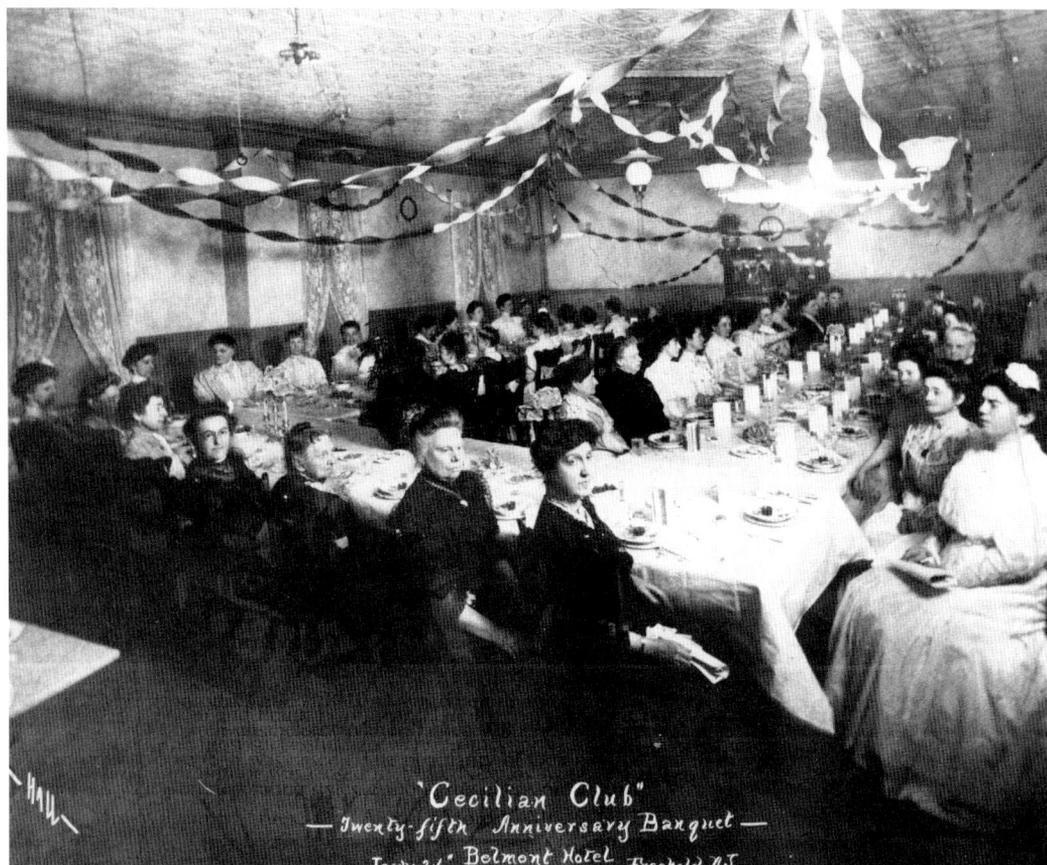

Above: Cecilian Club, 1908. At their 25th anniversary banquet held at the Belmont Hotel, members of the Cecilian Club look quite severe, in contrast to their purpose of bringing joy and appreciation of music to the citizens of Freehold. The group's contribution to the cultural life of Freehold was a significant one, as they presented concerts by their own members, many of whom were musicians or artists themselves, or by professional performers from outside the immediate area. This photograph was by Hall Studio of Freehold. (MCHA Archives.)

Opposite, above: Old Academy, *c.* 1890. The Academy, a very early Freehold school located at the corner of East Main and Spring Streets, was built in 1831. William and Charles Woodhull taught there before they opened another school, the Woodhull Academy, at Broad Street and Manalapan Avenue, in 1844. (MCHA Archives.)

Opposite, below: St. Rose of Lima School, *c.* 1910. First opened in 1875, St. Rose was Monmouth County's first parochial school. (Courtesy of Mr. and Mrs. James Higgins.)

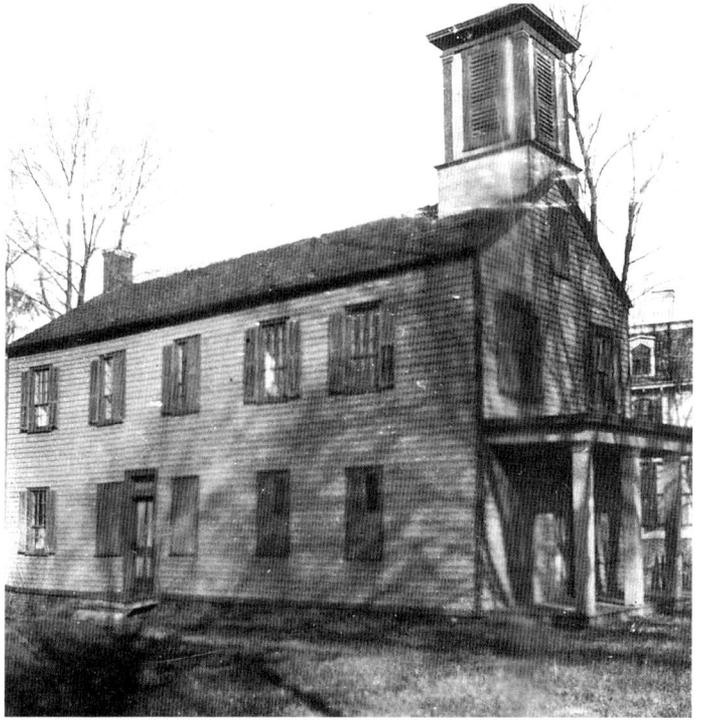

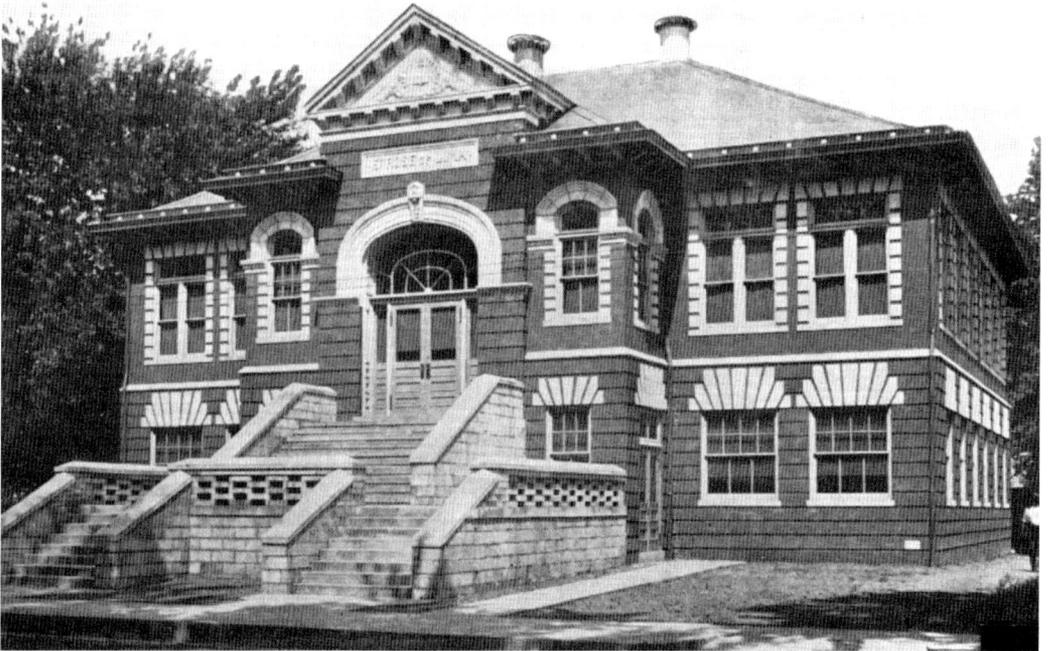

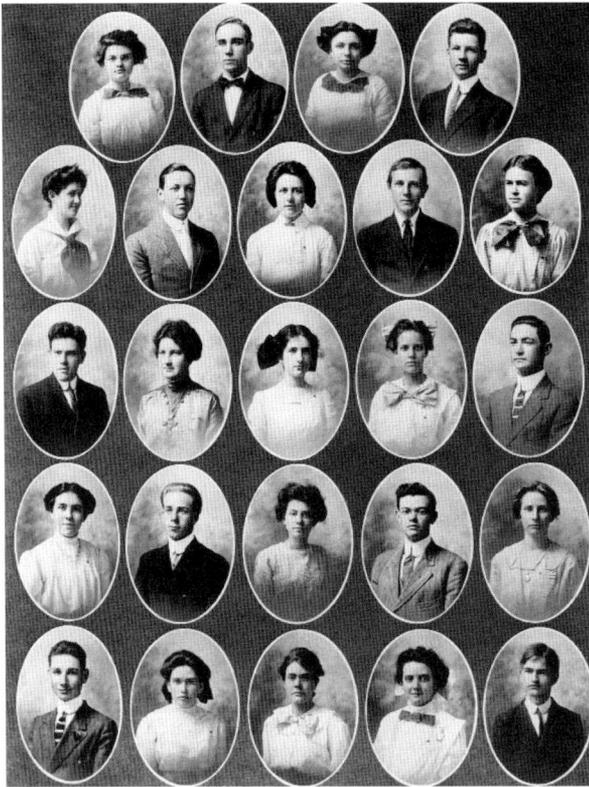

Left: Freehold High School Class of 1911. A graduating class of twenty-four are all dressed in their best, which meant enormous bows for the girls' hair and high Edwardian-style collars for the boys. This class picture was taken by Hall Studio in Freehold. (MCHA Archives.)

Below: Boy Scout Concert Band, *c.* 1915. The leader's baton indicates that this brass band was a marching band, and another photograph at the Freehold Public Library showing the band marching on Main Street confirms this. (Courtesy of Nancy DuBois Woods.)

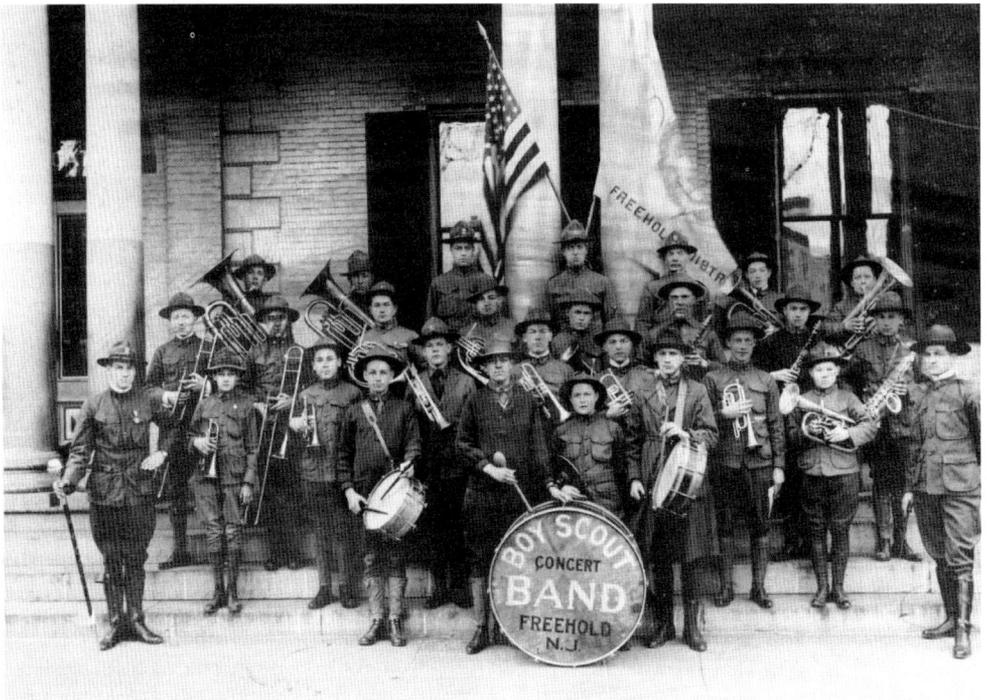

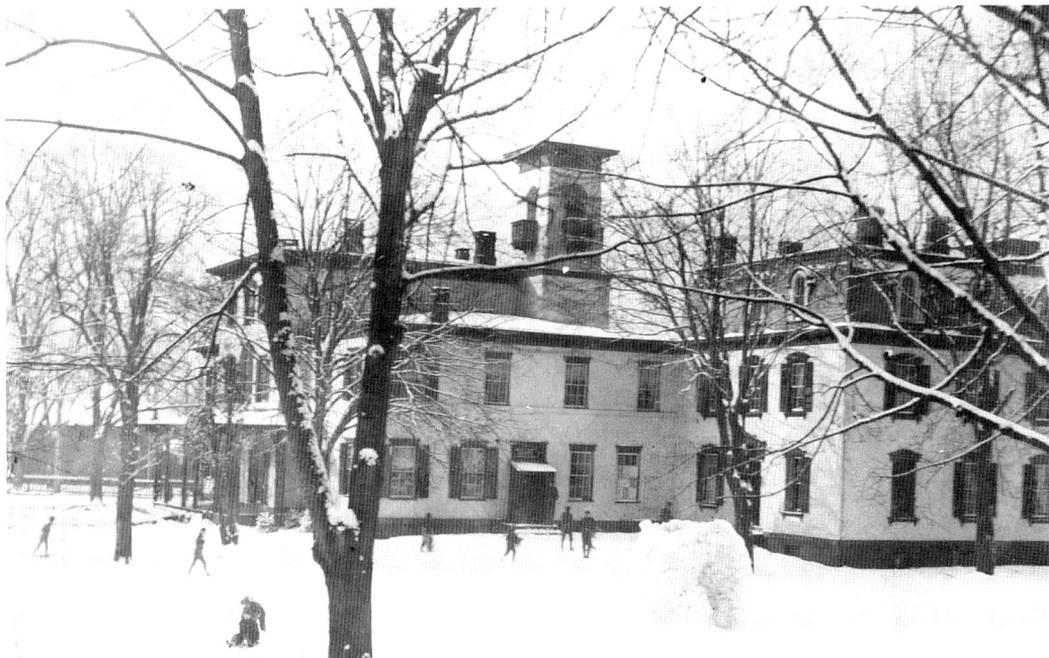

Freehold Military Institute, *c.* 1895. Photographed "from our bathroom window" by Helen Truex, this view of the Freehold Military Academy shows cadets at play in the winter snow. The school opened in 1848 at the corner of South and Institute Streets, and is now the site of the St. Rose of Lima School. (MCHA Archives.)

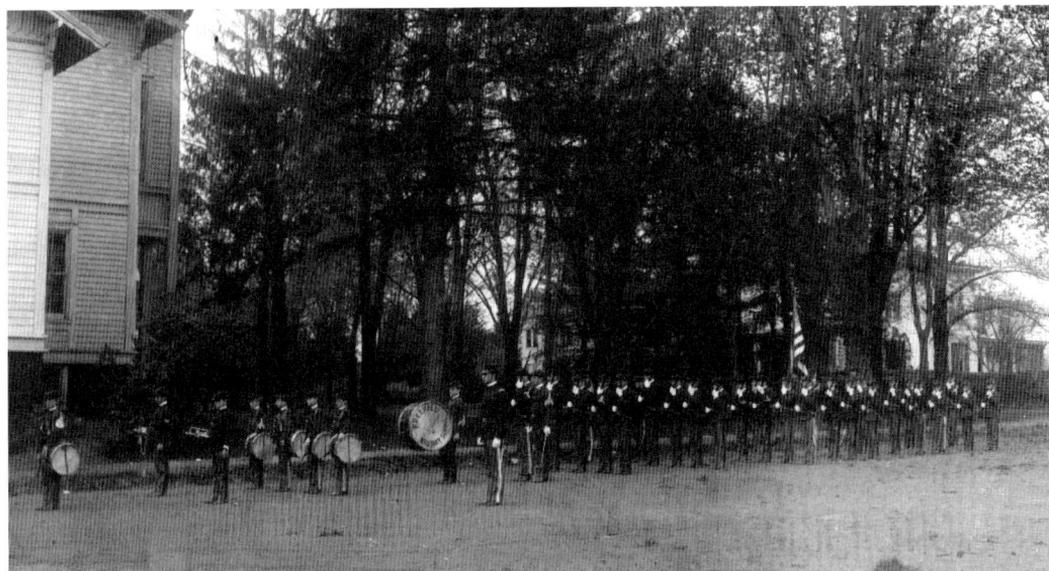

Freehold Military School, 1903. A rival institution to the one pictured above until they merged in 1916, the Freehold Military School began in 1900 on the grounds of the old Freehold Young Ladies Seminary. Old Richardson Hall appears to the left. This photograph was by Benedict of Freehold. (MCHA Archives.)

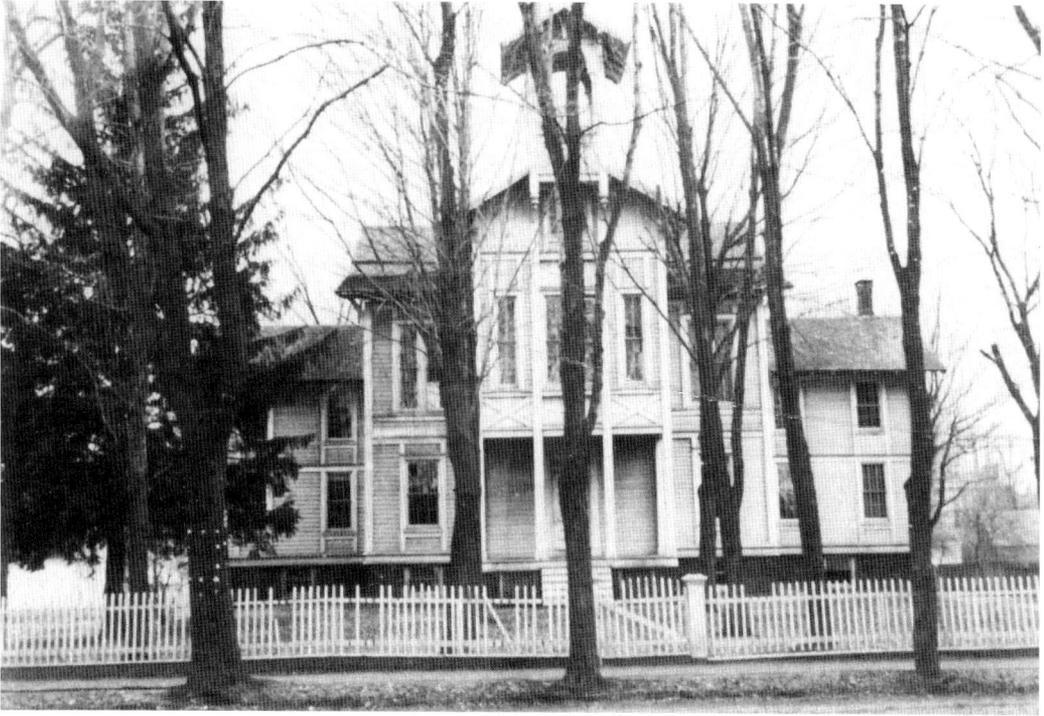

Freehold Young Ladies Seminary, *c. 1900.* Three buildings made up the campus of the Freehold Young Ladies Seminary, which was established in 1844 by the Reverend Daniel V. McLean, pastor of the Presbyterian church, and opened the following year. This one, Richardson Hall, built 1854/5, stood facing Broad Street and is a wonderful example of Victorian stick-style architecture. (MCHA Archives.)

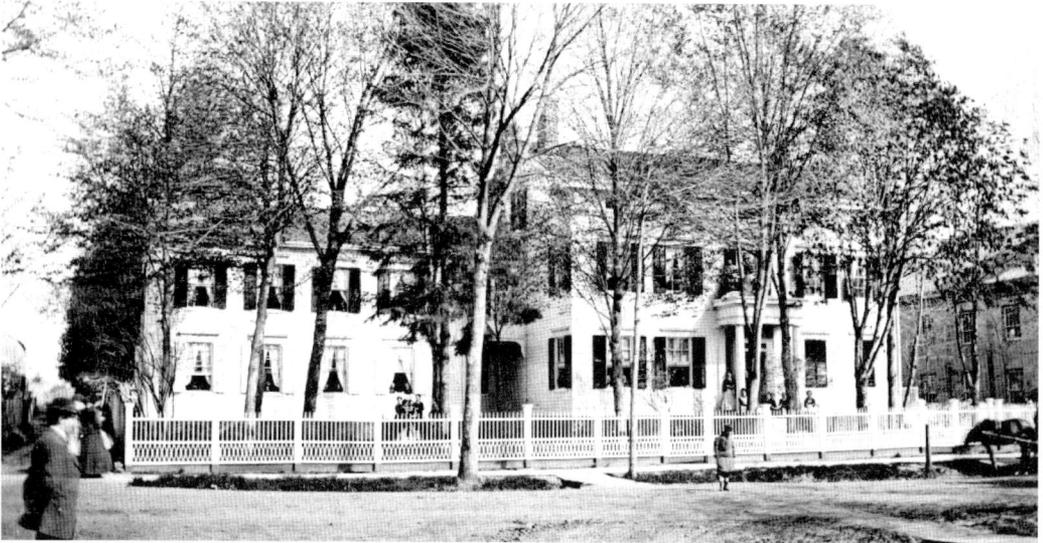

Freehold Young Ladies Seminary, June 14, 1870. These first buildings for the seminary were constructed in 1844 and faced Main Street. Annie P. Perrine and Annie L. Seabrook are shown standing in front of the school, and Fred A.E. Perrine is in the foreground. (MCHA Archives.)

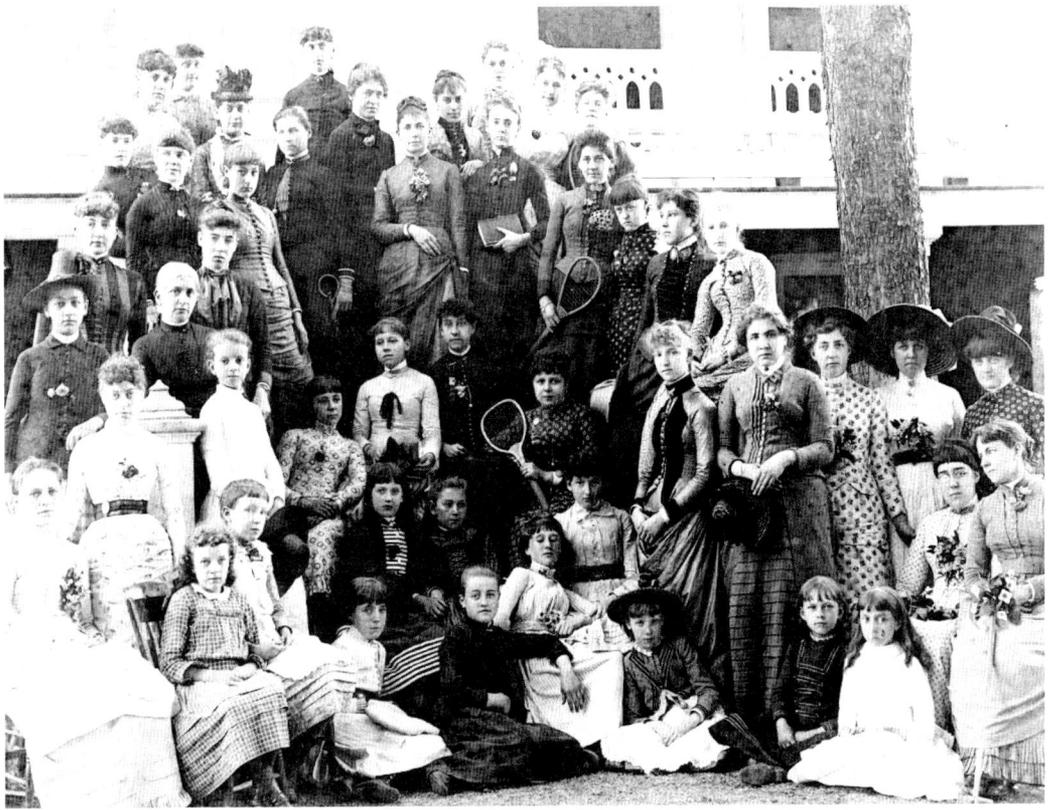

Freehold Young Ladies Seminary students in the 1880s. The students have been identified, and many of the names are familiar: Throckmorton, Rue, Yard, Meirs, Forman, Conover, Vredenburgh, VanMatter, and Schanck, to name a few. Many of the girls hold a nosegay and several hold tennis racquets, as physical education was part of the instruction. This photograph was taken by Pach Bros., 841 Broadway, NY. (MCHA Archives.)

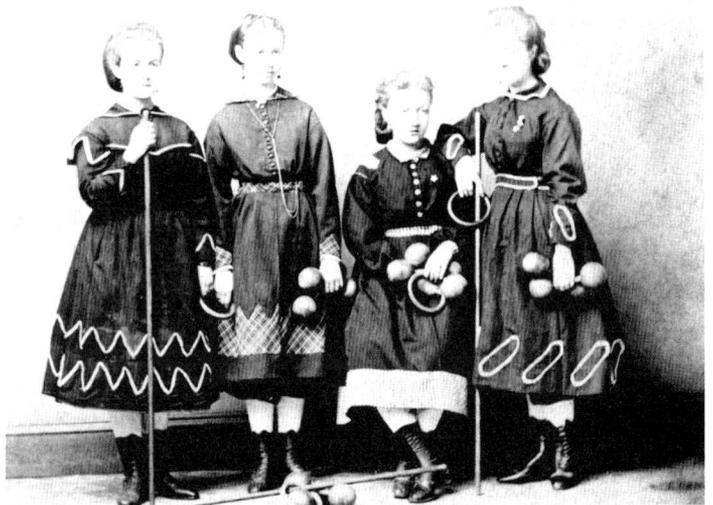

First quartette, 1871. Dressed and equipped for gymnastics class are: Laura H. Richardson, A.P. Perrine, Jennie A. Perrine, and Annie L. Seabrook. They formed the "first quartette, second line" in their exercise, which was overseen by gymnastics teacher B.J. Pettingill. The photographer was John Roth of Freehold. (MCHA Archives.)

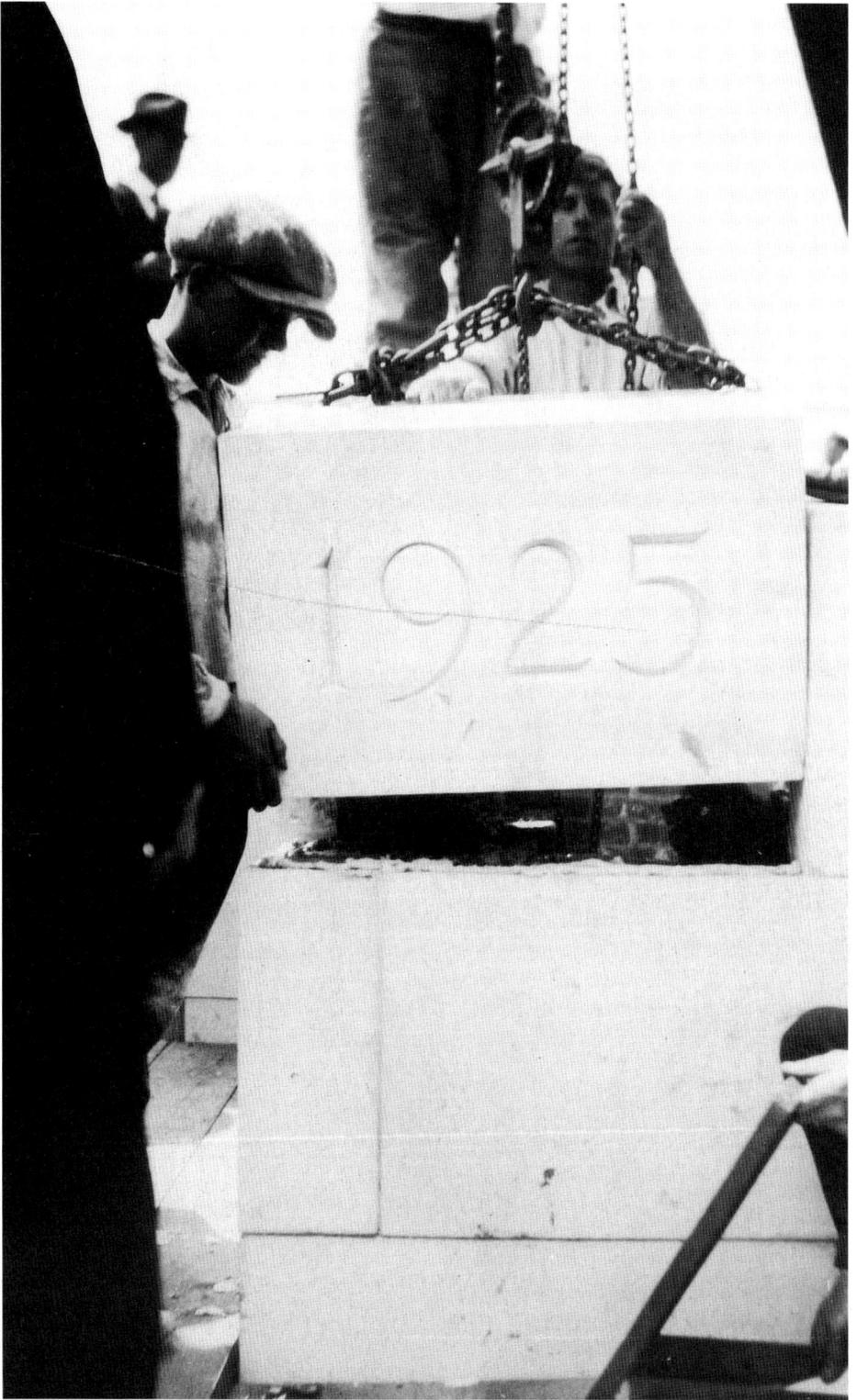

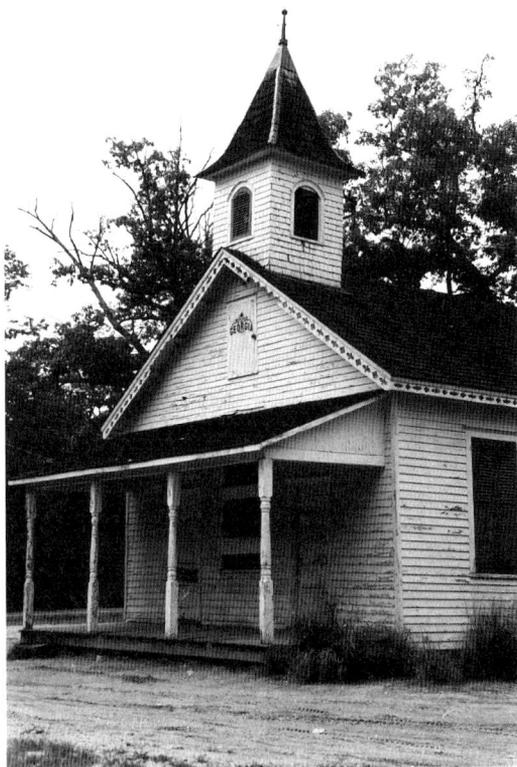

Opposite: Cornerstone, Freehold High School, 1925. The new Freehold High School, built on Broadway, replaced a smaller school on Hudson Street that now serves as the borough police headquarters. (MCHA Archives.)

Right: Georgia Schoolhouse, built 1862. One-room schoolhouses, such as this one located in the southern part of the township, were the educational resource for rural families, in contrast to the larger schools in what is now the borough. (Courtesy of Nancy DuBois Wood.)

Below: Maypole in the 1920s. A school class dances around a maypole at the back of the Hudson Street School. Note the Victrola to the left, supplying the music for the dance. (Courtesy of Freehold Public Library.)

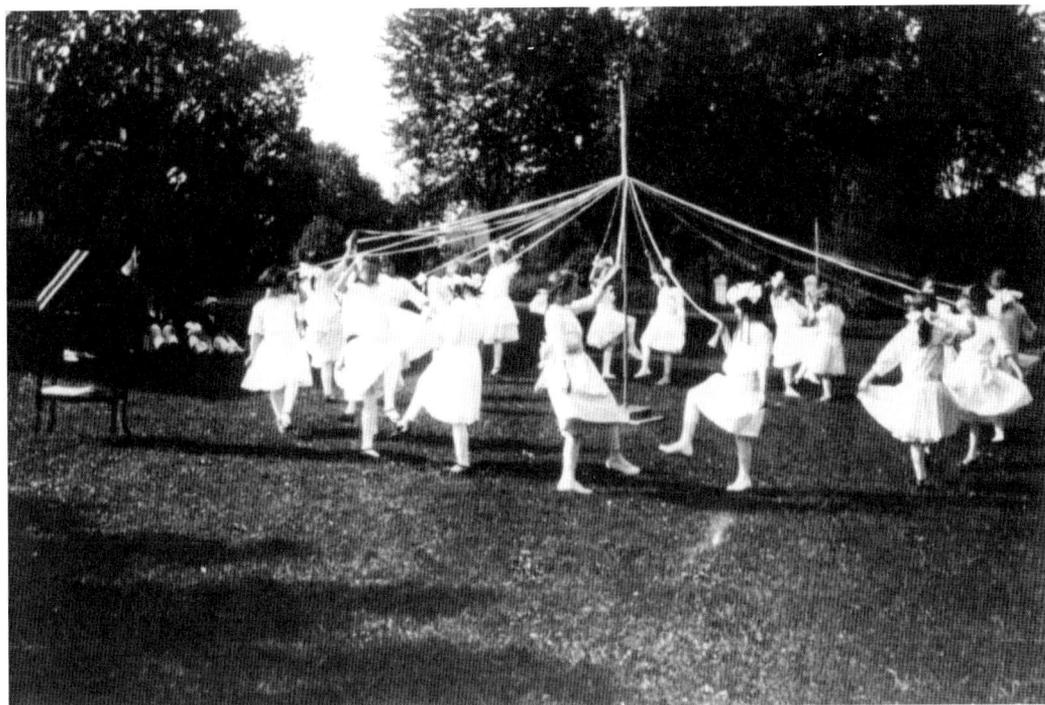

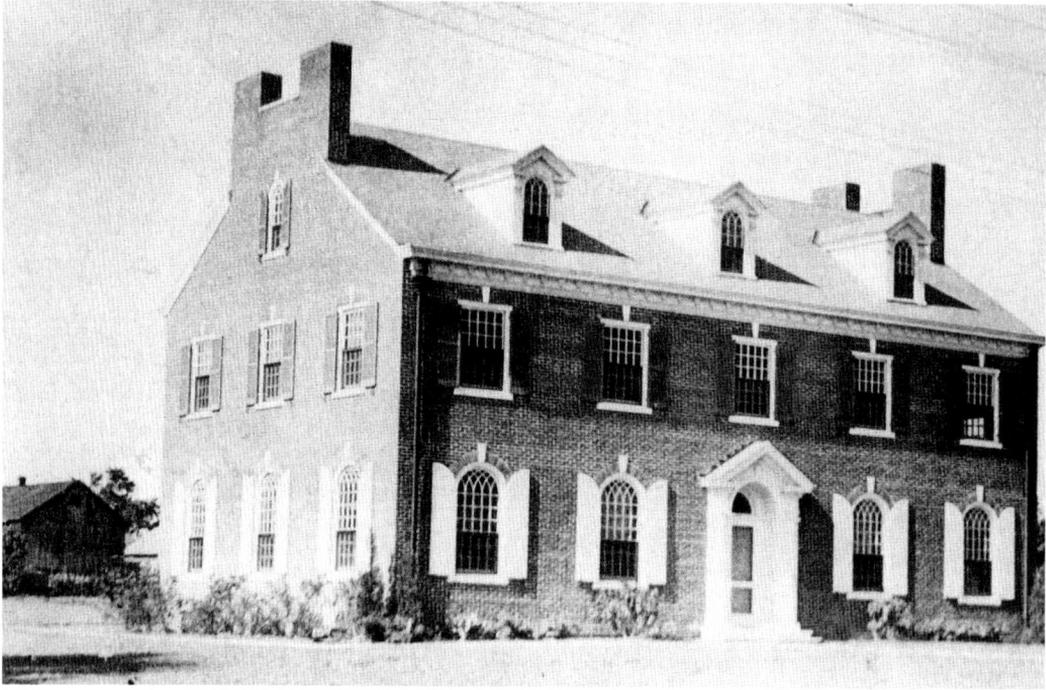

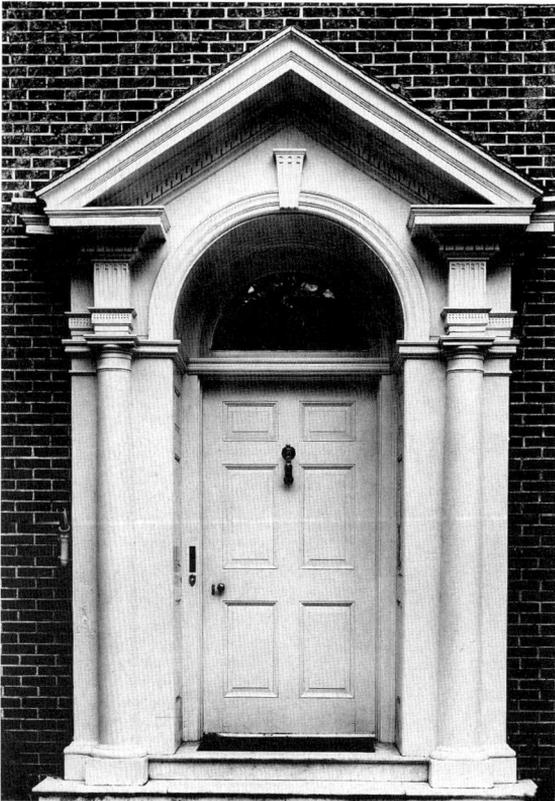

Above: Monmouth County Historical Association, built 1931. Founded in 1898, the Monmouth County Historical Association soon needed a museum and library to house its growing collection. A lot was donated by member David VanDerveer Perrine, and a Georgian Revival brick structure was designed by architect J. Hallam Conover (the son of Warren H. Conover) of Freehold. (MCHA Archives.)

Left: Monmouth County Historical Association. A detail of the doorway shows a masterful use of classical elements and proportion in the detailing of the building, which is executed in the interior spaces as well. (MCHA Archives.)

Opposite, below: Monmouth County Historical Association, *c.* 1975. In contrast to the attic, the Washington Gallery housed a formal permanent display of fine and decorative arts from the museum collections. Changing exhibitions are now mounted in that gallery, presenting a variety of subjects and making more of the MCHA collections accessible to public view. (MCHA Archives.)

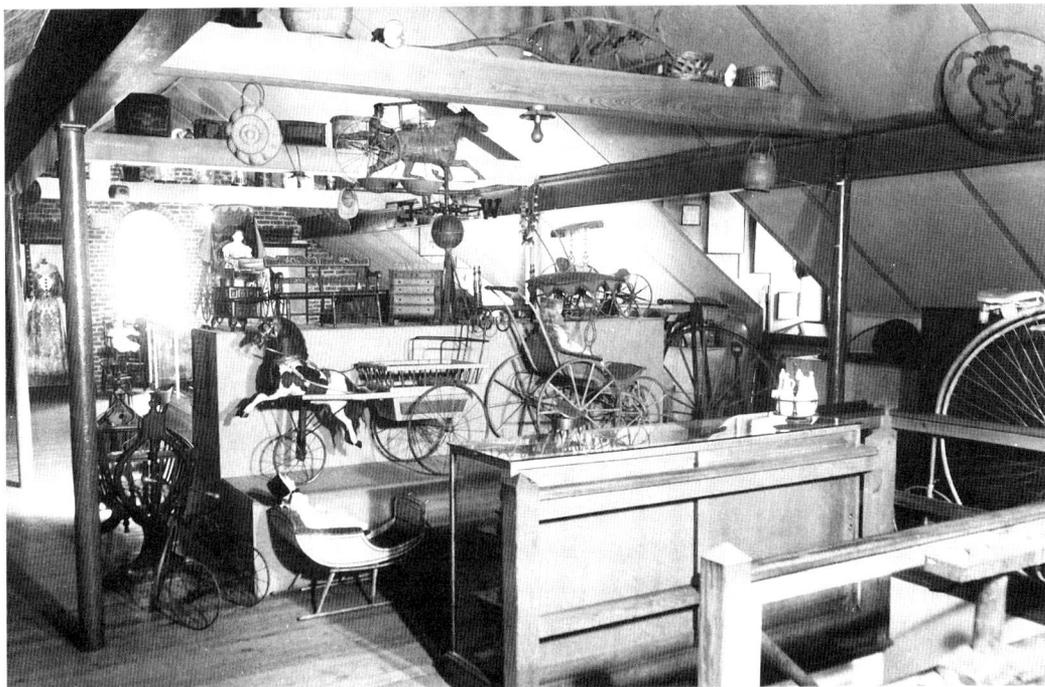

Above: Monmouth County Historical Association attic, *c.* 1975. A favorite with children, the historical association attic was for years a treasure trove of all kinds of artifacts from the collection. At least one college history professor has admitted that it inspired his career choice. Changing needs and public safety regulations made it necessary to convert the attic to office space in 1992. (MCHA Archives.)

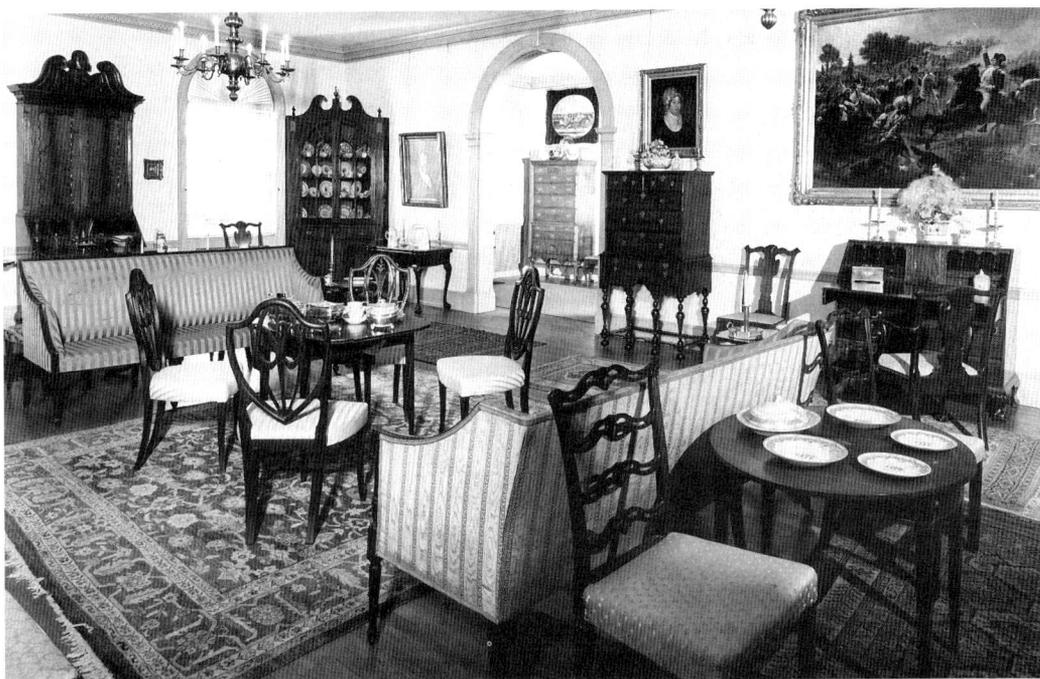

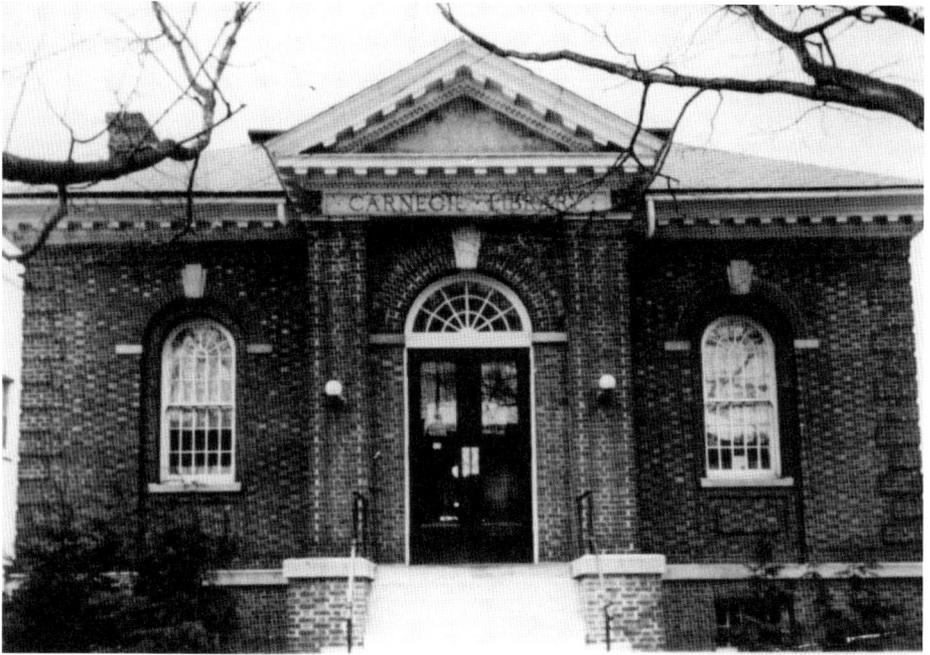

Freehold Public Library, built 1904. Funded by a grant from the Andrew Carnegie Foundation, as were many municipal libraries of this period, the Freehold library is a classically inspired Georgian Revival structure, which continues to serve the borough's residents. (Courtesy of Freehold Public Library.)

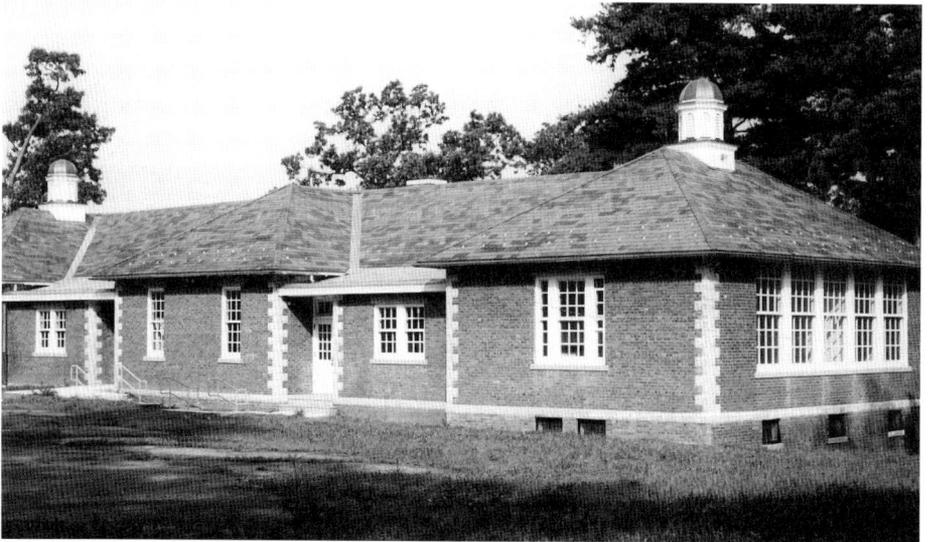

Court Street School, built 1921. Architect Warren H. Conover designed a rectangular Colonial Revival school building which served Freehold's African-American community until World War II when it was closed and used as an air raid shelter and ration station. After the war it was reopened as an integrated early elementary school and finally closed in 1974. Now restored with a grant from the New Jersey Historic Trust, it again serves the community as a neighborhood center.

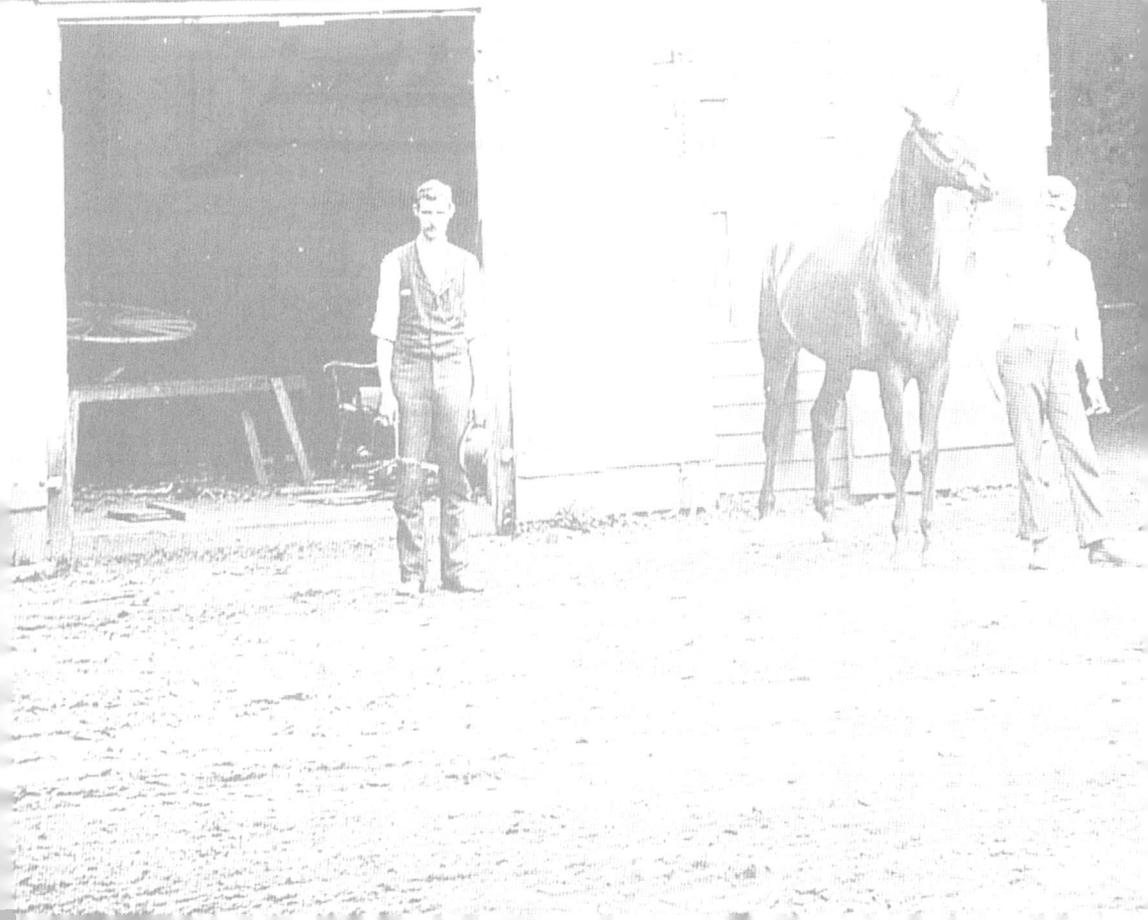

Villages and Farms

THOMAS. S. FOX.

EELWRIGHT CARRIAGE-PAINTER - TRIMMER.

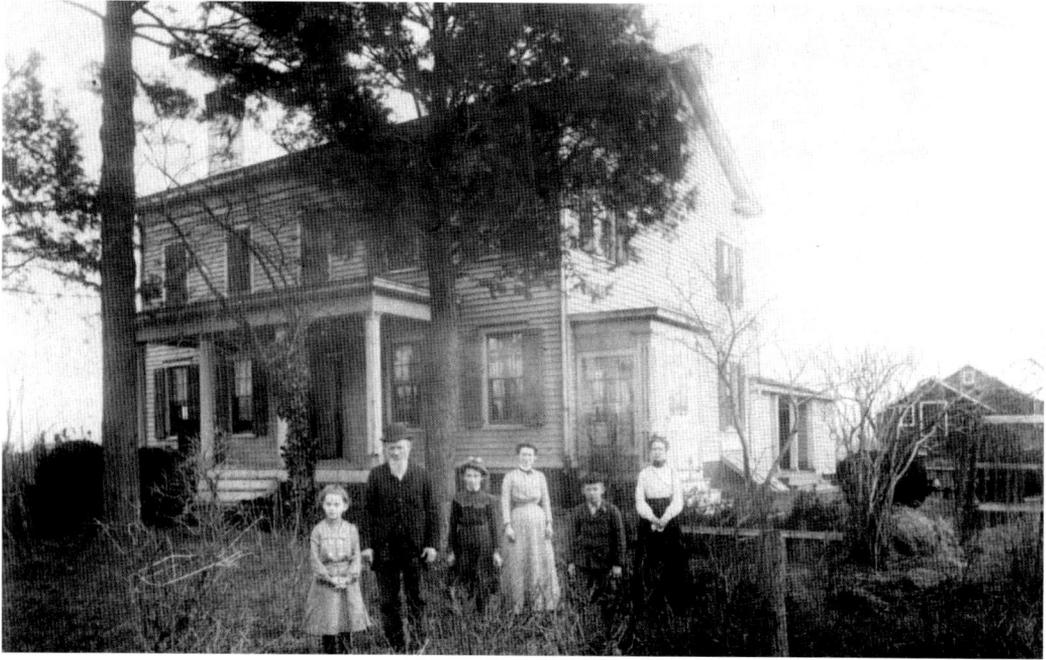

Moreau Homestead, *c.* 1880. Just outside of town on South Street is a Moreau family home that still stands on the present-day intersection of Barkalow Street. Pictured are Grandfather Rue, Aunt Lizzie and Jeannette, Aunt Ella, Marnie, and Jim. (MCHA Archives.)

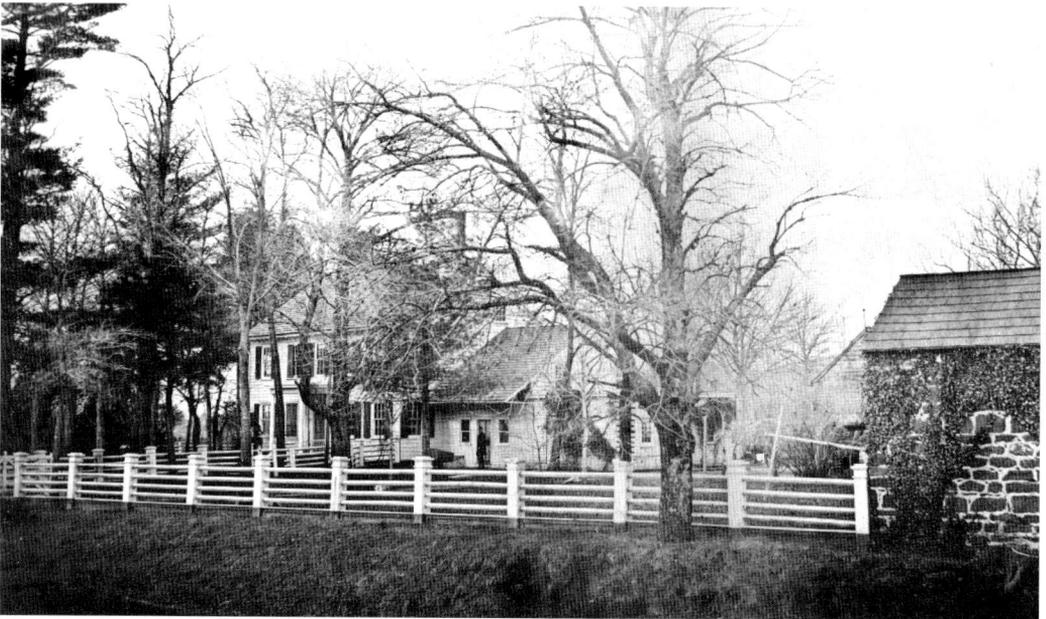

Dr. Samuel Forman Farm, *c.* 1890. The main house, which was built by Dr. Forman in 1820 and later occupied by his son John Fisher Forman, no longer stands, but the little stone smokehouse in the foreground can still be seen at the side of Route 537 near Kozloski Road. (MCHA Archives).

Tollhouse, built mid-nineteenth century. Small wooden structures such as this, that have outlived their original purpose, are rare indeed. It was one of a number of tollhouses that appear on the 1873 *Beers* map of Freehold. (Courtesy of Nancy DuBois Woods.)

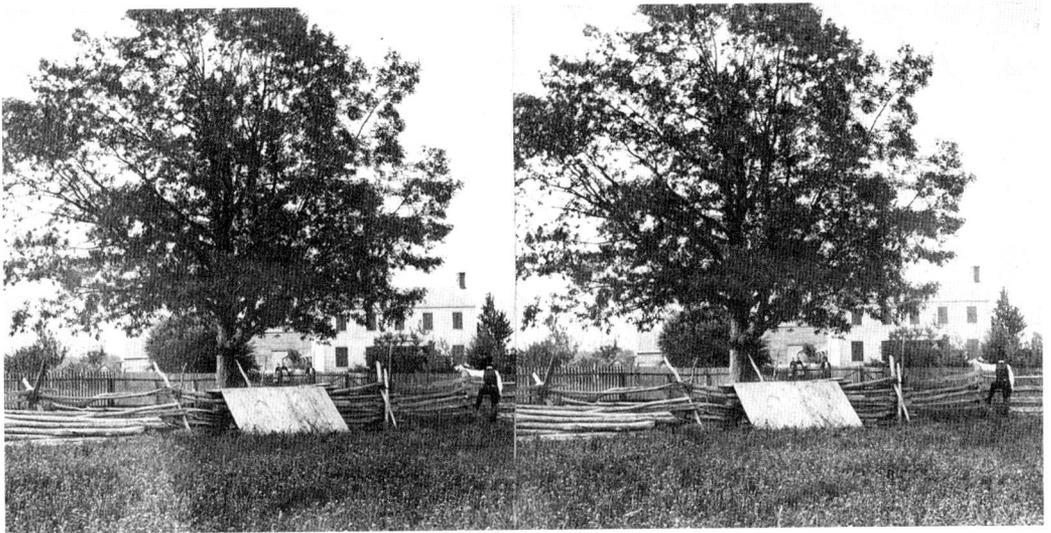

"Residence of J.A. Forman, Esq.," *c.* 1880. This stereographic view of one of the Forman family farms in East Freehold when viewed through a stereoscope would appear in three-dimension because of the slight off-set of the second photograph. This photograph was taken by L.R. Cheeseman. (MCHA Collection.)

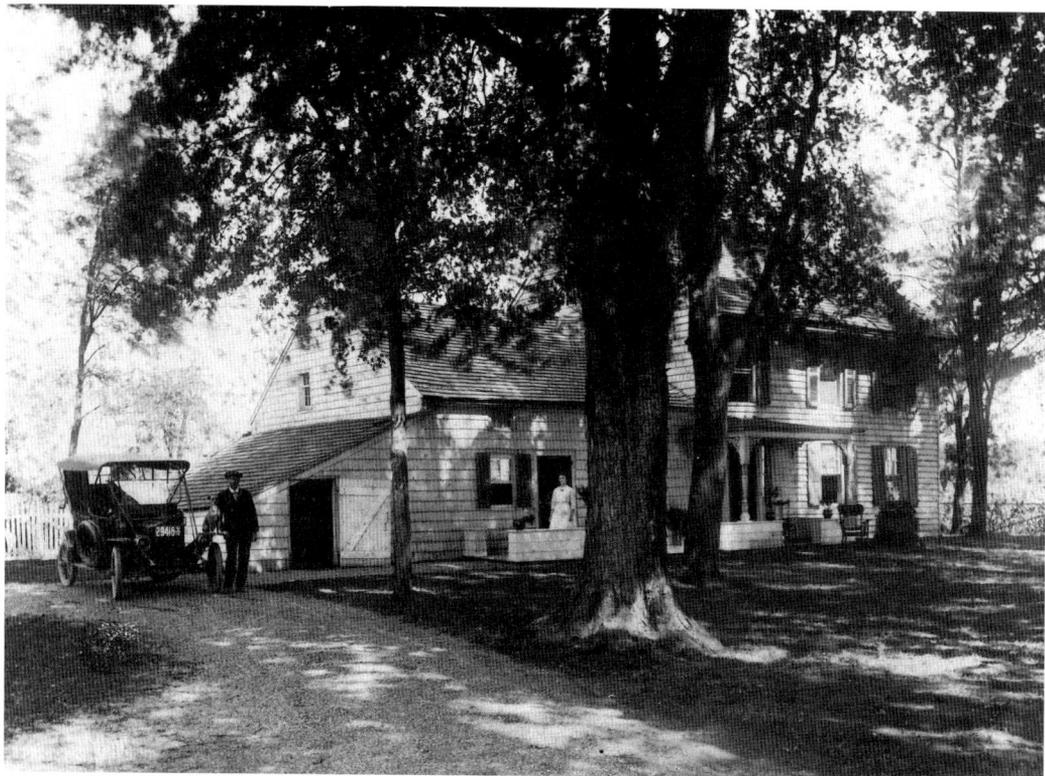

Jones Homestead, 1915. Howard and Sara Jones are pictured outside their home; Howard and his dog stand next to an early Everett-Metzger-Flanders car, c. 1908. The house and associated farm buildings no longer stand, but were located on Willowbrook Road where the 3M/Asbury Park Press buildings are now. This image was photographed by Hall Studio of Freehold. (MCHA Archives.)

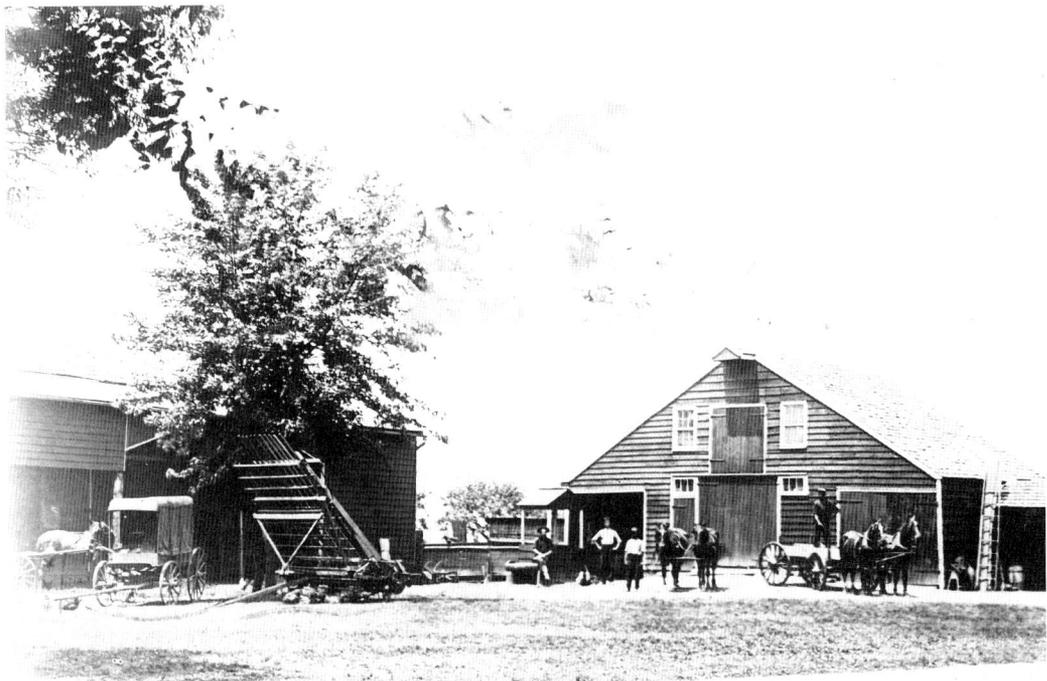

Jones Farm Buildings, 1912. Printed on a photo postcard, this view of the Joneses' farm buildings was sent by Sara Jones to a friend in Verona, New Jersey. She writes, "I send you a photo of some of our buildings, you must come and see the originals." (MCHA Archives.)

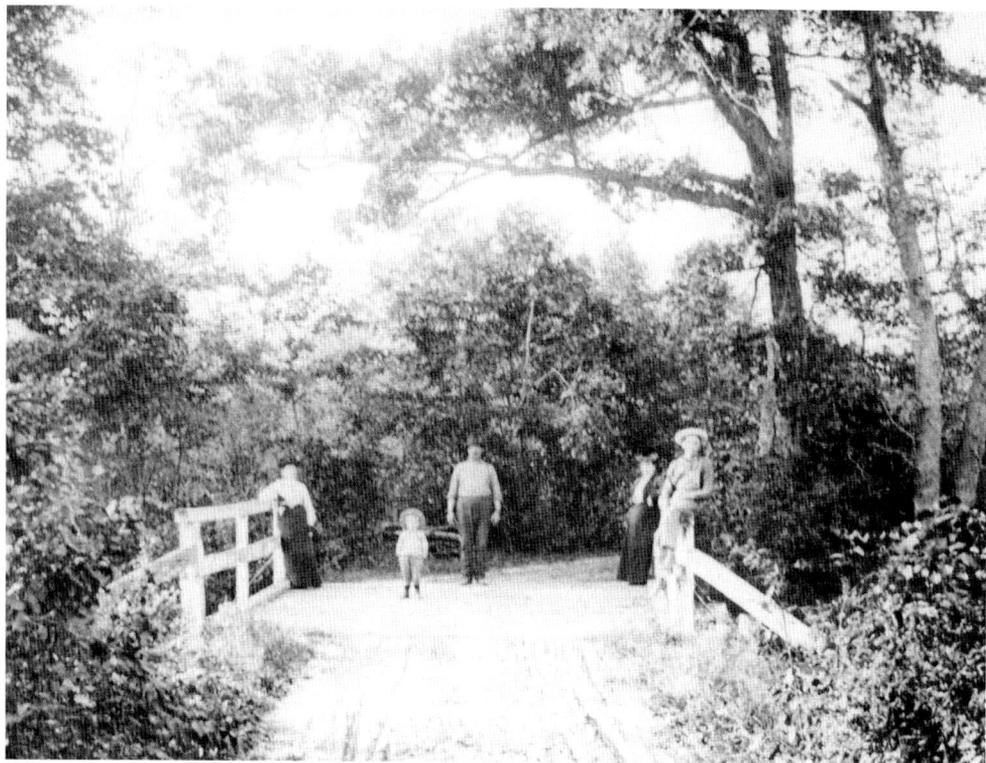

Above: Hall's Mill Bridge, *c.* 1903. The little boy in the middle of the bridge is Kortenius Schanck at about age three. (Courtesy of Mrs. William Freeman.)

Opposite above: Morgan's Mill, *c.* 1915. Located at the base of Hall's Mill Road near the border of Howell, this grist mill was built in 1747 by Stephen Haviland, and later played a part in the Revolutionary War when Colonel Daniel Morgan's troops were stationed there. Converted in the 1920s to a roadside stand and later a dance hall, the building burned down in 1932. (Courtesy of Mrs. William Freeman.)

Opposite, below: Joseph Nevis Farm, *c.* 1920. Also situated on Hall's Mill Road opposite the site of Morgan's Mill, the Nevis farm is now the site of Rutgers' Agriculture Experimental Facility. (Courtesy of Mrs. William Freeman.)

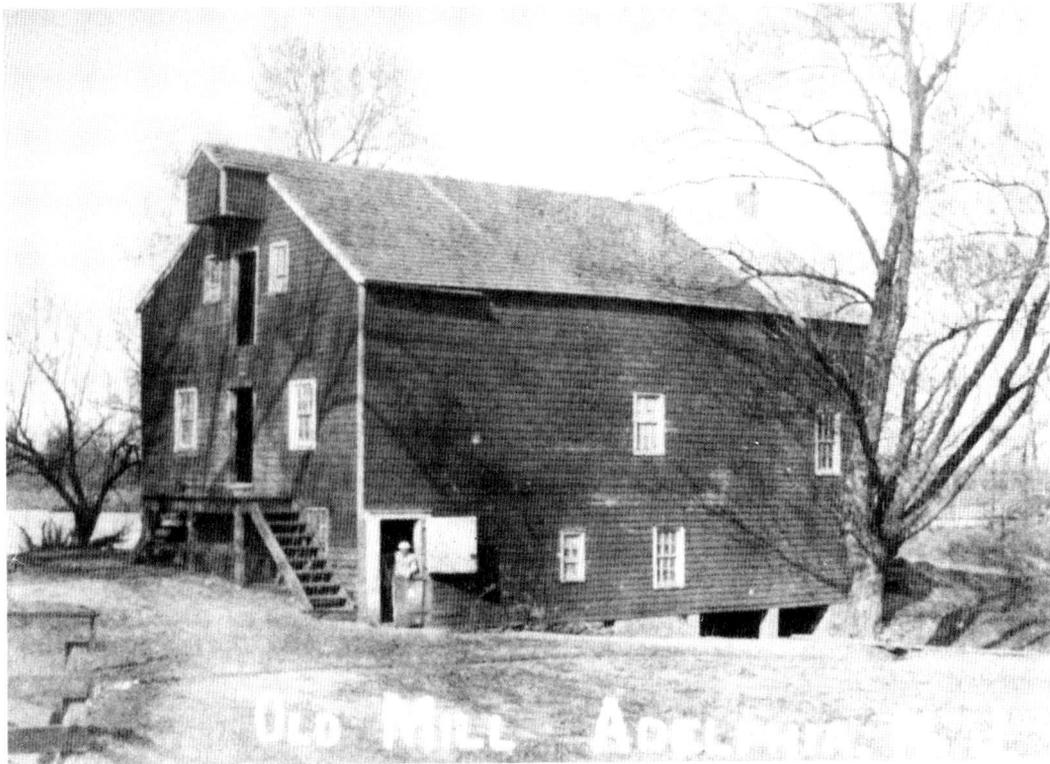

OLD MILL ADEL...

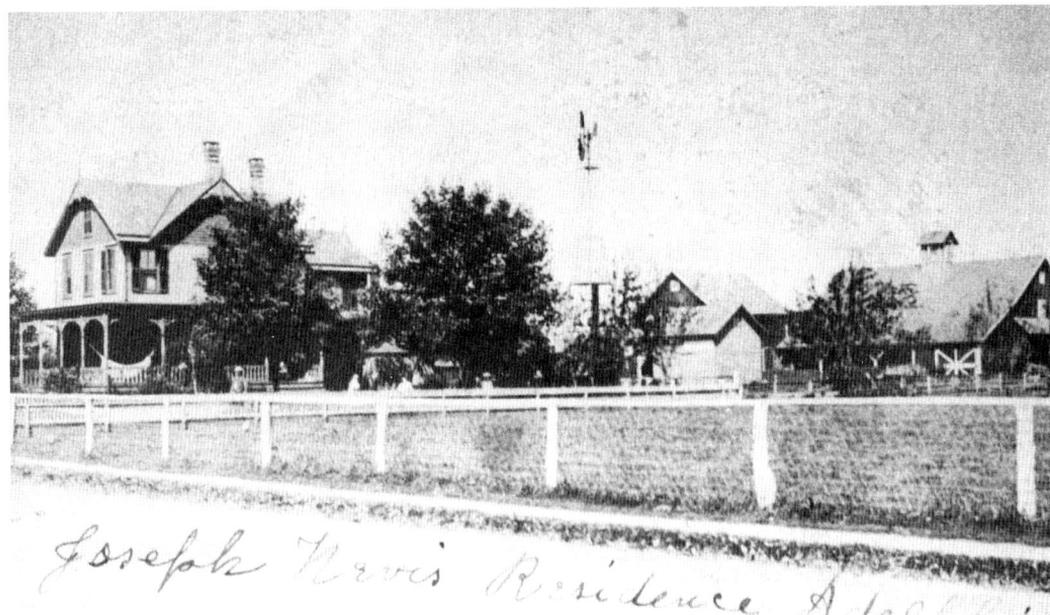

Joseph Nevis Residence Adel...

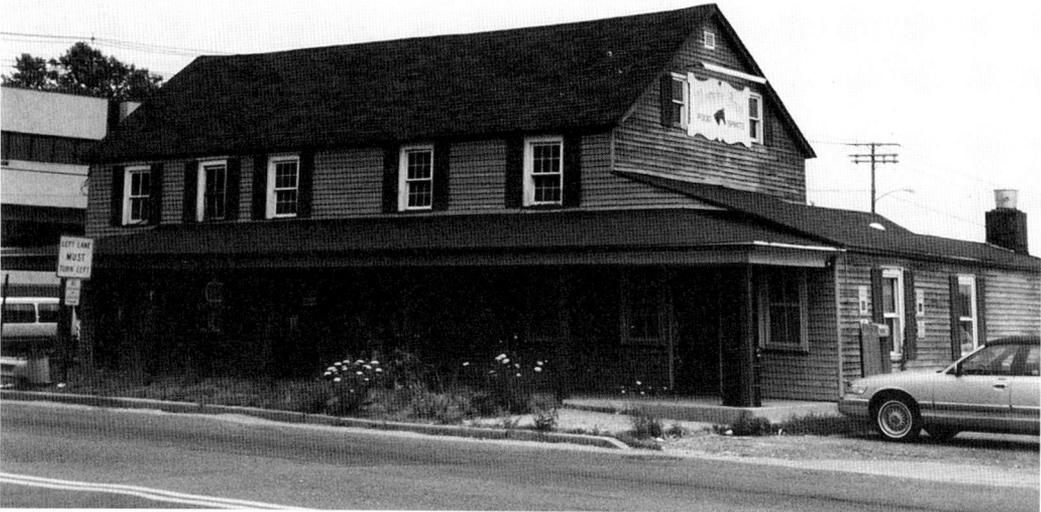

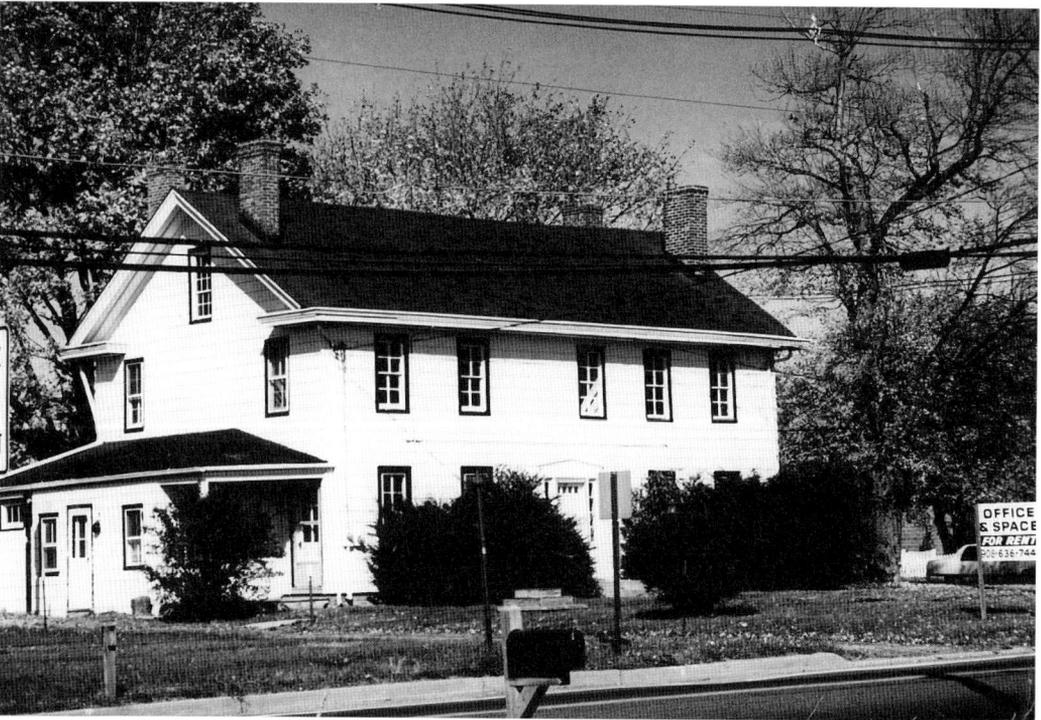

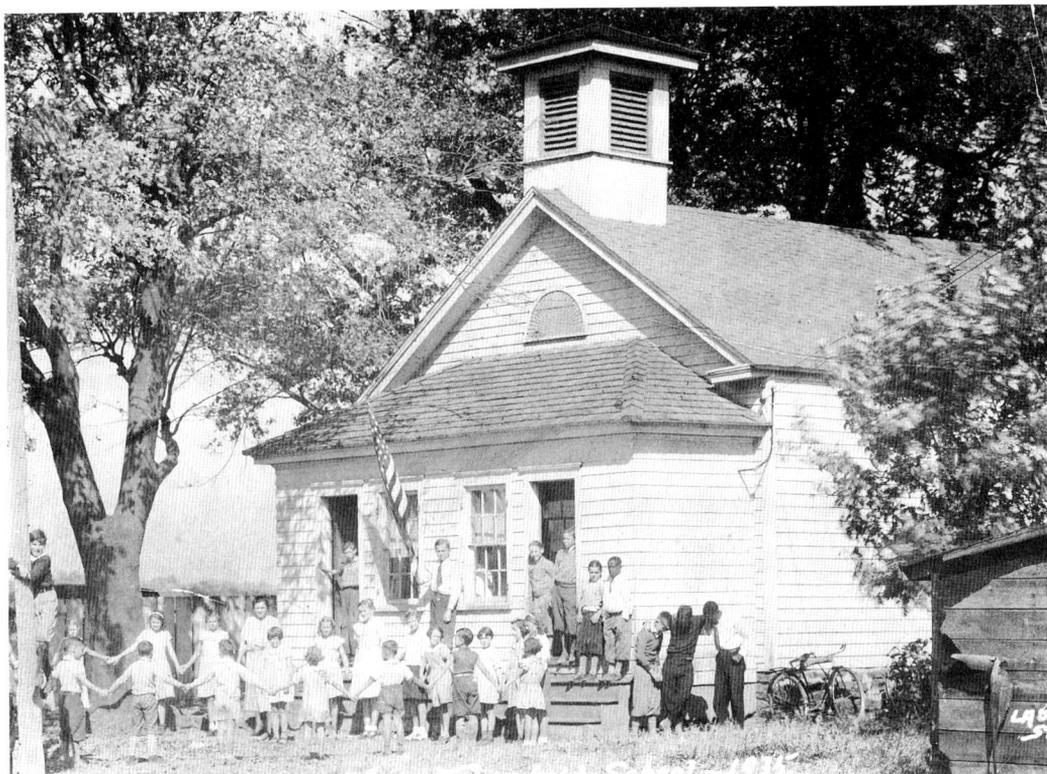

Above: Solomon Farm, built late eighteenth century. Opposite Moore's Inn stands a farmhouse that suffered damage during the Battle of Monmouth, when Hannah Solomon reportedly had to rebuild part of it after the British set it on fire in 1778. Today, the house still stands, with a barn and two outbuildings, as a last vestige of rural character at a rapidly changing intersection. (Courtesy of Nancy DuBois Woods.)

Opposite, above: Moore's Inn, built *c.* 1793. Originally known as Mount's Tavern, since it was operated by Moses Mount, this structure has served as a public house throughout its history to the present time. Moore's has been a popular meeting place for owners and staff from the Freehold Raceway in recent years. (Courtesy of Nancy DuBois Woods.)

Opposite, below: West Freehold School, 1935. One of two one-room schoolhouses in Freehold Township, the West Freehold School was built in 1847 and is shown here with its students during recess. This photograph was taken by Ladd Studio. (Courtesy of Nancy DuBois Woods.)

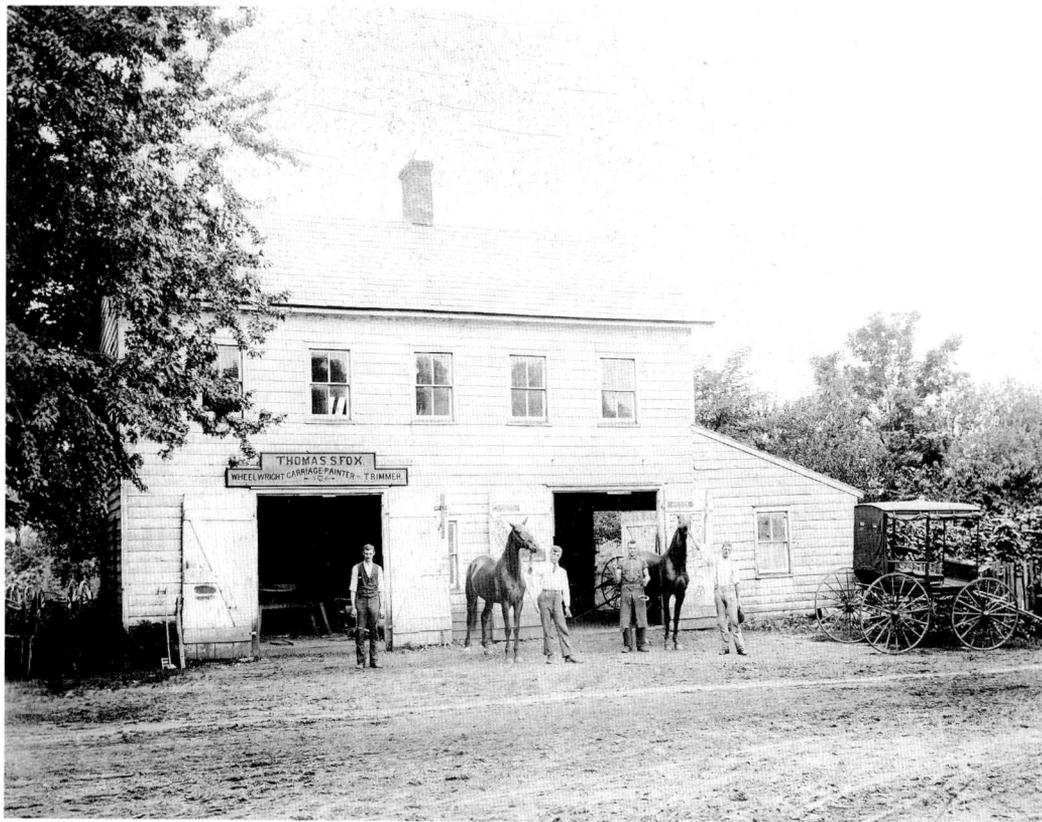

Above: Thomas Fox's business, *c.* 1880. Another West Freehold businessman catering to transportation needs, Thomas S. Fox operated a wheelwright and carriage painting shop, which stood where the Colonial Shopping Center is now. (MCHA Archives.)

Opposite, above: Oakley House, begun early eighteenth century. One of the earliest remaining farmsteads in Freehold Township, this complex on Wemrock Road is listed on the National Register of Historic Places. The earliest part of the house dates from the early eighteenth century, and sections were added in the eighteenth and early nineteenth centuries. (Courtesy of Nancy DuBois Woods.)

Opposite, below: Bond House, built between 1860 to 1873. The Italianate style exemplified in this farmhouse was very popular in both residential and commercial architecture in Monmouth County. The property is still in use as a farm whose produce is available at a small farm stand. (Courtesy of Nancy DuBois Woods.)

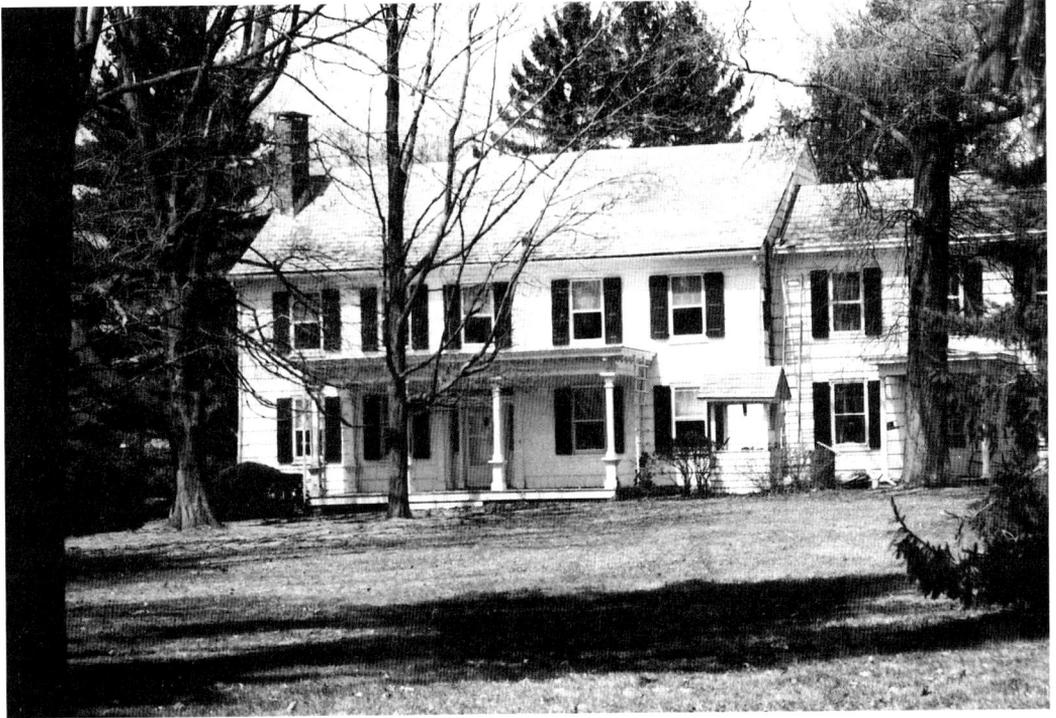

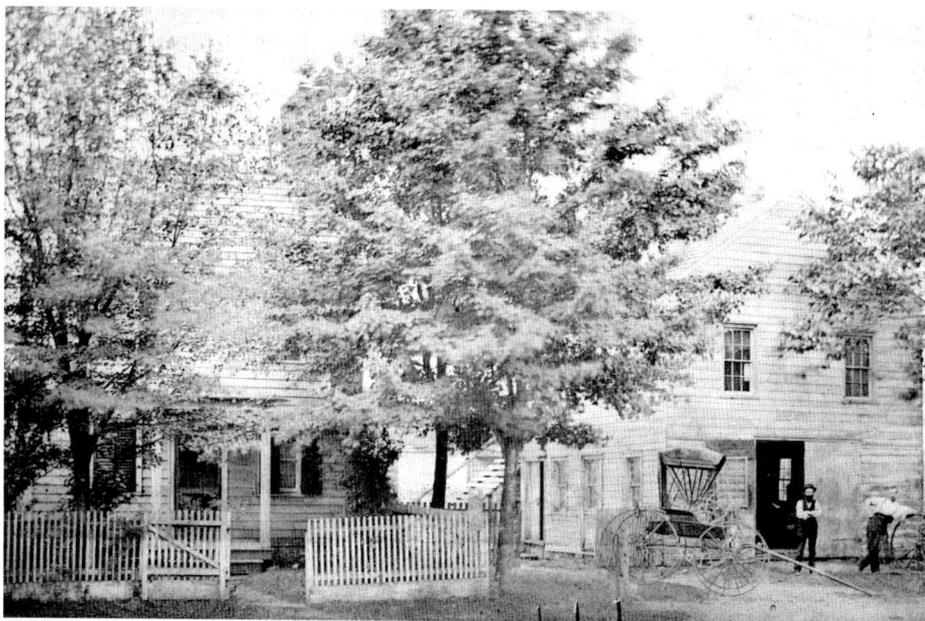

Residence and business of Leander Jewell, c. 1885. Directly across from the VanDerveer blacksmith shop in West Freehold, Leander and his son Harry operated a harness making and upholstery shop. Leander also was a wheelright and blacksmith; Harry specialized in painting wagons and carriages, and later automobiles. (MCHA Archives.)

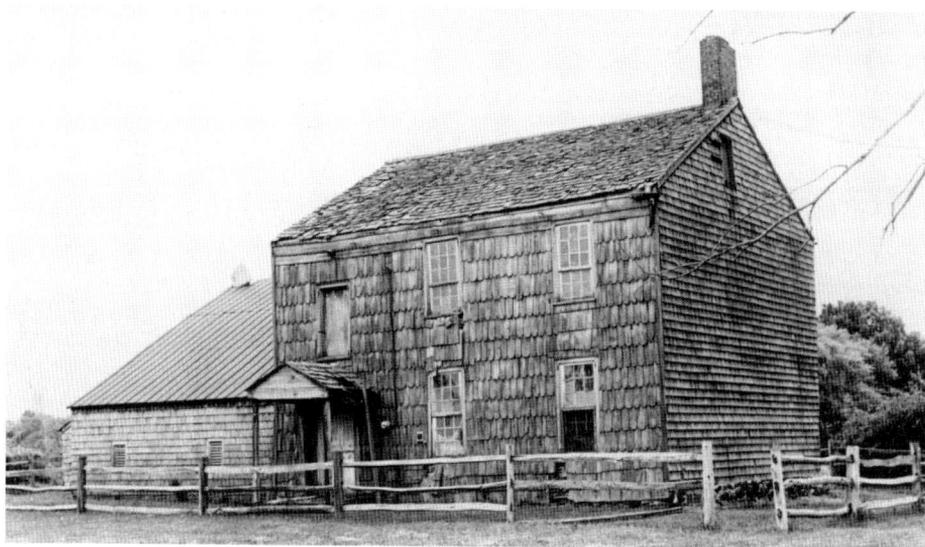

The Craig House, earliest section built c. 1710, main section built 1747. This view from c. 1950 was taken before the State of New Jersey restored the Craig House which stands on what is now Battlefield State Park. Archibald Craig, a Scottish Presbyterian immigrant, built both sections of the house which passed to his grandson, John Craig, upon his death in 1758. During the Battle of Monmouth, the Craig House was in the midst of the fighting, yet survived and remained in the Craig family until the mid-nineteenth century. (MCHA Archives.)

nine

War and Remembrance

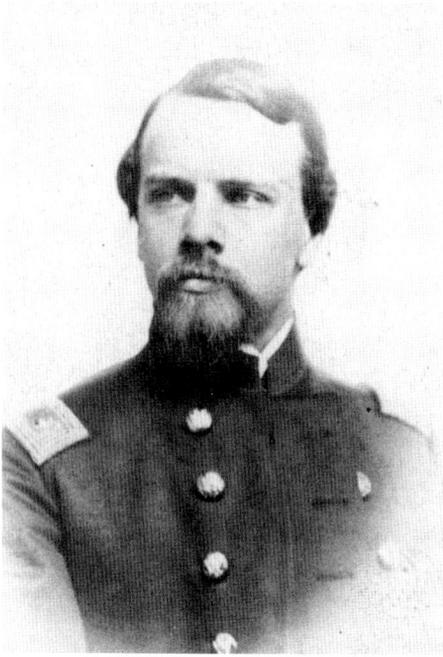

Left: Major Peter Vredenburgh, *c.* 1863. Major Vredenburgh's image was captured in a *carte de visite* by a photographer in Frederick, Maryland, before he and his command, the 14th New Jersey Volunteers, were sent to Virginia, where he died in the Battle of Winchester, September 19, 1864. Major Vredenburgh distinguished himself in his military career as he had in his civilian career as an attorney, and was regarded after his death as a local hero. This photograph was by Markens Gallery of Frederick, Maryland. (MCHA Archives.)

Below: Major Vredenburgh's horse, *c.* 1865. According to the inscription on the reverse, Major Vredenburgh rode this mare into the Battle of Winchester, where he was killed. The mare was also struck by the bullet that killed Peter Vredenburgh and bears the scar from that below her ear, as well as the brand "US" to indicate that she was a military mount. Colonel E. Applegate purchased the horse from Moses Johnson of Yardville, New Jersey, and she later was a standard participant in Memorial Day parades. (MCHA Archives.)

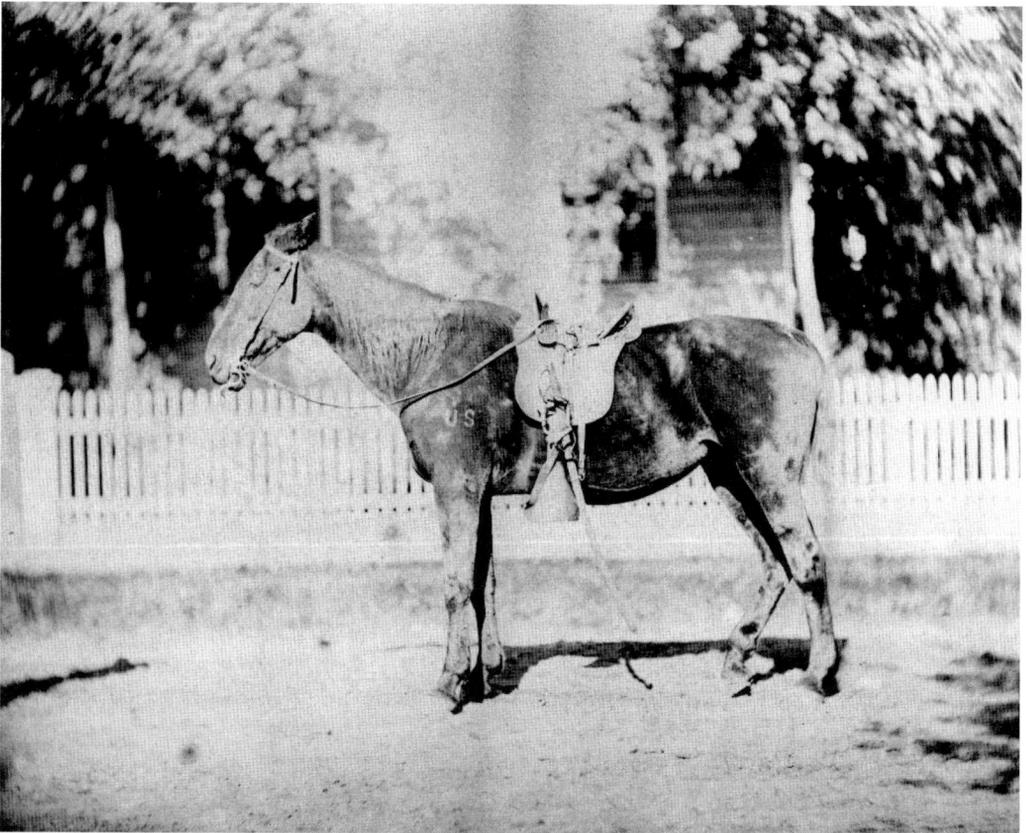

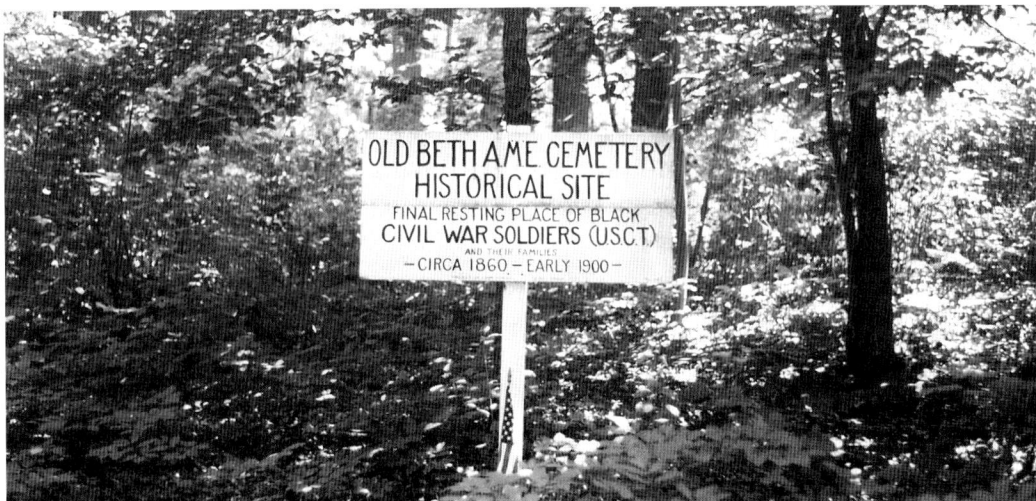

Bethel A.M.E. Cemetery. Members of Freehold's early African-American community who fought in the Civil War and their families are buried here in a section once known as Squirrel Town. The first church for the Bethel A.M.E. congregation was located nearby.

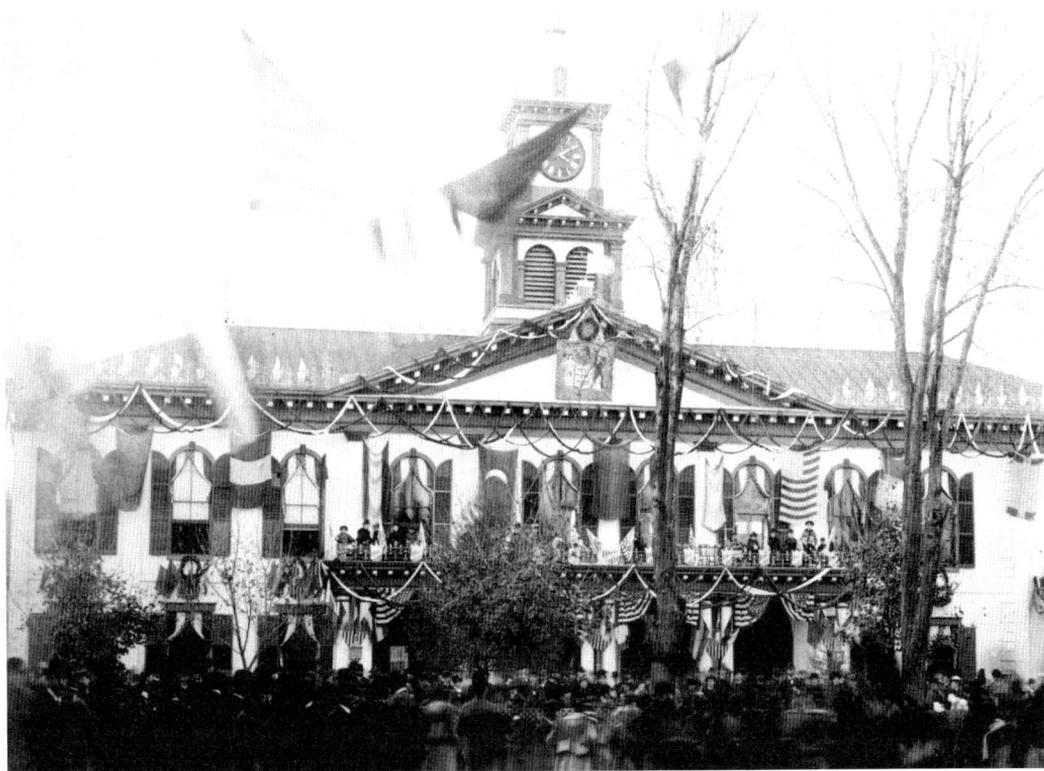

Monmouth courthouse, 1884. This celebration marked the unveiling of the Battle of Monmouth Monument, which was erected at the junction of Court and Monument Streets after seven years of successful planning and fund-raising. This photograph was taken by E.M. Bidwell, Union Square, New York. (MCHA Archives.)

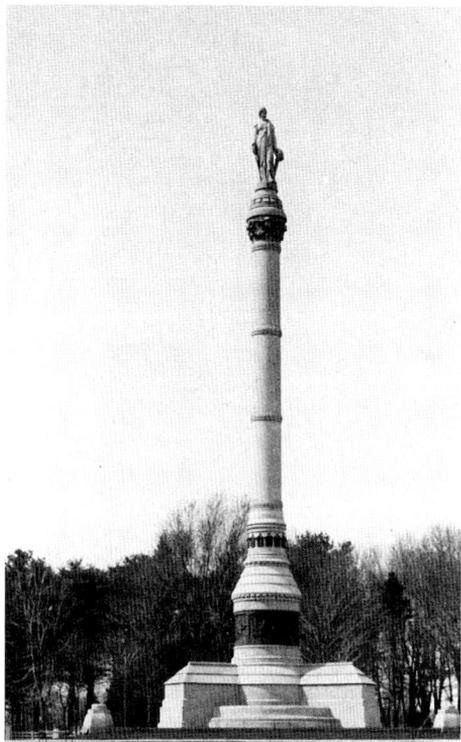

Left: Battle of Monmouth Monument, *c.* 1884. Former Governor Joel Parker and James S. Yard provided the vision and the energy that led to the construction of this 100-foot-high granite and bronze monument designed by architects Littell and Smythe, and sculptor J.E. Kelly. It cost nearly $40,000 to complete, the cornerstone having been laid in 1878 on the centennial of the battle. This photograph was by Scott Studio of Freehold. (Courtesy of Lydon Hendrickson.)

Below: Governor Leon Abbott and staff, 1884. New Jersey's governor and his staff attended a formal ceremony for the dedication and unveiling of the Battle of Monmouth Monument. This photograph was by E.M. Bidwell, Union Square, New York. (MCHA Archives.)

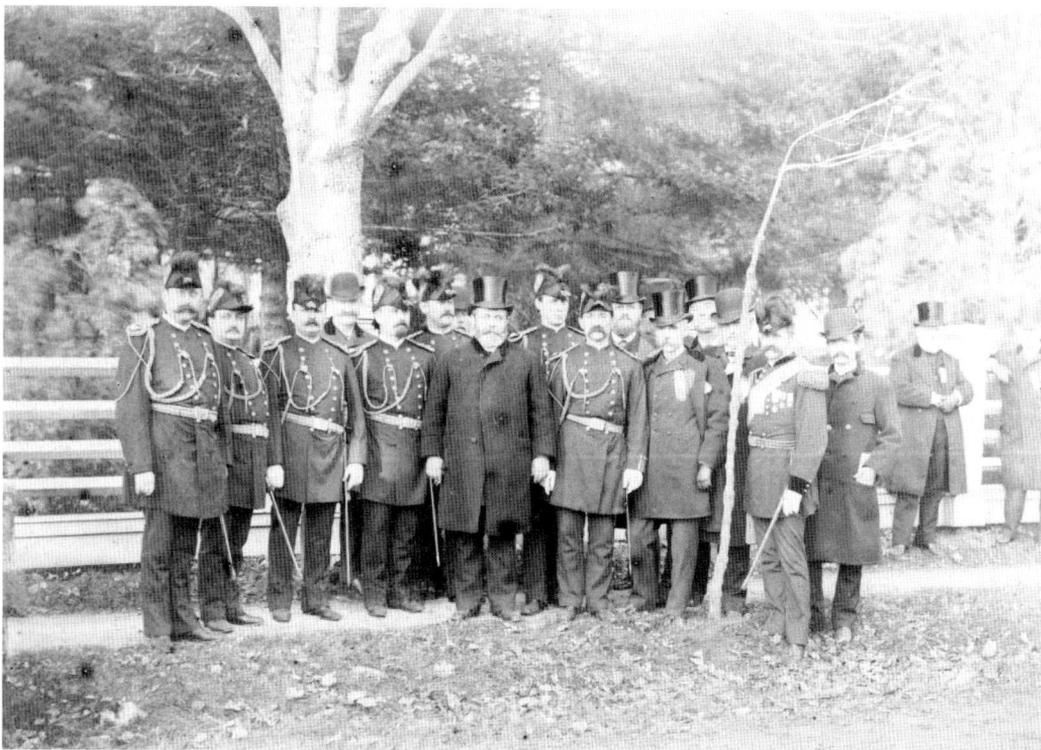

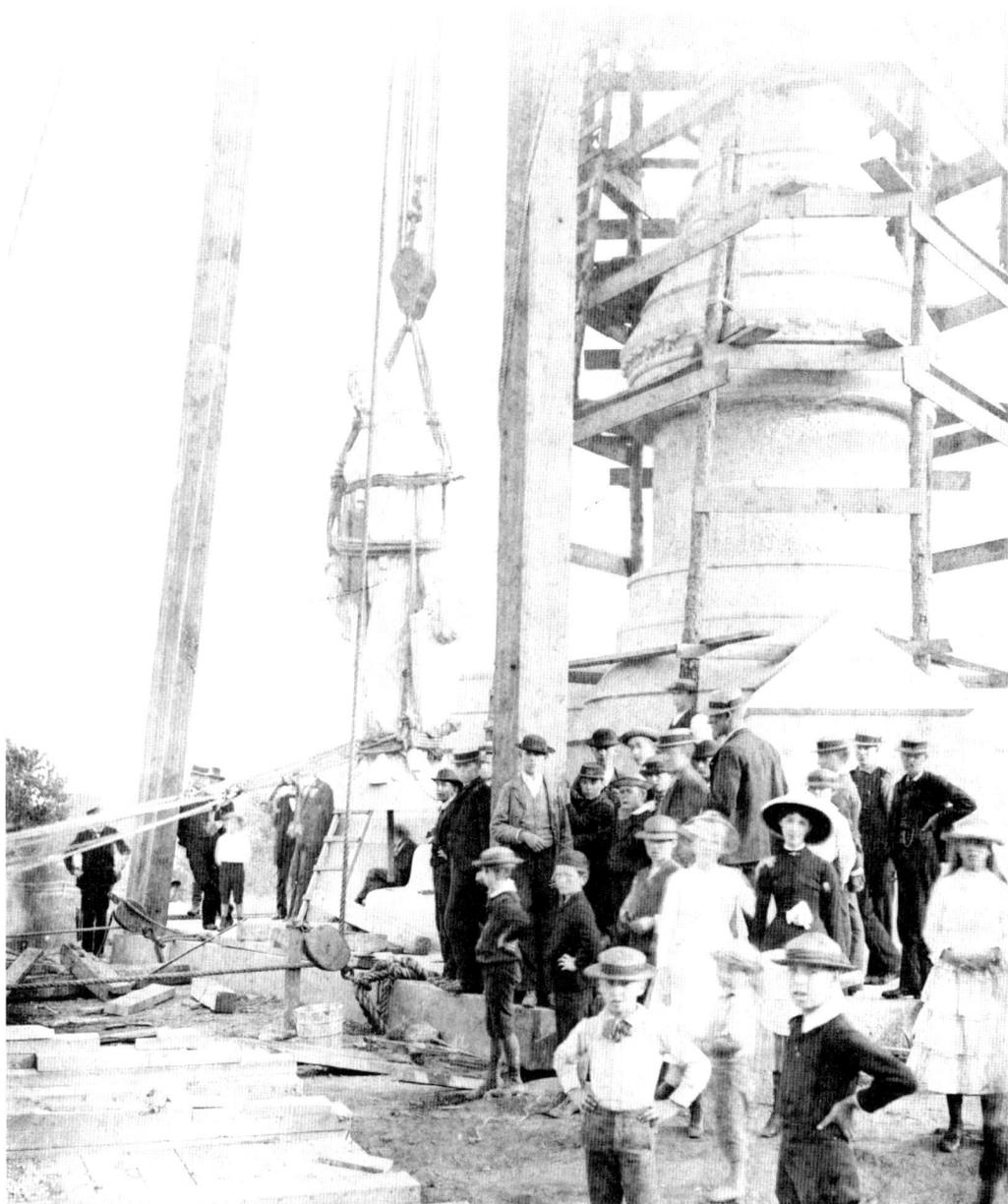

Statue of *Liberty Triumphant* being raised, 1884. The crowning feature of the monument is a colossal granite statue of *Liberty Triumphant*, for which Mary Anderson, a noted actress of her time, posed. This rare albumen print photograph shows the process of raising *Liberty* to the top of the monument, which is still under scaffolding. The photographer was F.C. Lockwood of Freehold. (MCHA Archives.)

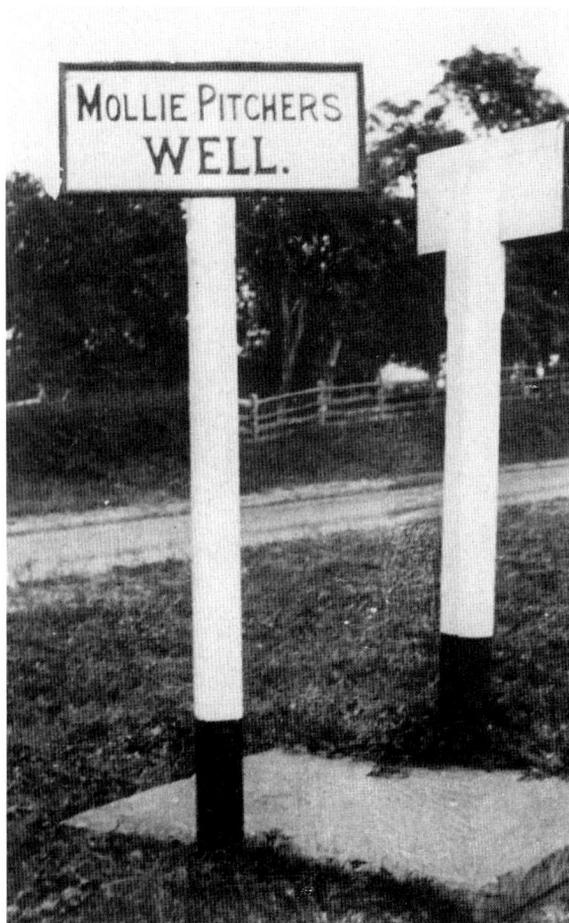

Left: "Mollie Pitcher's Well," *c.* 1890. Debate continues over the true location of the well where Battle of Monmouth heroine Molly Pitcher drew water to cool the cannons and quench the thirst of the troops. A number of locations have been proposed, many of which had been conveniently located for viewing by train travelers or tourists. (MCHA Archives.)

Below: Battle of Monmouth relics, *c.* 1870. Artistically arranged, these "relics" represent the nineteenth-century fascination with local historical events. On the reverse of this stereograph, the photographer advertises "out-door photographs of all kinds made to order. Local stereoscopic pictures for sale." This photograph was by F.C. Lockwood of Freehold. (Courtesy of George H. Moss Jr.)

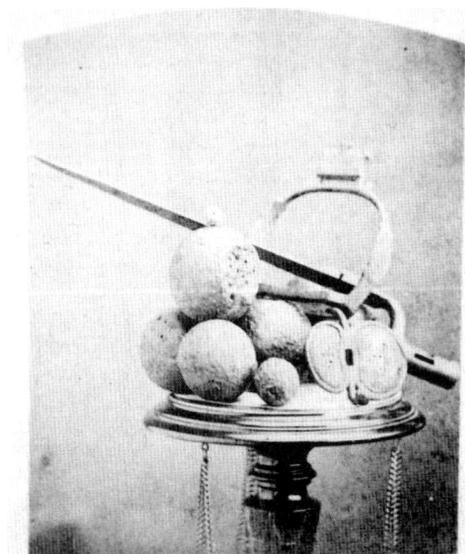

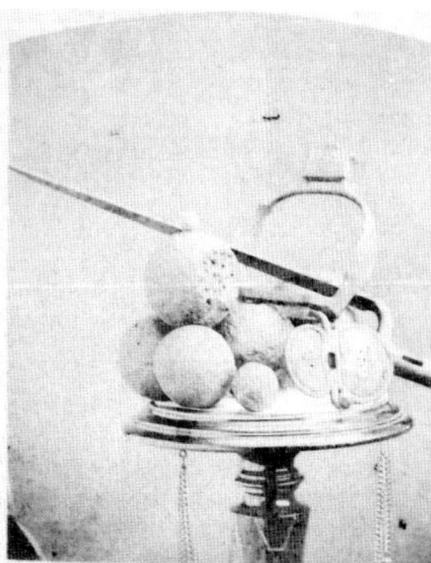

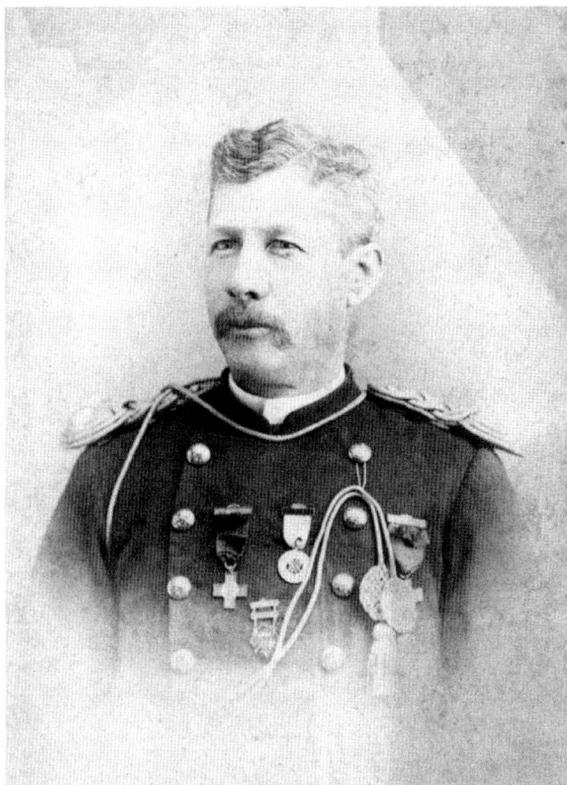

Right: Captain Andrew J. Buck, *c.* 1900. Commanding officer of the Company E 7th Regiment, National Guard of New Jersey is handsomely attired in his dress uniform. This photograph was by Scott Studio, Freehold. (MCHA Archives.)

Below: Vredenburgh Rifles, *c.* 1901. Posed in front of St. Peter's, which was right next door to Scott's studio, the occasion for this gathering may have been the return of Captain Vredenbergh from the Phillipines, where he had served in the Spanish-American War in 1901. This photograph was by Scott Studio, Freehold. (MCHA Archives.)

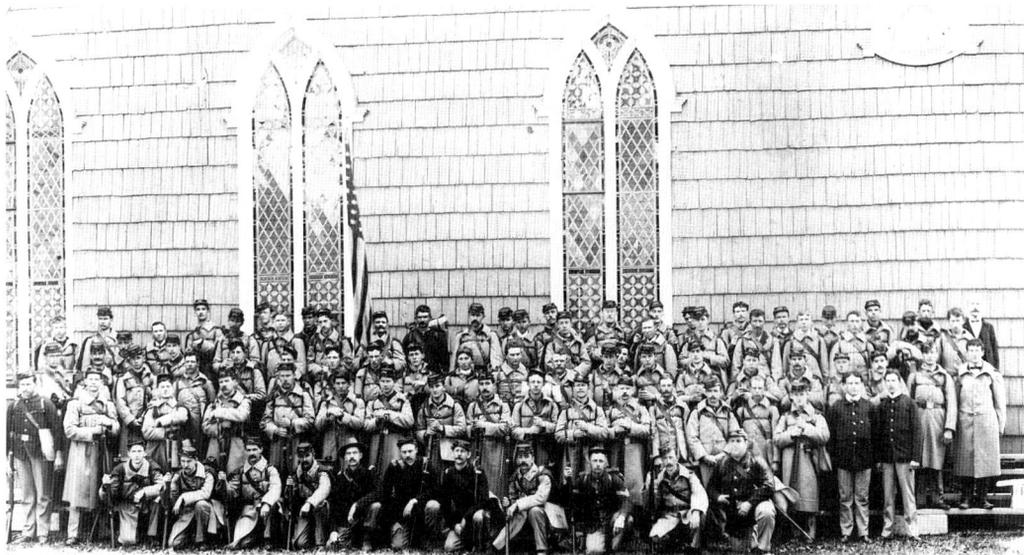

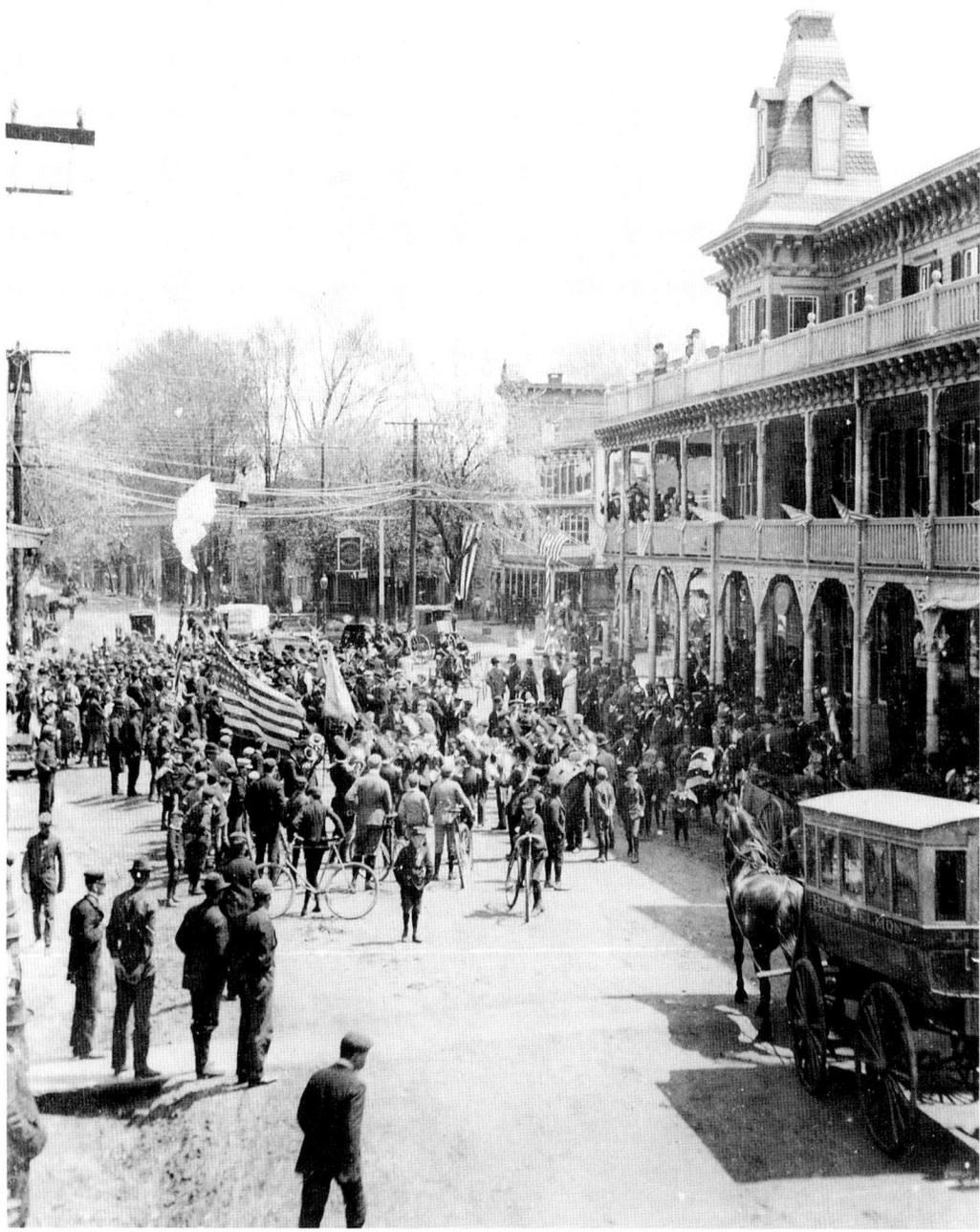

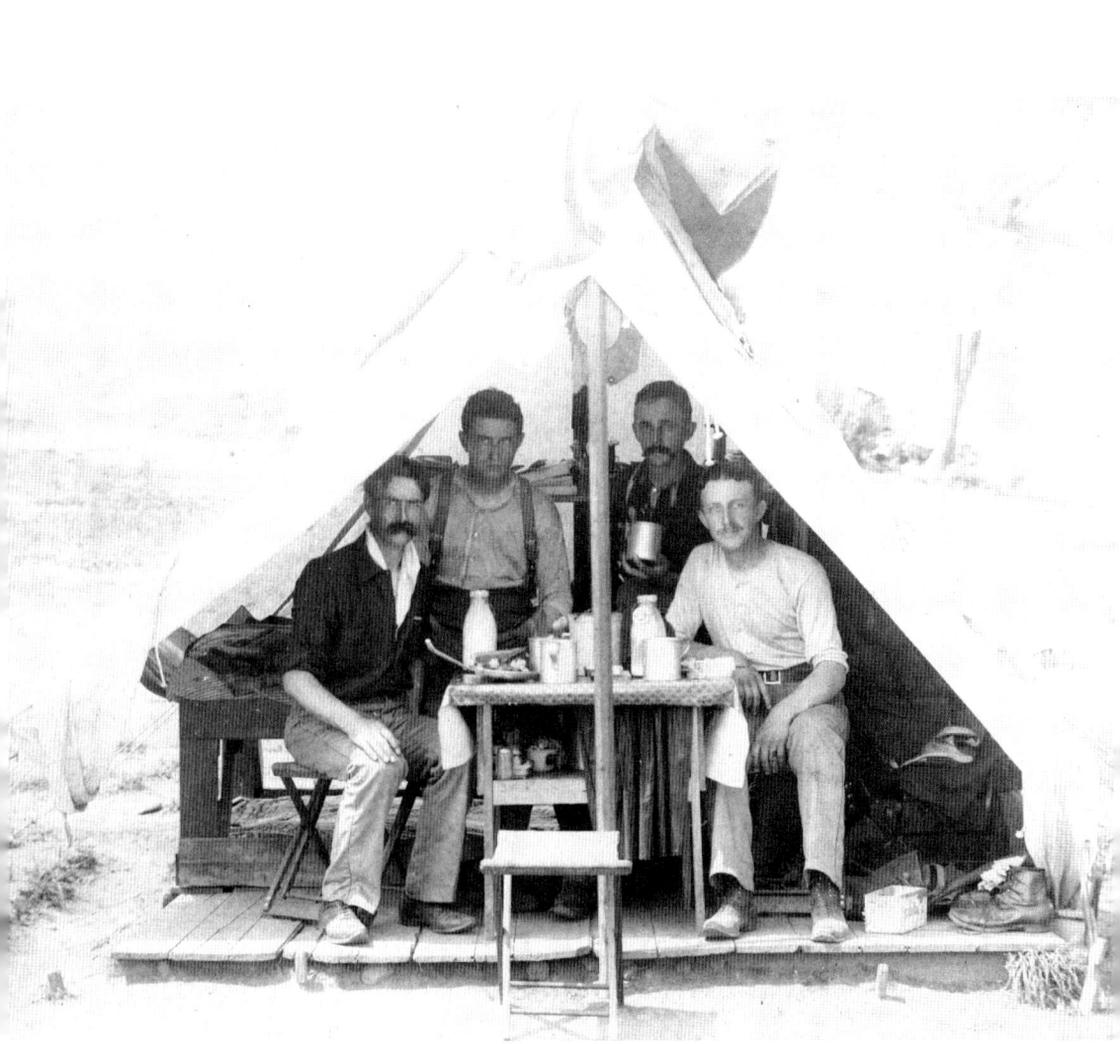

Above: Training camp, 1898. Prior to the Spanish-American War, soldiers from Freehold were sent to a training camp in Pompton Lakes, NJ. Pictured in their tent are: John DeRoche, John Denise, William T. Buck, and an unidentified man. (MCHA Archives.)

Opposite: Parade, Vredenburgh Rifles, *c.*1901. A parade of the National Guard unit passes in front of the Belmont Hotel, welcoming back veterans of the Spanish-American War. (MCHA Archives.)

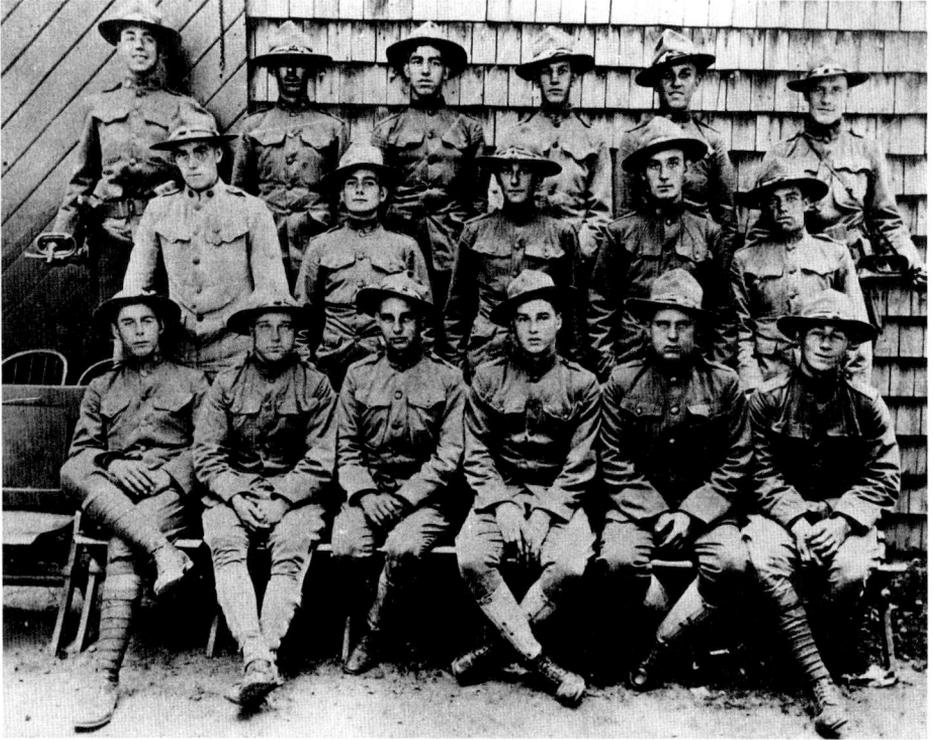

World War I veterans, c. 1917. Pictured from left to right are: (front row) Eugene Reynolds, Clarence Ray, Alex Griffiths, Francis Cahill, Ben Allen, and Fred Mills; (middle row) William Carter, Charles Lewis, Harold Stansfield, William Donohue, and John "Scotty" Carswell; (back row) Joshua Allen, Willard Metzel, Albert Carlson, unknown, Henry Barkalow, and Raymond Jones. (Courtesy of Freehold Public Library.)

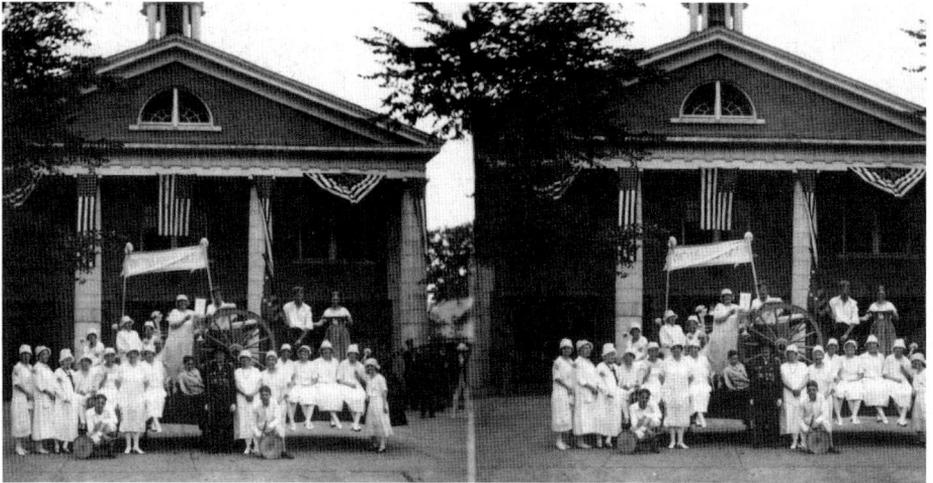

Liberty Loan Float, c. 1917. Standing in front of the Freehold Borough municipal building with a parade float, supporters of a Liberty Loan drive are ready to do their part for the war effort. (MCHA Archives.)

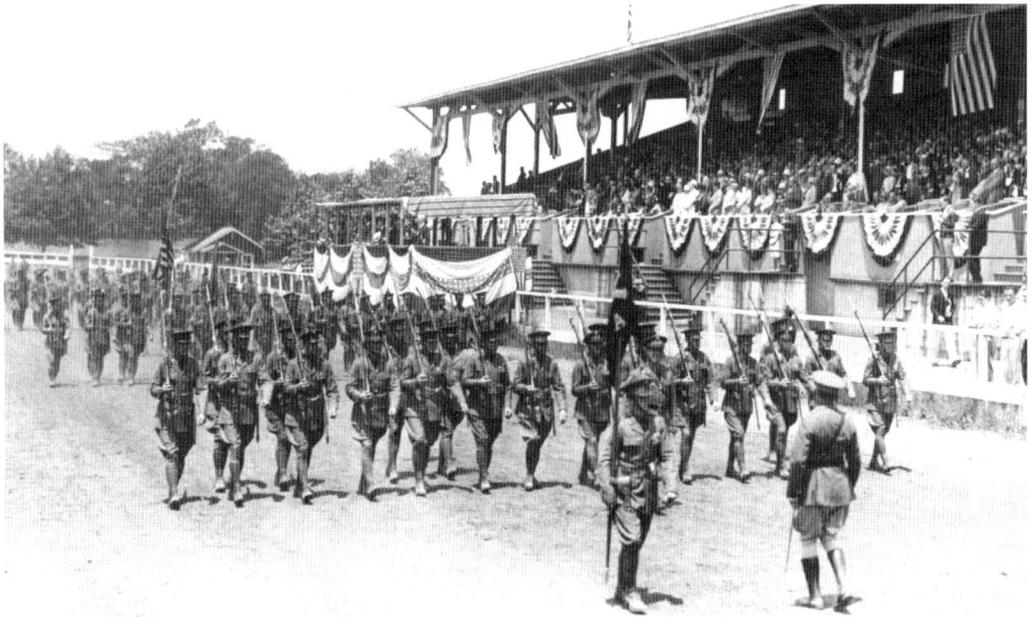

Battle of Monmouth 150th anniversary celebration, 1928. The New Jersey National Guard passes the reviewing stand at the Freehold Raceway in a parade to celebrate the sesquicentennial of the Battle of Monmouth.

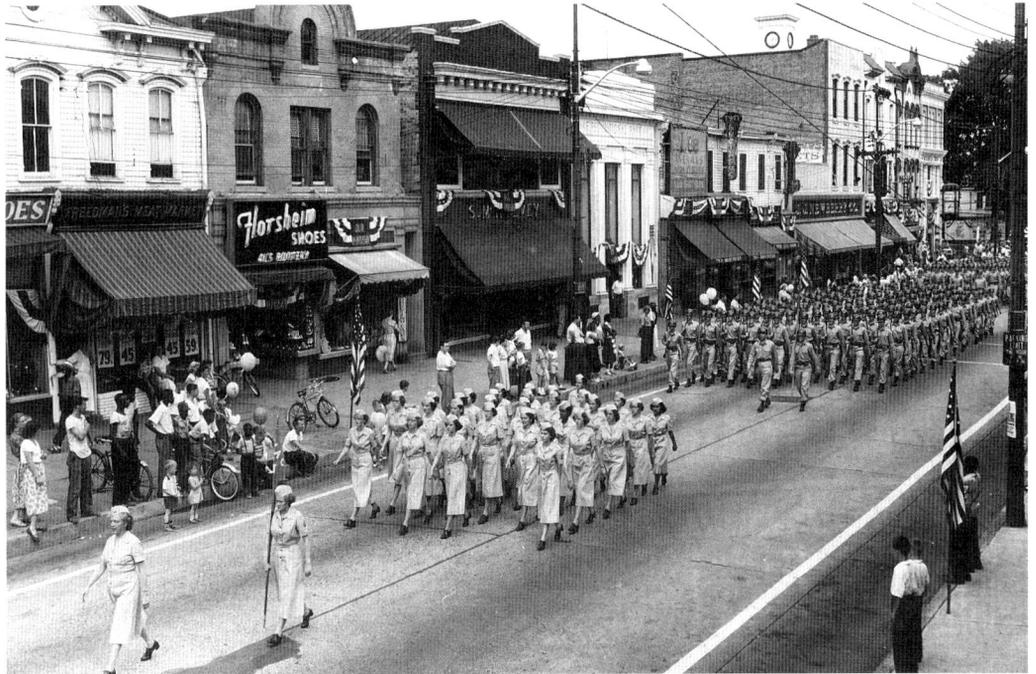

175th anniversary parade, 1953. The Battle of Monmouth was celebrated again at its 175th anniversary. The photographer was Arthur Schreiber. (MCHA Archives.)

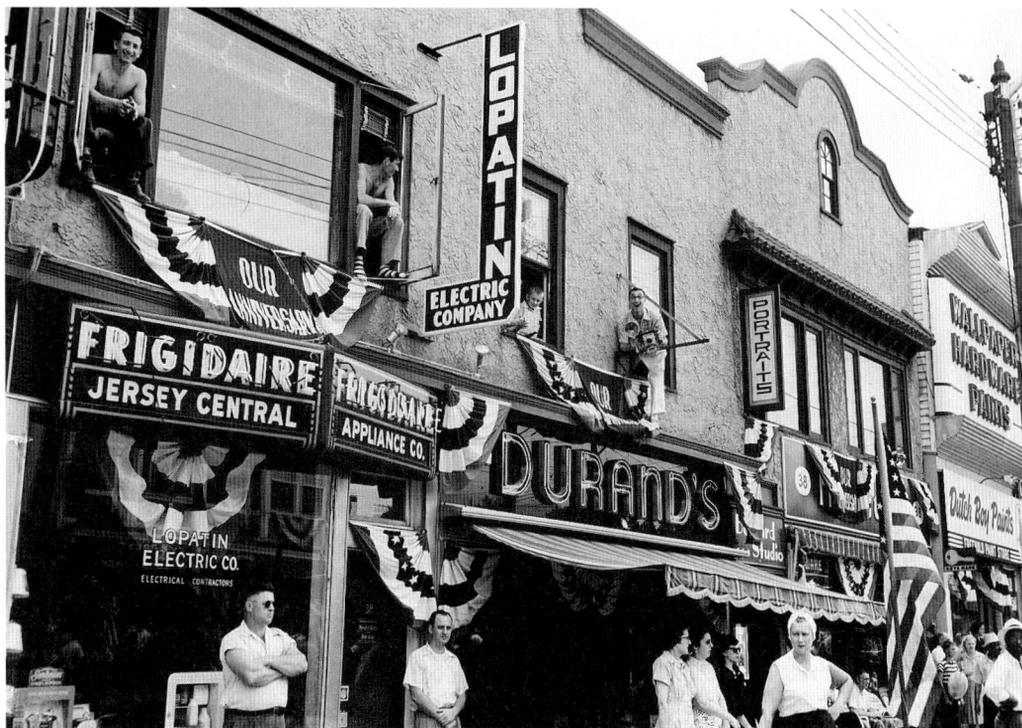

175th anniversary parade, 1953. The photographer at the window was capturing the event. This photograph was by Arthur Schreiber. (MCHA Archives.)

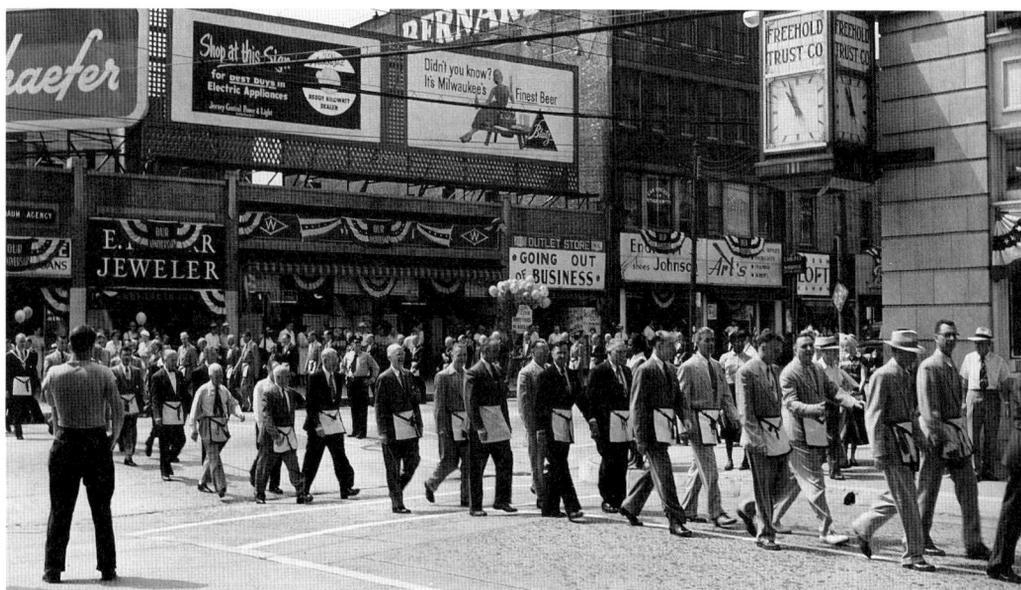

175th anniversary parade, 1953. The Masons round the corner from Main to Court Streets on their way to the end of the parade at the Battle Monument, passing under the old Freehold Trust Company clock. This photograph was by Arthur Schreiber. (MCHA Archives.)